W9-BML-159

free trade

Pair of vases

£20.0s.

free trade

Vase

£5.0s.0d

Mary Routh

1803

free trade

loving cup

£2.0s.0d

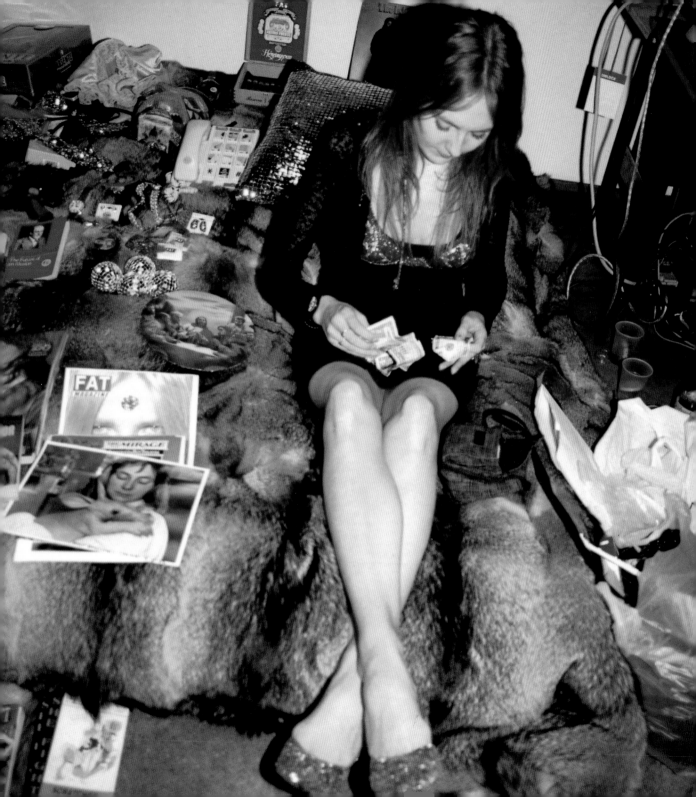

ART WORKS

MONEY

KATY SIEGEL AND PAUL MATTICK

With 188 illustrations, 178 in color

Thames & Hudson

For Raymonde Moulin

First published in 2004 in paperback in the United States
of America by Thames & Hudson Inc., 500 Fifth Avenue,
New York, New York 10110

thamesandhudsonusa.com

Library of Congress Catalog Card Number 2004102814
ISBN 0-500-93004-X

Art direction and design by
Martin Andersen / Andersen M Studio

Printed and bound in China by C & C Offset Printing Co Ltd

CONTENTS

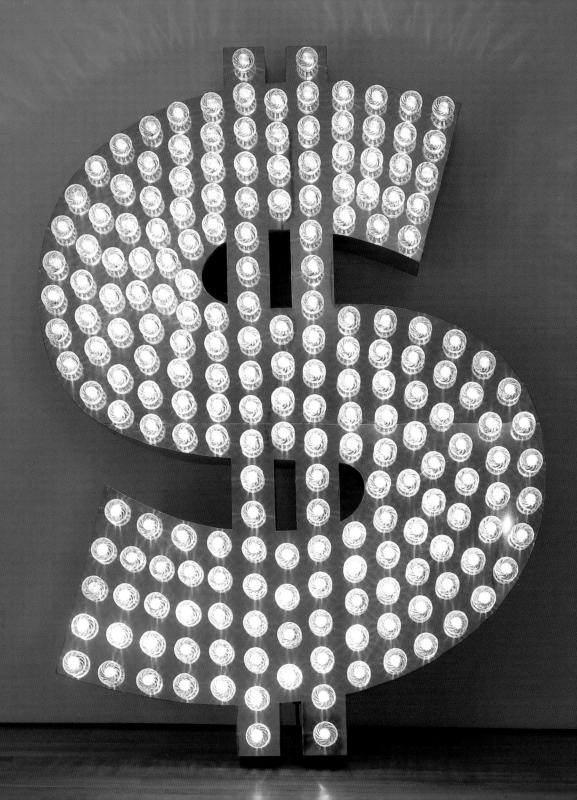

ART AND MONEY

The major concern of the epoch – the economy – is to today's art what
the nude, the landscape, or the myth of the new were in their time to
neoclassicism, impressionism, and the avant-garde: both a motivator of
creativity and a theme to the taste of the moment.

Paul Ardenne

Modern art has always involved the public exhibition
of a private experience. How can the artist's private
fantasies and thoughts find their way in a highly public
marketplace? Today, artists' concerns about the art
world often turn on questions about the market: how
do I get shown, how do I get someone to notice my
work? Is there a place for someone who doesn't make
work that's big and spectacular? How do I make work
that *is* big and spectacular? If a photograph is supposed
to be fifteen feet long, how do I find the funds to
produce such an object? As these examples suggest,
artists' concerns about making a living (and a life) as
an artist affect the look of art in a number of ways.

Some artists make highly produced, obviously
expensive things: Andreas Gursky's wall-size colour
photographs; feature-length movies, such as Matthew
Barney's *Cremaster* series; Toland Grinnell's sculptural
copies of luxury goods. Others go in the opposite
direction, towards the amateurish and handmade, such
as Sarah Sze's whimsical sculptures made from leftover
consumer goods like Q-tips, and Brian Calvin's
awkwardly painted adolescent portraits. Some seem
to have lost faith in art's importance within the larger
commodity culture, and mimic modes historically
classed as non-art, such as TV or design, but which
seem more culturally central. Jorge Pardo and Liam

opposite

$

Tim Noble and Sue Webster, 2001

Gillick are two among many making art almost indistinguishable from furniture or architecture. Perhaps the most common as well as the clearest response to this situation is work like that of installation artists Ernesto Neto, Maurizio Cattelan and Jessica Stockholder, who have produced site-specific pieces to commission, rather than work on 'spec'. Some artists make work that deals explicitly with the business of making and selling art. Danica Phelps made an exhibition about collecting, at the LFL Gallery in New York in spring 2002, and there are numerous people who make work about stores and selling commodities, such as Franco Mondini-Ruiz, as well as artists who make mock or real corporate entities out of themselves, such as Takashi Murakami.

Art, which has always been an object of financial as well as spiritual investment, may be discussed more frankly in monetary terms.

Art is part of the greater social world, and it changes with the concerns of that world. The situation artists face when they make and attempt to sell their work is shaped, at whatever distance, by economic forces that individuals may hardly be aware of. Of particular importance during the last two decades, for its effects both on people's economic lives and on their thinking about society, is the return to ideological fashion of the old idea of the self-determining global market, with no mercy for losers. This has been accompanied by an increase in the weight of financial speculation within the world economy, and its operation on an increasingly global scale, although the US, Europe and Japan remain the central foci of monetary flows. Wealth, consumption and the pleasure that money can buy have become publicly accepted as values in a nineteenth-century robber-baron way – though now without the nineteenth-century ideal of culture as a spiritually redeeming force countering the crassness of a commercially-oriented society. Art, which has always been an object of financial as well as spiritual investment, may as a consequence be discussed more frankly in monetary terms.

Art institutions have adapted to this situation. Art dealers compete and cooperate in pursuit of internationally active artists and collectors. Auction houses, also operating internationally, have attempted to penetrate the retail art market. And museums, even apart from thronged shows like 'Matisse/Picasso' and 'Manet/Velásquez', have become increasingly popular destinations, featuring shops, restaurants and, most recently, stunningly adventurous architecture – not to mention hosting wine and cheese parties, jazz nights and children's workshops. Running like businesses, and counting on ticket sales to replace public funding, have, not surprisingly, affected the kind of art that museums show. There is, of course, the familiar complaint that motorcycles and Italian pantsuits and celebrity portraits are replacing real art as the subject of exhibitions in our modern box populi. And that shows of Impressionist painting spring up with the annual regularity of crabgrass. Museums are also increasingly invested in exhibiting, buying and even

Wall Drawing #896
Sol LeWitt, 1999

producing or commissioning contemporary art, for several reasons. Older art – even older modern art – is scarce (they aren't making any more Leonardos or Picassos, even if someone digs one up now and then in a basement), difficult to borrow, and expensive to acquire. Contemporary art is relatively inexpensive, particularly at the beginning of an artist's career, when the right investment can pay off big later on. Because museums and contemporary art have become so intertwined, the changing conditions of the museum affect the art that gets exhibited and talked about, and even the ways that ambitious artists make art. Most major museums now sponsor 'project rooms', places dedicated to the display and even production of contemporary art never seen before, and often made

for that space. Many artists today operate without studios, instead moving from site to site, producing work that has already been purchased or at least commissioned. Sol LeWitt's huge floor-to-ceiling *Wall Drawing #896* was created for the lobby of the new headquarters of Christie's auctioneers in the

Because museums and contemporary art have become so intertwined, the changing conditions of the museum affect the art that gets exhibited and talked about, and even the ways that ambitious artists make art.

Rockefeller Center, New York. Even painting – long the province of 'real' art, private, resistant to the public, made for contemplation – shows up in the walk-in painting installations that rely on and cater to the institution of the museum and its specific architecture. The film and video installations ubiquitous in museums are easy and inexpensive for museums to ship and store.

It is no surprise that this enormous structure confronting them not only affects artists' thinking about their careers but also appears as a subject, in various forms, in their work. In the words of Paul Ardenne, 'The major concern of the epoch – the economy – is to today's art what the nude, the landscape, or the myth of the new were in their time to neoclassicism, impressionism, and the avant-garde: both a motivator of creativity and a theme to the

taste of the moment.'[1] That theme has given rise to a number of exhibitions. France alone, for instance, saw three in recent years: 'Capital', organized by the CRAC at Sète (summer 1999), 'Pertes et Profits – troc, vente, emprunt, gratuité' at the CNEAI in Chatou (July, 2000), and 'Trans_actions' at the Galerie de l'Université Rennes II (summer 2000). The Düsseldorf Kunsthalle mounted the enormous exhibition 'Das Fünfte Element – Geld oder Kunst' in early 2000, setting contemporary art into the context of objects from a wide range of cultures and periods bearing on the relation between art and money; in 2002 the Deichtorhallen Hamburg mounted 'Art&Economy', an exhibition demonstrating how 'art serves to combine corporate activities and representation as well as social responsibilities'; 2002–3 saw 'Shopping:

> The fact that money can be exchanged for goods of all sorts is mysterious, if we stop to contemplate it.

A Century of Art and Consumer Culture', an exhibition examining 'the creative dialogue between art and commercial presentation', at the Tate Liverpool and the Schirn Kunsthalle in Frankfurt. Curiously enough, the United States – with the world's most frankly business-oriented culture, and the global centre of the art trade – has made the least effort to confront the intersection of these aspects of modern life in the form of exhibitions or public discussion.

This book explores artists' responses to the commercial context of their practice during the last several years. Our emphasis is on the art, which speaks for itself; we begin with an account of the fundamentals that artists must confront: the place of art in a social world dominated by money.

Money

Money appears in many types of society, but capitalism is the first one in which it plays a central role in the production and distribution of goods and services. In all societies, goods have moved from place to place, from person to person. In capitalism, an opposite circulation of money matches the movement of goods. When goods are consumed, the money earlier exchanged for them continues to wend its way from hand to hand, bank account to bank account. The motion of money, in fact, controls that of goods: only because money has been transferred, or promised, by one person to another do planes full of clothing leave Bangladesh for the US or does oil pumped from the Middle East sail to Japan. The reason the goods move is to make possible the movements of money – which is why unbought goods pile up or are destroyed even if people without money need them.

In the form in which we normally meet up with it, money seems to be nothing but pieces of printed paper, or coins with a merely nominal worth. The fact that it can be exchanged for goods of all sorts is mysterious, therefore, if we stop to contemplate it. The power of money, its exchangeability for things we need or want, derives from the fact that it is a symbol.

Money represents something essential to modern society, though otherwise invisible: the social character of productive labour.

Money is central to capitalism because this is the first social system in which most productive activity – apart from activities directly related to individual consumption, like cooking dinner, cleaning the house, or repairing objects in the home – is wage labour, performed in exchange for money. Most people, lacking access to land, tools, raw materials, or enough money to purchase these, cannot produce the goods they need; they must work for others who have the money to hire them as well as to supply materials and tools. This money flows back to the employers when employees buy goods they – as a class – have produced.

It is the network of exchanges of products against money that binds all forms of work together to make one economic system.

Meanwhile, employers buy and sell goods – raw materials, machinery, consumer goods – from and to each other. Thus flows of money connect all the individuals involved in one social system. There are other principles of organization at work in modern society: some, like nationality and race, are modern inventions; others, like religion and gender, are adaptations of older ideas. But increasingly the threads of money pass through all these groupings, linking the world's people to each other.

The people who produce goods for a business have no direct relationship with the people who will buy and consume those goods or services, even though it is ultimately for these consumers that they are producing. Each business itself only finds out from its success or failure in selling its products at sufficiently high prices to what extent it is meeting the needs of customers. In this way, production for the needs of society as a whole is carried on by businesses that, as the property of individuals or corporations, are linked to the rest of society only by the exchange of goods for money, when they buy materials and labour and when they sell their products. When products are sold, the labour that has made them counts as part of social labour – the labour performed throughout, and for, society as a whole. It is the network of exchanges of products against money that binds all forms of work together to make one economic system. Money is central to modern society, a society based on the principle of individual ownership, because it represents the social character of productive activity in a form – bits of metal, paper symbols, or electronic pulses – ownable by individuals.

Like all forms of representation, money is an abstracting device: by being exchangeable for any kind of product, money transforms the different kinds of work that make them into elements of an abstraction, 'social productive activity'. Businesses are interested in the abstract, not the particular: for them, the specific product they sell represents a means to acquire money that, as the abstract form of social productive activity, can be exchanged for any sort of thing. Executives

move capital from one area of business to another not because they care more about automobiles than soybeans or stuffed animals, but to make money. The goal of business is to make profits, to collect more from sales than must be paid out in costs. This is what 'capital' is: money used to make money. A business that does not make a profit will cease to exist. The ability to make money constrains what goods are produced, or even whether money is invested in the production of goods at all.

In a money-centred society, if something is privately owned, money must be paid for it. Even things that are not produced, like land or oil deposits, are handled as if they were products and were worth money. Interest – money – must be paid for the use of someone else's money. Things that are simply symbols of money, like IOUs – for instance, banknotes, or stocks and bonds issued by companies – can be bought and sold, since they entitle their owners to money incomes.

Money's basic function remains the representation of the social relevance of the various productive activities individuals and businesses carry on.

As such examples show, the fact that money is the most important practical way in which the social aspect of productive activity is represented allows it to misrepresent social reality as well. By being exchanged for money, natural resources are represented in the same terms – as worth sums of money – as humanly produced things. Goods must be priced so that their sale allows businesses to make a profit; as a result, the prices of goods need have no connection to how important they are to human life nor how much effort was required to produce them. The amount something costs is affected by the amount people are able and willing to spend on it.

But money's basic function remains the representation of the social relevance of the various productive activities individuals and businesses carry on. Though it serves to measure the degree of desire for goods of different sorts, its movements across society are determined independently of the will of the individuals who engage in economic transactions, who must simply adapt to social forces experienced as changes in money prices. For example, while individual securities prices rise and fall irregularly, the stock market moves up and down as a whole in ways mysteriously linked to the general state of the economy, which itself cycles between prosperity and depression. On a shorter time scale, competition forces businesses to charge similar prices for similar products; since they must themselves buy goods (labour and materials), their ability to compete by lowering prices depends on the production techniques they employ. Historically, this has led to a strong tendency towards raising the productivity of labour. Already in the eighteenth century, employers assembled workers into large workshops, within which labour was divided into smaller and smaller tasks. This led in turn to the substitution of machines for people, whenever this raised profitability. By the end of the twentieth century, most production had become

mechanized mass production. Nothing could seem more different from this mode of production than the way art is made, but what art is and how it works can only be understood by considering it in relation to the money-oriented society in which it exists.

Art

The 'popular' or 'mass' arts, like other commercial products, are mass-produced to be sold to as many people as possible by enterprises primarily motivated to make a profit and typically employing large numbers of people. But a 'fine' art like painting is carried out as the work of an individual, even if various sorts of assistants are employed. It is more like the work done in a workshop in premodern times: volume is small, and each object has a unique status as the product of an individual, the artist.

This contrast with normal capitalist production has given rise to the distinction, drawn in almost all writing about art for the last two hundred years, between art and what is typically referred to as 'everyday life' or 'ordinary things'. Although critics and theorists rarely explain these concepts, the first – 'everyday life' – clearly refers to the normal activities of modern people, the activities of earning money, spending it, and consuming the goods bought with it, while 'ordinary things' are industrially produced objects. While art serves private functions of decoration, entertainment and investment, its difference from 'ordinary things' is signalled by providing special places for its display, museums, where it sits simply to be studied and admired, not bought or consumed in any obvious way.

In the intellectual world, art history is a distinct field, in which art has its own story, even if that story might come into contact with economic or political history.

Yet art as we know it is a product of the same historical development that brought us a society dominated by money-making. The roots of art in the modern sense lie in the Italian Renaissance, when the growth of urban wealth led to an interest in the furnishing and decoration of secular spaces, civic buildings and private palaces, alongside religious buildings. The explosion of visual, architectural, literary and musical creation we now associate with the period both emerged from and helped to dynamize a society increasingly based not on feudal relationships but on finance and

Yet art as we know it is a product of the same historical development that brought us a society dominated by money-making.

merchandising – on money – as well as war. The self-assertion of a new type of elite took the form of an emphasis on the ownership of beautiful things, things that cost a lot of money. As one historian explains, 'The passion for collecting that was aroused in the Renaissance was itself a product of a new consumer mentality; it represented not just the objectification of cultural values but the rationalization of possessiveness in an expanding world of goods.'[2] Collecting things of beauty, interest, and historical importance came to express not just the wealth of the collector but his

(or her) excellence as a user of wealth. Accordingly, aspects other than the sheer monetary value of possessions became important, such as the skill, learning or fame of the maker, laying the basis for 'taste' as a specifically aesthetic mode of appreciation.

The features of the new society emerging in Europe could be seen even more clearly in the seventeenth-century Netherlands, where 'the social status of the urban and rural population was defined more by democratic market-based relationships, which had replaced feudal relationships in the cities and countryside,' than by inherited status.[3] Painters increasingly produced for an anonymous market of businessmen, artisans and farmers rather than for princely or ecclesiastical patrons. Painting became a differentiated field of production for a broad spectrum of customers. At this time, before the Industrial Revolution, pictures were goods much like other artisan products. Technical innovations affected production costs and so sale prices, notably when the invention of the so-called tonal style of landscape painting 'cut down the time that was needed to produce a painting' so that 'landscapes became cheaper', leading to an expanded market for this kind of picture, which also appealed to groups of people without the knowledge to decode historical or allegorical works.[4]

The 1648 statutes of the Guild of Saint Luke in Leiden grouped together all workers with brushes, so still did not differentiate between artists and house-painters. However, the French artists who in the same year formed an Academy modelled on earlier associations of literary humanists distinguished themselves carefully from artisan guilds by forbidding the sale of works at their annual exhibition, the Salon. Of course, these artists lived, like others, by the sale of their works, to the state and to private collectors. But the higher social status embodied in the work of academic art was expressed by a theoretical disdain for monetary considerations; the fine artist, like the aristocrat who was his ideal customer, worked in theory not for money but for personal and national glory. The academic model set the tone for art across Europe. In England, the commercially successful portrait painter Sir Joshua Reynolds called for state-subsidized programmes of history painting. In France, it seemed natural to Madame d'Epinay, in 1771, to write of Jean Honoré Fragonard that 'He is wasting his time and his talent: he is earning money.'[5] On a more abstract plane,

> The fine artist, like the aristocrat who was his ideal customer, worked in theory not for money but for personal and national glory.

Immanuel Kant and other philosophers of the late eighteenth century defined artistic activity as 'free', not performed for wages but governed only by the genius of the artist.[6]

The long life of this idea is due to the fact that it expressed not only aristocratic disdain for trade but also the new conditions of artistic production that resulted from the replacement of patronage by market

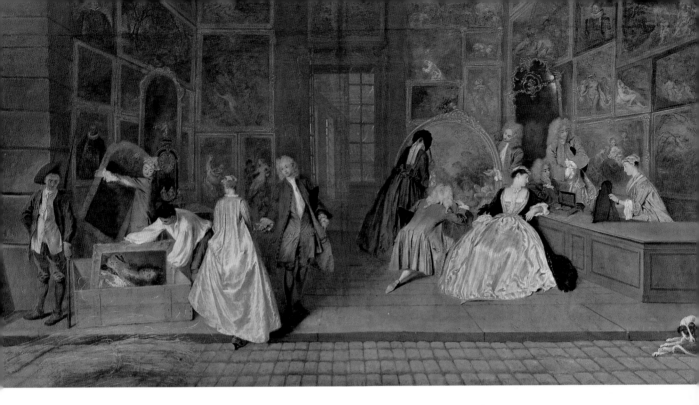

exchange as the chief form in which artists were paid for their work. Earlier, the artist producing for ecclesiastic or noble negotiated subject matter, size, approach, even sometimes colours and numbers of figures, with the patron. With the growth of the market for art works that came with the advancing displacement of feudal by capitalist social relations, the artist became responsible for selecting subjects and approaches that might catch the eyes of potential customers. The displacement of religious and mythological imagery by still life, portrait and genre painting multiplied the imaginable types of subject-matter and approaches. Increasingly, not tradition, academic rules, or any other authority, but the genius of the individual – his individuality itself – was to be

the dominant principle of artistic activity. The masculinity of the artist, earlier shared with craft-work generally, was now a sign of his bold inventiveness, in common with the scientist, businessman and politician.

Artistic labour gained new dignity against the background of developing capitalism, a social system that, in contrast to earlier systems, honoured productive activity and viewed the unproductive upper classes of the feudal past as parasites, however much the new rich aped their way of life by buying land, titles and art works. The fine artist came to seem a near-miraculous creator of value, transmuting relatively inexpensive materials, sometimes even in short periods of actual labour-time, into fabulously

expensive commodities. Art came to appear as the highest form of human productive activity, the model against which other forms of work could be measured, in particular the routinized, divided, manager-directed labour that came to dominate the factories and offices of developing capitalism.

As the Industrial Revolution destroyed craft production, the individuality of the artist came to contrast with the anonymity of the modern working masses, just as the self-directed production of art provided an alternative to the alienation of wage labour. For the collector, art alchemically transformed the money generated by capitalist investment into an updated simulacrum of aristocratic indifference to financial gain. Museums transformed treasures of the past into representatives of the higher aspirations of the current social order.

Like all the freedoms associated with the market, artistic freedom – freedom from direction and from wage labour – was double-sided. Freedom to create could mean freedom to starve; for the lucky artist, however, creative effort in fine disregard of commercial considerations could lead to great wealth. This paradox took institutional form with the development of the gallery-dealer system of art marketing at the end of the nineteenth century. The aesthetic needs of the new, expanding upper class of financiers, industrialists, merchants and professionals proved incompatible with the academic system. In a society proudly based on science and progress, classical subjects and forms necessarily gave way to 'the painting of

Portraits in an Office (New Orleans)
Edgar Degas, 1873

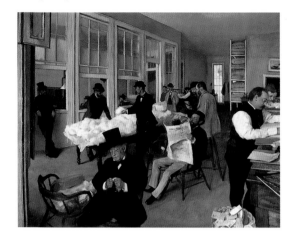

modern life'. There was a concurrent breakdown in the system of training and display associated in Paris with governmental institutions, the School of Fine Arts and the annual Salon. Private art schools rivalled

The fine artist came to seem a near-miraculous creator of value, transmuting relatively inexpensive materials into fabulously expensive commodities.

the state academy, and private dealers, most famously Paul Durand-Ruel, competed by exhibiting the work of select groups of artists. At first commanding only low prices, these 'modern' artists could therefore be marketed as non-commercially devoted to their personal visions, in distinction to the conformism of the Salon. Those who collected them were, accordingly, true art-lovers as opposed to the merely

wealthy under the sway of fashion. Initial neglect and even rejection by the art-buying public testified to an inner greatness whose existence was soon enough confirmed by commercial success. As the critic Théodore Duret wrote in 1878, 'Because it is necessary that the public who laughs so loudly over the Impressionists should be even more astonished! – this painting sells.'[7] The archetypal hero of this story has been, since the late nineteenth century, Vincent van Gogh, whose works his art-dealer brother was unable to sell during the artist's lifetime, only to be received rapturously by connoisseurs of painting throughout Europe by the turn of the century; by the end of the twentieth, paintings by van Gogh achieved the highest prices ever paid for works of art. Possessed by a need to make art, van Gogh lived and died, by his own hand, as a saint of modernity, abandoning normality, regular work, and wealth to create inspired objects in which all men and women can find aesthetic salvation in the face of their own submission to the laws of commerce.

Market competition to embody the true spirit of modernity fitted with the idea, natural to an era that celebrated its commitment to progress, of an historical progression of great artists and art movements; thus competing galleries showcased the series of competing avant-gardes – Cubism, Futurism, Purism, Dadaism, Surrealism, etc. – structuring the history of modern art. As a student of this development observed: 'These 'isms' are not just the great creative flow of a generation, but a mentality, haunted by the need for originality, by the need to supersede one's competitors, by the desire to get a piece of the market share, to be

discussed.'[8] The success of *La Peau de l'Ours*, a syndicate of collectors who started systematically buying avant-garde works in 1903 and sold them at auction after ten years at a 300% profit, made unmistakable the connection between the idea of the avant-garde and speculative investment in art.

Like capitalism itself, the market for advanced art was from the start a global one. Apart from the World's Fairs in which nations explicitly competed by showing off a full range of products from industrial manufactures to fine art, the Paris Salon itself showed the work of foreign artists and also attracted an international clientele. Commercial galleries operated across national borders, while the global movement of pictures and (especially) photographic reproductions led to an international homogenization of styles. Even the Great Depression of the 1930s, and the Second World War to which the nationalist regimes it produced abandoned themselves, did not destroy the international character of artistic modernism, but simply relocated its capital from Paris to New York. This facilitated the delayed entrance of American artists into the modernist mainstream, from which they had long been excluded.

Just as the war effected the removal of the centre of capitalist economic, political and military power to the United States, so American art became the most important art in the world (a fact made generally evident by the first prize awarded in 1964 to Robert Rauschenberg at the Venice Biennale, founded in 1895 during the first heyday of the international art

market). Germany, after the war as before it the leading economic power of Europe, hastened to stake its claim as a cultural centre by such initiatives as the founding of the cinquennial exhibition Documenta in 1955. In this activity the German government was following in the footsteps of the American state, which had joined with private institutions like the Museum of Modern Art to sponsor travelling exhibitions of post-war American painting. Keynesian economics, that is, had its cultural counterpart in the growing involvement of governmental institutions in the promotion of art (in the US, this to a large extent took the typical form of tax policy, as opposed to direct subventions).

Even today, however, the idea of art remains in creative tension with the developing business society that produced it.

The avant-garde, the typical orientation of artistic modernism in the epoch of the private gallery, disappeared in the new regime thus established – what Barthelémy Schwartz has called 'art of the mixed economy'. As at the previous *fin-de-siècle*, the close of the twentieth century saw an international art market, now a truly global one, as the Shanghai and Kwangju Biennials joined those of Venice, São Paulo, and New York's Whitney Museum. Operating on an immensely greater scale, with many more artists (selected from the tens of thousands graduating annually from university art programmes in various countries), the art system of the year 2000 was supported by a range of public and private institutions, ranging from governments and museums to auction houses, international super-galleries, and even particularly wealthy collectors. While the art business continues to represent a very small share of global economic activity, it plays an important public role as an incarnation at once of human productivity, financial speculation, and the fusion of ideas of economic and cultural value in which a business civilization seeks to represent its aspirations.

Art about Money

Even today, however, the idea of art remains in creative tension with the developing business society that produced it. While a luxury good, art has always incarnated the idea of rising above purely commercial preoccupations, for those who collect it and those who make it alike. This is no doubt one reason why, throughout its history, art has so seldom engaged directly with money as a subject, even while it has always hovered in the aesthetic atmosphere.

The economic growth of the northern Netherlands in the sixteenth century was reflected in religious and moralizing paintings in which gold and coins embody either earthly vanity or the homage the wealthy ought to pay to God. Renaissance and baroque images of Christ driving the moneychangers from the temple or of Judas's pieces of silver respond to the threat the emerging money economy posed to the religiously-sanctioned feudal order it was displacing. In the nineteenth and early twentieth centuries, prostitution became a favoured theme in all major art forms, from

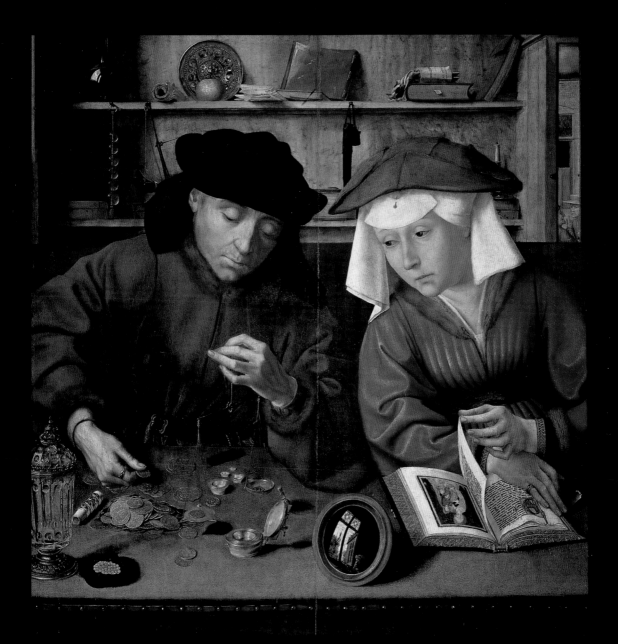

The Moneylender and his Wife
Quentin Matsys, 1514

painting to opera, as an image of the commodification of human relations and values. What paid sex is to love, we might say, money-seeking is to the high-mindedness of art. Characteristically, it was in the frankly business-oriented United States that the kinship of

artistic representation and the representation of economic value by money was most directly addressed. The 'money-painters' of the late nineteenth century shared with Americans generally a preoccupation with the substitution of symbols – banknotes and

government-issued 'greenbacks' – for actual gold. This preoccupation took artistic form in trompe-l'oeil paintings of paper money so realistic that viewers sometimes tried to remove an image from the canvas on which it was painted. After several federal prosecutions of artists for counterfeiting, Congress passed a law in 1909 prohibiting facsimiles of paper currency, a law that led to 1950s money artist Otis Kaye keeping his work secret, and which has produced trials and punishments for his modern-day follower, J.S.G. Boggs (see page 52).

Marcel Duchamp characteristically stayed closer to his own terrain – that of art – in addressing similar issues: paying his dentist with a hand-drawn cheque, issuing handmade bonds to raise money for a casino-gambling scheme. These artistic stunts reflected Duchamp's insistence on the artist's idea rather than his hand as the source of artistic value. Just as his choice of an industrially manufactured product (a 'Readymade') turned it into a work of art, so the artist's signature gave value to a piece of paper, transforming it into a cheque, the equivalent of money. (The same idea was expressed in the late 1950s by the beat poet Bob Kaufman, in his *Abomunist Manifesto*: poets 'don't write for money, they write the money itself.')

In the decades following World War II, a few important European artists, working in different countries and in different artistic practices, took on the issue of what value is in art, both parodying and celebrating the spirit of the artist as itself a precious material. Yves Klein was the first of these post-war conceptualists,

perhaps best known for patenting a cobalt blue pigment as 'International Klein Blue', and using it to create trademark monochrome paintings. In 1957 he exhibited identical paintings with completely different prices, seeming to mock the idea of art as something that could be rationally priced and purchased. At his most sardonic, Klein designated empty spaces within a gallery as 'Immaterial Zones of Pictorial Sensibility', marketing them with official certificates.

Piero Manzoni, influenced by Klein's work, took on this issue of the nature and institutional cooption of the artistic spirit in many projects. He stamped his thumbprint – a kind of primitive signature – onto hard-boiled eggs to create art works, as well as signing real people, turning them into what he called 'living sculptures'. He also made *Artist's Breath*, a series of inflatable sculptures that he himself blew up, and that would presumably both outlive him and eventually deflate and be devalued (like, perhaps, all art). Most notoriously, in 1961 he made *Merda d'artista*: ninety cans of his shit, packaged for sale (see page 50). More than a prank, this was a sardonic comment on the idea that everything the artist produces is incredibly

valuable. And in fact, Manzoni's canned shit has become quite valuable.

Joseph Beuys, one of the most important modern German artists, created a mythology around himself, casting the artist in the role of shaman. Investing various materials – fat, felt, honey, gold leaf, dead animals – with metaphoric, and often alchemical significance, in his drawings, performances and sculptural installations, Beuys insisted that 'Kunst=Kapital' – in other words, that art had its own power and value. More optimistic and politically-minded than Klein or Manzoni, Beuys believed that the shaman-artist had the capability to create sweeping social transformation.

But the recent history of money and art, that of the past fifty years, has been dominated by the boom in the American art market, and the response of artists and critics to the increasing amount of money and attention paid to contemporary art. When the Abstract Expressionists first came to public attention in the 1940s, American collectors were buying very little American art – they looked to France for avant-garde paintings, much as they did for clothes and wine. This lack of interest gave artists such as Jackson Pollock, who supported themselves with other kinds of work and lived on very little money, a certain freedom to make difficult, large-scale paintings, anticipating that they would interest no one but other artists. Despite – or perhaps because of – Pollock's avant-garde style, after his death in 1956 his work commanded high prices, proving that in prosperous post-war America

even the most challenging art could be sold. Not only that, but the avant-garde artist could be transformed into a celebrity, a fact denounced by critic Clement Greenberg, Pollock's great champion, in an essay

After his death in 1956, Pollock's work commanded high prices, proving that even the most challenging art could be sold.

written in 1961 for the *New York Times* Sunday Magazine, 'The Jackson Pollock Market Soars'. Greenberg and other critics saw the shift of the artist towards commerce and celebrity as inevitable, though whether they regarded this a positive or a negative light depended on their critical position.

In the year of Greenberg's article, sculptor Claes Oldenburg played on this realization in an installation called *The Store* (see page 114) where he sold small sculptures of such objects as airmail envelopes, pastry, and pantyhose in a storefront on East 2nd Street in New York. Oldenburg and the other Pop artists, including Roy Lichtenstein, Tom Wesselmann and Andy Warhol, depicted banal consumer goods: Coca-Cola, girlie magazines, billboards, toilets and, most famously, Campbell's soup cans. Warhol adopted not only the imagery but the techniques of commercial culture, mimicking the effects of mass-production by using photographs and silkscreen printing to create repetitive, multiple images, and naming his studio the Factory. Pop artists may have rejected the high-minded

attitudes of the Abstract Expressionists, but they embraced the lesson that, whatever the intentions of the artist or the content of the art work, art is a commercial product.

By the end of the 1960s, however, many artists were becoming frustrated with the increasing professionalism and business orientation of the art world. Some sought to move outside the gallery system by making huge art works in remote locations; in 1969, Michael Heizer removed enormous quantities of dirt from two facing mesas to create *Double Negative*. Other strategies for making seemingly uncollectable art included

Even when it doesn't make much money, critical or difficult art can also be used by both artists and institutions to accumulate cultural capital.

performance pieces that simply disappeared after one enactment, or conceptual art that might consist of a single sentence typed on ordinary paper, or even published in a magazine. For her *Real Money Piece* of 1969 (see pages 168–69), Lee Lozano invited people to visit her studio, where she offered them a jar of money which they could add to or help themselves from, and recorded the various reactions.

Lozano was unusual but not alone in directly addressing the subject of money. Between 1963 and 1973, Akasegawa Genpei's project *Model 1,000-Yen Note Incident (Mokei sen-en-satsu jiken)* involved duplicating yen notes and circulating them with invitations to an exhibition. He was eventually tried, and convicted, of counterfeiting. The trial served as a public battleground for definitions of art and artist, with the jury ultimately deciding that though he was an 'artist', and his works were 'art', he was nonetheless a criminal.

Other artists of the 1970s challenged various art world institutions, such as the museum and the gallery, and commented on the business of art. Hans Haacke is perhaps the best known among them, for art works like those that traced the buying and selling of a single painting by Manet, or exposed the economic politics of Mobil, a corporate exhibition sponsor (including the company's dealings with the South African military). Despite its radical content, this art too was sold, usually in the form of documents and photographs. And even when it doesn't make much money, critical or difficult art can also be used by both artists and institutions to accumulate cultural capital, the credibility or prestige that comes from higher political or theoretical aspirations, the aura of avant-garde rebellion or intellectual seriousness.

In the booming art market of the 1980s, some artists shook off the opposing imperatives to either ignore or critique the art market. Following in Duchamp's and Warhol's footsteps, Jeff Koons became famous for exhibiting manufactured, commercial products such as vacuum cleaners in museum vitrines, as art works. Koons didn't make the objects, he simply recontextualized them, moving the vacuums from

Sears to the museum, highlighting the role of display in creating the aura surrounding the art commodity. Koons, along with Haim Steinbach, Ashley Bickerton, and others, no longer seemed to resist the way art operates under current conditions of materialism and go-go capitalism.

These twin impulses of the 1970s and 1980s to critique the market or to accept (and even exaggerate) its centrality to modern life together form the background for the contemporary art reproduced in this book. The themes we have chosen reflect the wide variety of attitudes of artists towards money and its relationship to art. There are artists who use paper money and coins directly in their work, but we have also chosen artists who address more abstract aspects of the monetary society that we all live in, such as the look of the corporation, and the ways in which art and money circulate. We have organized their work into several interrelated categories. 'Precious Materials' contains art that uses currency, precious metals, or other valuable substances, such as cocaine. 'Credit' gathers together art works that somehow depend on reputation, using the artist's signature or image, or a product's brandname to guarantee value. In 'Production' you will find objects that highlight the methods and labour it took to produce them, whether that work was done by the artist, assistants or even a machine. 'Store' is full of pictures and projects that focus on the sale and purchase of goods. 'Circulation' emphasizes the ways in which both art and money travel around a global economy. 'Business' collects images relating to the business world, as well as artists who operate as businesses or corporate entities. Finally, 'Alternatives' presents projects that propose the possibility of another system, another world beyond capitalism. All of these artists and art works comment on how money works in the art world, but they also use art to puzzle out the complicated ways in which money functions in the larger world of getting and spending.

1 Paul Ardenne, 'Economics art, l'heure du bilan', in *artpress* 22 (2001), p. 103.
2 Richard A. Goldthwaite, *Wealth and the Demand for Art in Italy, 1300–1600* (Baltimore: Johns Hopkins University Press, 1993), p. 247.
3 Michael North, *Art and Commerce in the Dutch Golden Age*, trans. Catherine Hill (New Haven: Yale University Press, 1997), p. 132.
4 *Ibid.*, p. 101.
5 Quoted in Étienne Jollet, "Il gagne de l'argent': l'artiste et l'argent au XVIIIe siècle', in L.B. Dorléac, ed., *Le Commerce de l'art* (Besançon: La Manufacture, 1992), p. 129.
6 Paul Mattick, 'Art and Money', chapter 3 of *Art in its Time* (London: Routledge, 2003).
7 Cit. Robert Jensen, *Marketing Modernism in Fin-de-Siècle Europe* (Princeton: Princeton University Press, 1994), p. 18 n.2.
8 *Ibid.*, p. 15.

PRECIOUS MATERIAL

What medieval alchemists never understood is that money is a social product, not a chemical one – even when it is made of gold. Renaissance artists used precious metals, along with expensive pigments, to make objects more valuable. But artworks themselves came to be worth more than gold. When Marcel Duchamp invented the Readymade – the mass-produced object transformed into art, with cultural and commercial value out of all proportion to its material origins – he demonstrated that the artist's touch can work like Midas's. This mysterious transubstantiation, like that of gold into money, is social in origin: what makes it possible is the artist's place within the network of relationships constituting the world of art.

'Gold? yellow, glittering, precious gold?...
Thus much of this, will make black, white; foul, fair;
Wrong, right; base, noble; old, young; coward, valiant,
...What this, you gods? Why, this
Will lug your priests and servants from your sides,
Pluck stout men's pillows from below their heads;
This yellow slave
Will knit and break religions; bless the accursed;
Make the hoar leprosy adored; place thieves,
And give them title, knee and approbation,
With senators on the bench; this is it,
That makes the wappen'd widow wed again:
...Come damned earth,
Thou common whore of mankind.'

Shakespeare, Timon of Athens, Act 4, Scene 3

'For money is so artfully scattered that it may multiply; it is expended that it may give increase, and prodigality giveth birth to plenty: for at the very sight of these costly yet marvellous vanities men are more kindled to offer gifts than to pray. Thus wealth is drawn up by ropes of wealth, thus money bringeth money; for I know not how it is that, wheresoever more abundant wealth is seen, there do men offer more freely. Their eyes are feasted with relics cased in gold, and their purse-strings are loosed. They are shown a most comely image of some saint, whom they think all the more saintly that he is the more gaudily painted. Men run to kiss him, and are invited to give;

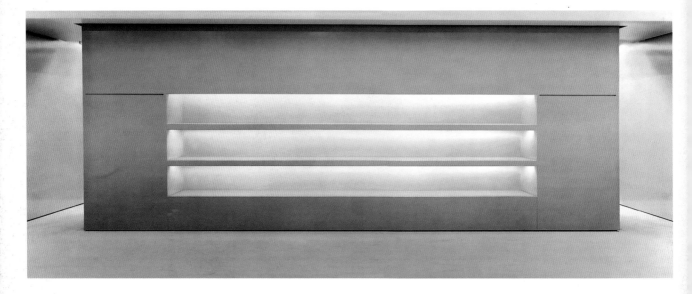

there is more admiration for his comeliness than veneration for his sanctity. Hence the church is adorned with gemmed crowns of light – nay, with lustres like cart-wheels, girt all round with lamps, but no less brilliant with the precious stones that stud them. Moreover we see candelabra standing like trees of massive bronze, fashioned with marvellous subtlety of art, and glistening no less brightly with gems than with the lights they carry. What, think you, is the purpose of all this? The compunction of penitents, or the admiration of the beholders?'

Bernard of Clairvaux, 12th century

Art, like the church, is supposed to be a matter of
spiritual rather than material riches. But just as medieval
reformers complained that the church had become an
economic enterprise, so many contemporary artists
have brought out the parallels between commercial
culture and fine art. Andreas Gursky's photograph
presents a temple to luxury
consumer goods, alluding both to the
sacred 'white cube' of the gallery
and to other artists who have
displayed such goods as a comment
on the nature of contemporary art,
such as Andy Warhol and Jeff Koons.
Chuck Ramirez's piece alludes to
Gursky, showing us what seems to
be a golden altarpiece stripped of its
relics – empty of the luxury
chocolates it once contained.

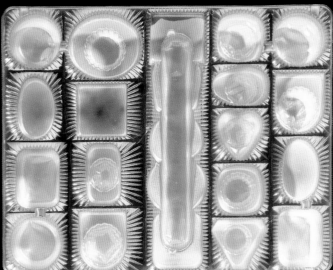

Godiva 2
Chuck Ramirez, 2002

Pope Fans Reaching Toward British Open Fan
Andrea Bowers, 2000

Andrea Bowers goes to mass spectator events, such as rock concerts and baseball games, photographs individual audience members, and renders them in careful detail using coloured pencil. The fans (the crowd gathered to worship the Pope) and not the star (the Pope himself) become the focus of these drawings. Other times the artist features the stars, turning them into modern day icons, as in the case of the female rappers Salt 'n' Pepa. Bowers emphasizes the nature of these images as contemporary versions of religious icons by drawing on the shiny, cheap metallic material used to make iron-on t-shirt motifs.

Hot, Cool and Vicious
Andrea Bowers, 2000

'Liking money like I like it, is nothing less than mysticism. Money is a glory.'
Salvador Dali

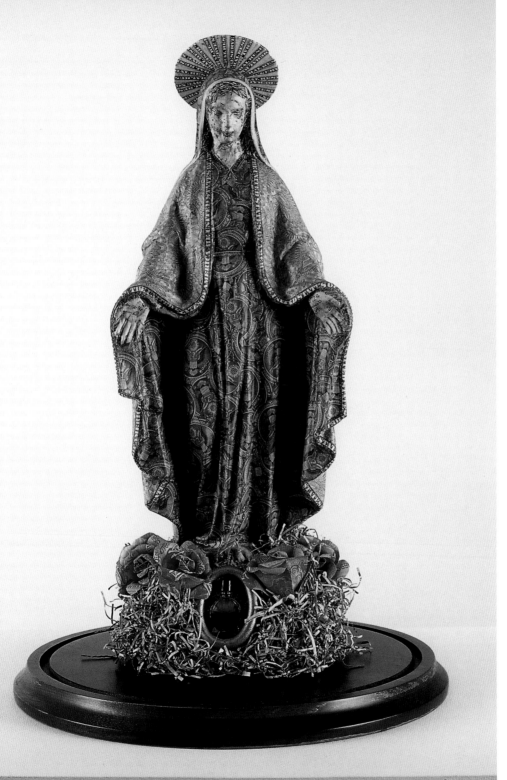

Reliquarium
Barton Lidice Benes, 1996

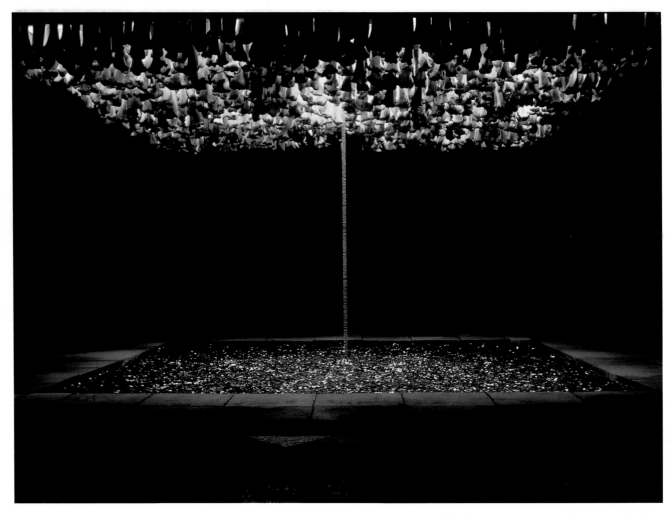

Missão/Missões (How to Build Cathedrals)
Cildo Meireles, 1987

Cildo Meireles made the large installation work *Missão/Missões (How to Build Cathedrals)* out of 600,000 pennies, 800 communion wafers, and 2,000 cow bones; the constellation of money, religious accessories, and emblems of death invokes the violent, imperialist history of evangelical Catholicism in South America.

The Human Abstract

Pity would be no more,
If we did not make somebody Poor:
And Mercy no more could be,
If all were as happy as we:

And mutual fear brings peace:
Till the selfish loves increase.
Then Cruelty knits a snare,
And spreads his baits with care.

He sits down with holy fears,
And waters the ground with tears:
Then Humility takes its root
Underneath his foot.

Soon spreads the dismal shade
Of Mystery over his head;
And the Catterpiller and Fly,
Feed on the Mystery.

And it bears the fruit of Deceit,
Ruddy and sweet to eat:
And the Raven his nest has made
In its thickest shade.

The Gods of the earth and sea,
Sought thro' Nature to find this Tree
But their search was all in vain;
There grows one in the Human Brain

William Blake, Songs of Experience, 1794

Many artists use money itself as a precious material. Rainer Ganahl is an Austrian artist who made a series of collages called *The Last Days of the Sigmund Freud Banknote*, referring to the disappearance of the Austrian 50 Schilling note bearing Freud's portrait. Ganahl recorded his dreams for several months leading up to 28 February 2002, the day the note ceased to be legal tender in Austria. In a kind of alchemy in reverse, Ganahl's materials became worthless as he finished his project – although market success could potentially transform them back into something of value. As in Freud's dream analysis, events in the real political world reappear, in altered form, in the artist's private consciousness.

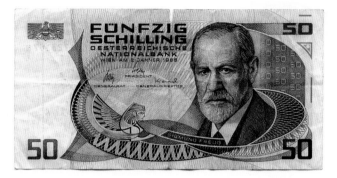

Das Zählen der letzten Tage der Sigmund Freud Banknote

Mo., 17. Dezember 2001, Nice, Quelle: cnn.com, 5:57 pm

50 Austrian Schilling = 3.28299 US Dollar
50 Austrian Schilling = 3.64777 Euro
50 Austrian Schilling = 2.24863 British Pound
50 Austrian Schilling = 418.66384 Japanese Yen
50 Austrian Schilling = 7.10768 German Mark
50 Austrian Schilling = 23.83454 French Franc
50 Austrian Schilling = 5.35128 Swiss Franc

Vergleichsdaten:

1 Euro = US $ 0.9000
Dow industrials: 9913.70 up
Nasdaq: 1980.75 up

Sigmund Freud am Internet:
amazon.com: 1217 matches for Sigmund Freud
buecher.de: 166 Artikel, Sigmund Freud

Traumaktivität - aufgefangene Erzählungen - Assoziationen:

I am standing at a rather wild party filled with New York art people. it is held in a run around rectangular corridor. Colin de Land is completely wasted and drunk. Somebody carries him over to me. He was looking for me. Suddenly, he wants to grab my testicles and demands: "Gimme my glasses, gimme my glasses, I know you have my glasses." he barely can stand on his feet and hangs all over me trying to grab my testicles. he thinks my balls (Eier) look like a pair of glasses. My reaction is rather strong: I yell and scream: "Isn't it enough that I fucking have to see you self-destroy yourself and now, you want to drag me down with you!"

I wake up disturbed and scared with these accusing-mega-reactive sentences in my mind.

There is a larger part of this dream buildup that has escaped though somehow I think of my family backyard where my step mother's car used to park. The colors of the car and the blanket in the car I hated. I referred to them as piss colors, completely abject. I am staying at the Villa Arson in Nice and all these woolen blankets I need so desperately are of a similar color: it is 3 AM, freezing and I don't know whether the blankets smell urinal or just dry cleaned. I arrived yesterday from NY. I slept 3 hours in an overcrowd airplane quite well on the floor under the seats between the last row and the toilet. Jet lagged and shocked by this castrating nightmare. I'm unable to continue spleeping.

I left to the airport directly from the memorial for susan goldman who committed suicide and departed through an excruciating gate of drugs, alcohol and a plastic bag. talking to Jonathan horrowitz is always an intense looking across his heavy glasses. we don't really talk but, we stick our eyes physically across his heavy black glass frame, crystallizing time. the accessories of this nightmare are as evident as there are paradigmatic and metonymic schemes of interpretation along the line of personal sexual choices. right after me, Jonathan talked very long to Jahn, a german artist whose eyes without glasses really fascinated me. they are as gray-green/blue as mine.

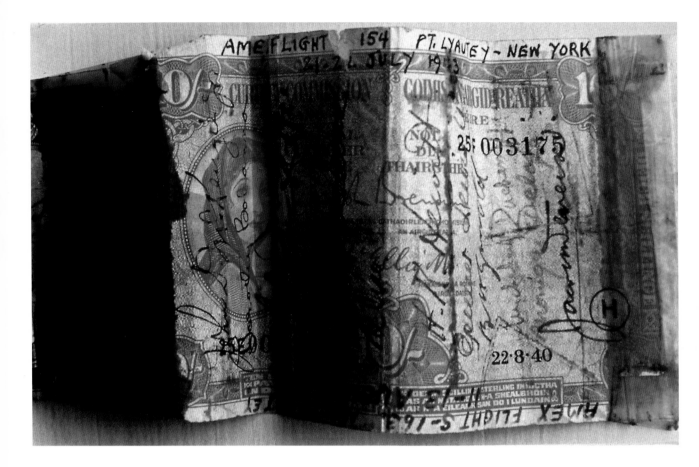

During World War II, GIs collected paper currencies as souvenirs, taping them together as a record of the places they had been. These scrolls of money became known as 'short snorters', a term also used for a short sleep before going into battle, a short stay in port, a brief wind, or a glass of whiskey. Soldiers usually began their scroll with a US dollar bill, to be used when returning from battle to buy a glass of whiskey. Andrew Bush photographed these scrolls for a series called *Short Snorters*. The soldiers turned socially valuable material (money) into personally meaningful objects by removing the paper bills from the country where they functioned as legal currency. By photographing them, the artist then transformed them into art, which, in the context of the gallery and the art market, acquires monetary value, completing the cycle. Through all of these alchemical changes, the original nature of the money as commercially valuable reasserts itself in the end.

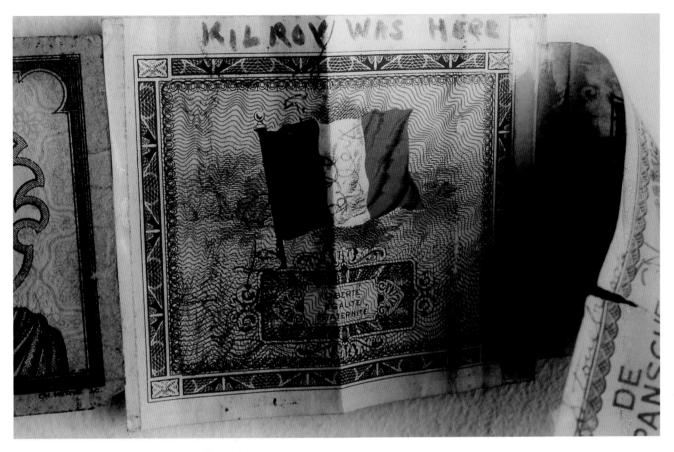

Short Snorters Series, Kilroy (France)
Andrew Bush, 1994

opposite
Short Snorters Series, Dollar Bill (US)
Andrew Bush, 1994

Untitled
Tom Friedman, 1999

For this piece Tom Friedman cut up and rearranged thirty-six real dollar bills to make one gigantic dollar bill. He converts real objects into a representation – the most basic process of art making, and also ironically the way that real objects and real labour are converted into money, itself a rather abstract representation. And of course, in the end the art work was reconverted back into many thousands of real dollar bills for the artist.

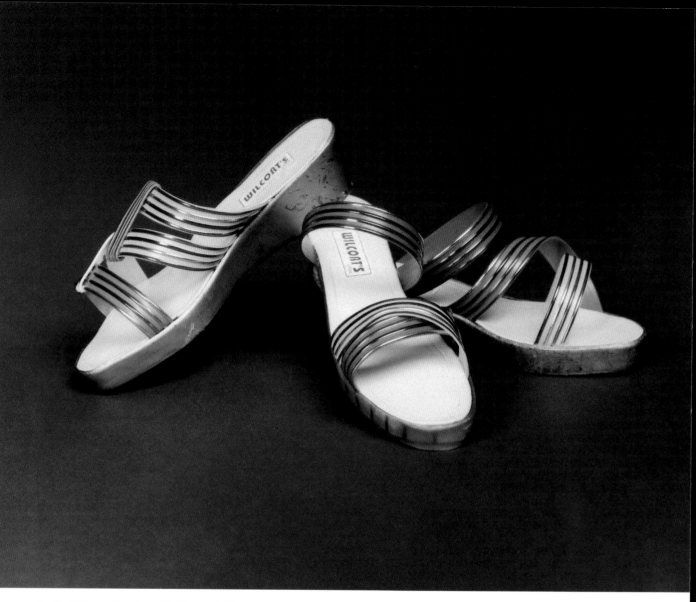

Ladies' Shoes, Cocaine with Manmade Materials, Costa Rica
Boris Becker, 1999

In many cultures, including our own, cocaine is as valued and as economically constant a material as gold. Once the coca plant is chemically treated and rendered into its most expensive form, smugglers often fill commonplace objects with the powder, or mould it in the image of an ordinary product, so that it can be smuggled across national borders. German artist Boris Becker photographs these objects – shoes, a paper blotter – after government drug enforcement officials have confiscated them. The contraband looks so real, so ordinary – who would guess these cheap-looking shoes were filled with something so expensive and illicit?

Colombian Cocaine Blotting Paper
Boris Becker, 1999

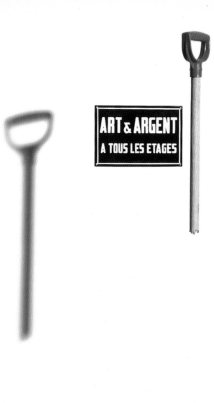
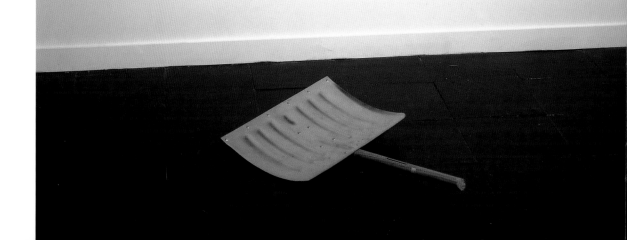

In 1915 Marcel Duchamp bought a snow shovel in a hardware store and hung it from the ceiling of his New York studio, signing it and giving it the title *In Advance of the Broken Arm*. The original shovel, thus transformed into art, soon disappeared, but collectors and museums eventually called for replicas, which Duchamp (making new hardware-store visits) was happy to supply, for a price. Hans Haacke alludes to the miraculous transformation of store-bought base metal into art-gallery gold with his gilded shovel, its handle broken well in advance of any arm. The title links the piece with 'R. Mutt', the name Duchamp used to sign the urinal he tried to exhibit in 1917. Originally rejected, it too became collectible in replica. Duchamp had demonstrated once and for all that, just as the social convention of buying and selling makes money the equivalent of every imaginable object or service, so the convention of art allows the artist's signature to give aesthetic value – and so monetary value – to the humblest object. In 1958, Duchamp made a fascimile of the plates once affixed to French apartment buildings, proclaiming 'Eau et gaz à tous les étages' (water and gas on every floor). He used this on the cover of a limited edition book on his work. Haacke has replaced the utilities with 'Art & Argent' – Art and Money.

It is obvious how gold, money, consumer goods, even cocaine can be considered precious material – but shit? Shit is the least precious of materials, the ultimate waste product. But an artist's shit is the product of a genius. The artist takes in experience, digests it, and transforms it into an object of great value. Piero Manzoni parodies this model of artistic production, and shows that an artist's shit doesn't stink – it can be the most precious of materials. His canned shit has become rare and expensive.

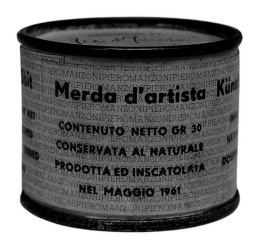

Artist's Shit N° 066
Piero Manzoni, 1961

CREDIT

Symbols with little intrinsic value, such as paper currency, can take the place of gold and silver money in most transactions. The creation of credit takes this one step further. Credit is fictitious money whose materialization is promised for the future. Stock certificates, for example, circulate as if they were actual sums of money. 'Blue chip' art, like the blue chip stocks that the term came from, provides a relatively safe investment. But here too, the artist's signature represents only a promise of value, aesthetic and monetary: time alone will tell if the credit extended to the artist is justified.

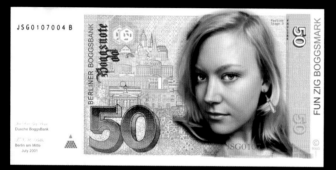

J.S.G. Boggs's hand-drawn bills look so much like the real thing that he has several times been prosecuted for counterfeiting, even though his drawings always contain elements stamping them as his products rather than those of the US Mint. Nonetheless, he has insisted on using them to pay for things he wants. Thus, in one conceptually complex transaction, he used 'money' of his manufacture to buy a picture (the work of an earlier money painter) from a gallery. Presumably the gallery thought it was a good deal for them: a forgery is a worthless piece of paper, but a work of art by Boggs may well be worth more than the bill it pictures.

top
94 Stories – No 16
J.S.G. Boggs, 1994

middle
50 BM Boggs Mark #JSG0107
J.S.G. Boggs, 2001

bottom
Money of Colour
J.S.G. Boggs, 1994

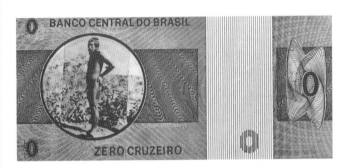

Zero Cruzeiro
Cildo Meireles, 1978

Cildo Meireles made three works – *Zero Dollar* (1978–84), *Zero Cruzeiro* (1974–78) and *Zero Centavo* (1974–78) – that closely imitated currency, and circulated them as money. They were all done as unlimited editions – an almost unheard-of phenomenon in fine art printing, where rarity and small editions ensure high prices. By doing this in the 1970s, a period of political repression and hyperinflation in Brazil, Meireles publicly criticized the administration responsible for the country's economic woes, and created provocative interactions between art and money, value and worthlessness. His own status in the art world was such that these prints could have commanded a respectable price, a striking contrast to the face value of the currency they depicted. By printing an unlimited quantity, he deliberately diluted their value – just as the Brazilian government was doing with the national currency.

In his series *Fakes*, Boris Becker photographed
contraband objects, seized by customs officers because
they were in some respect not what they seemed. The
blue jeans bear fake designer labels; the 'oil painting' is
made with cocaine paint. Both masquerade as legitimate,
desirable objects, with a social value derived from a
familiar brand name (such as Levi's) or form (an oil
painting or a work of art).

Oil Painting 1651
Cocaine Paint
Boris Becker, 1999

opposite
Pirate-Label Jeans
Boris Becker, 1999

Capital
Neil Cummings and Marysia Lewandowska, 2001

'Prestige is the shadow of money and power. Where these are, there it is. Like the national market for soap or automobiles and the enlarged arena of federal power, the national cash-in area for prestige has grown, slowly being consolidated into a truly national system.'

C. Wright Mills, The Power Elite (1956)

This 2001 installation by Neil Cummings and Marysia Lewandowska at Tate Modern in London presented 'a series of encounters between two iconic institutions' – the Tate Gallery and the Bank of England – by way of images, seminars and actions (such as the gift of artworks to random visitors to the gallery and to the bank). As the lender of last resort to British financial institutions, the Bank of England regulates the availability and so the price of credit, and guarantees the integrity of the financial system. Perhaps, Cummings and Lewandowska suggest, the Tate 'guarantees the integrity and value of the artworks it distributes' within the global economy of art. But while banks deal in debt, the Tate, like other cultural institutions, depends on gifts, since its founding in 1897 with a gift from industrialist Henry Tate. 'How are these debts to be repaid?', the artists ask.

Capital (Bank of England Monetary Analysis)
Neil Cummings and Marysia Lewandowska, 2001

Capital (Matisse's Snail Ready to Go)
Neil Cummings and Marysia Lewandowska, 2001

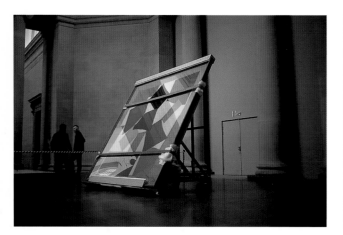

Capital (Tate Archive Bankers' Boxes)
Neil Cummings and Marysia Lewandowska, 2001

The artists photographed aspects of the gallery not normally visible to the visitor: storage, record-keeping and conservation or repair. Just as money requires production, transportation and storage to play its daily roles, art requires institutional care-taking and management to continue to fulfil its social functions. And like a bank, the gallery accumulates, lends, and maintains the value of its holdings.

Capital (Conservation)
Neil Cummings and Marysia Lewandowska, 2001

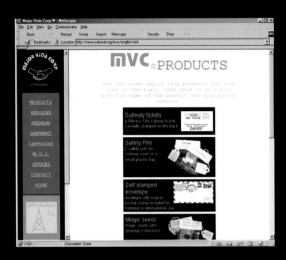

Under the name 'Mejor Vida Corporation', Mexican artist Minerva Cuevas provides a number of goods and services. On the MVC website, visitors can order fake (and free!) subway tickets, identity cards and stamps, as well as printable barcode stickers that lower prices on chicken or canned corn at local grocery stores throughout North America.

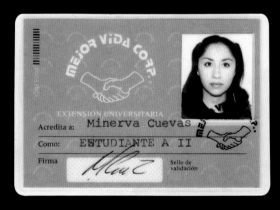

top
MVC Website
Minerva Cuevas, 2002

middle
Barcodes
Minerva Cuevas, 2002

bottom
MVC Student ID Card
Minerva Cuevas, 2002

opposite above
MVC Logo
Minerva Cuevas, 2002

opposite below
IDs Desk
Minerva Cuevas, 2002

For a human interface

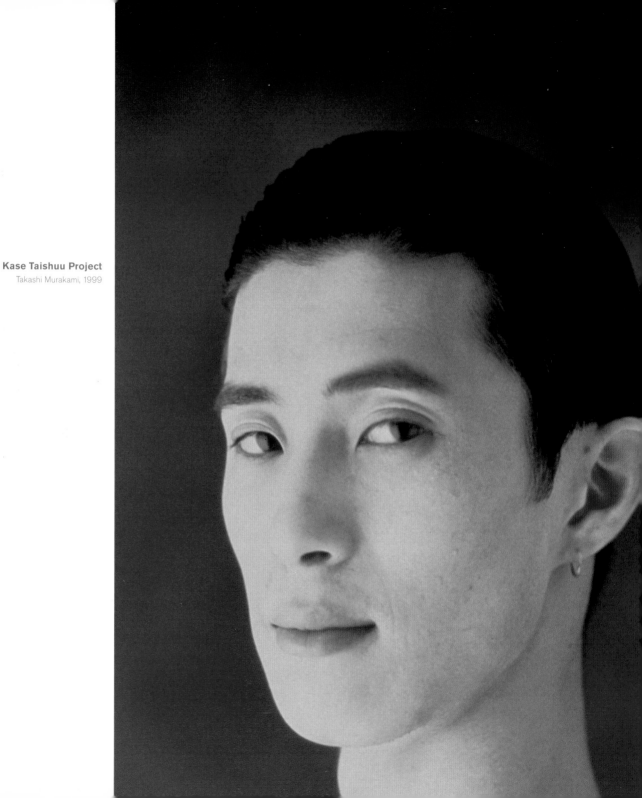

Kase Taishuu Project
Takashi Murakami, 1999

When popular Japanese television star Kase Taishuu lost the legal right to use his image and his name to his manager, the management company hired another actor to become 'Kase Taishuu'. Amused by this identity switch, the artist Takashi Murakami hired four art students to also 'become' the actor. His stunt was heavily covered by Japanese magazines and television, and the Japanese mafia, financially involved in the entertainment industry, requested that he stop the project, because it was interfering with their profits. Murakami shows that a name can earn fame and fortune in the absence of its original bearer. Louis Vuitton is dead, but people still buy 'his' luggage. As a painter, Murakami himself gets credit for his paintings, even when they are made by assistants.

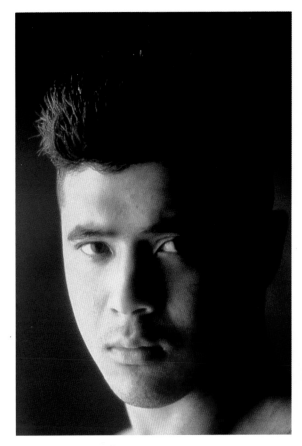

Kase Taishuu Project
Takashi Murakami, 1999

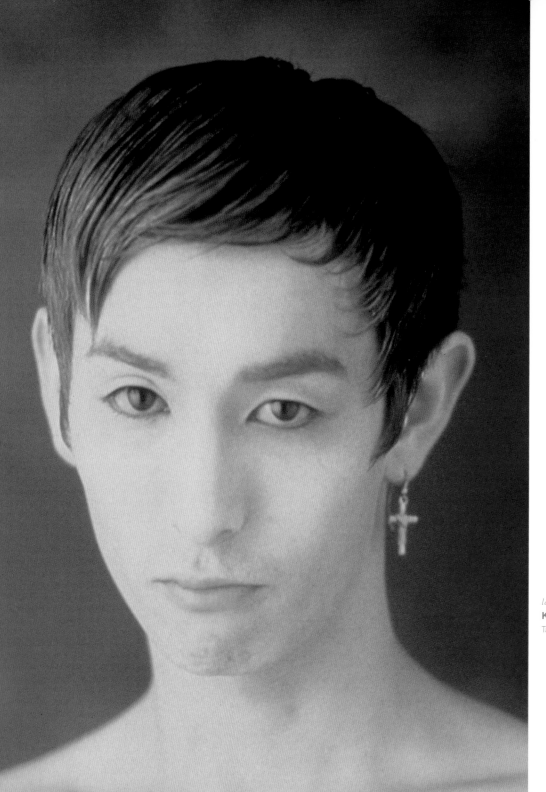

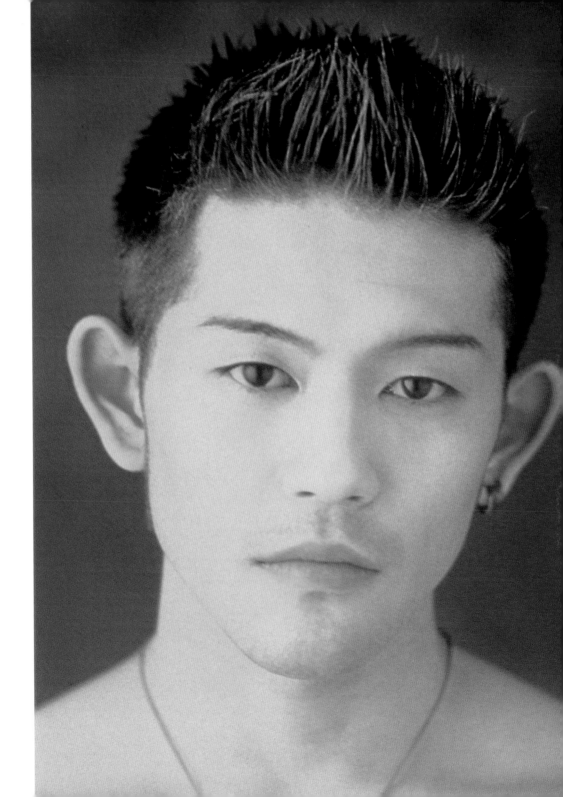

Maurizio Cattelan created a project at the Museum of Modern Art in New York for which he hired an actor to portray Pablo Picasso. With a giant papier-mâché head and striped shirt, the Disneyworld version of Picasso greeted visitors at the entrance and signed autographs. Cattelan teasingly points up the museum's metamorphosis into an entertainment mecca not unlike Disneyworld itself, filled with shops, food and celebrity art, a place people visit to see a famous name, not to contemplate high art. They don't care if the figure who greets them is the real artist or not. (In public talks and interviews, Cattelan has sent a friend to impersonate him.) But his project had a positive side as well – the public loved the greeter, who made what can be a forbidding, elitist institution literally welcoming.

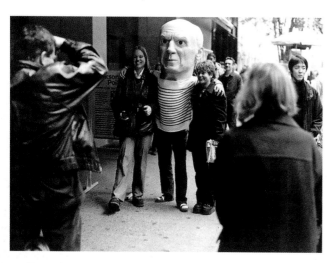

above and opposite
Untitled (MoMA Project #65)
Maurizio Cattelan, 1998

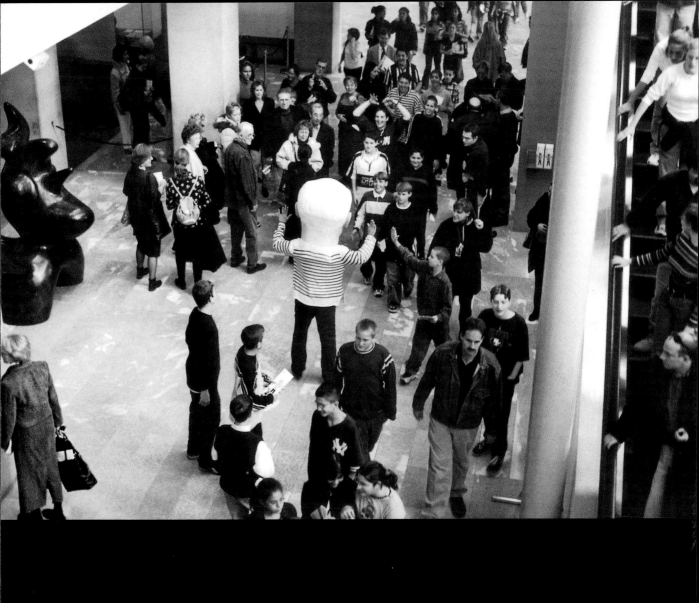

Sean Landers made one of his first art works after leaving art school out of a written correspondence he had with the Massachusetts Higher Education Assistance Corporation, the company holding his student loan. The letters he wrote them alternately promising to pay the loan and complaining that he didn't

'ATTN. MISS GONZALES

PLEASE FIND THIS STRANGE LETTER AMUESING. IT IS A XEROX OF ONE OF MY ART WORKS,
IT'S SALE FACILITATES THE ENCLOSED PAYMENT. IT WAS WRITTEN IN RESPONSE TO A
LETTER I RECEIVED ON SEPT. 16, 1991, FROM M.H.E.A.C. ALTHOUGH THE TONE OF THE LETTER
WAS MEANT TO BE HUMOROUS, BECAUSE MOST ARTISTS ENDURE LIKE HARDSHIPS,
I AM SERIOUS ABOUT MANY OF THE STATEMENTS EXPRESSED THERE. PARTICULARLY
REGARDING MY GUILT ABOUT MY CONTRIBUTION TO THE S. AND L. CRISIS...
I LOVE LIFE MISS GONZALES, I LOVE THIS COUNTRY. I WANT TO OWN UP TO MY DEBTS.
I WANT FREEDOM FROM THIS SELF IMPOSED PRISON OF POVERTY. I HAVE ONLY TO CRY
OUT AND SAY: ENOUGH! I REFUSE TO BE A FAILURE AT WHAT I DO. I SHALL NOW BECOME
WEALTHY AND SUCCESFULL... SOBERING NOW I REALIZE THE ONLY PIECE OF PAPER YOU
WANT FROM ME IS SINGLE BLUE LEAF INSCRIBED 'PAY TO THE ORDER OF'... YOU DON'T
APPRECIATE ME! I'M A DAM GOOD ARTIST AND YOU AND YOUR ORGANIZATION DON'T CARE.
MASSACHUESSETTS DOESN'T CARE, THE FEDERAL GOVERNMENT DOESN'T CARE. FUCK IT!
I'M NOT GIVING YOU THE CHECK. IN FACT I'LL RIP IT UP AND ENCLOSE IT HERE.'

Sean Landers
Sean Landers, 2001

The signature is the ultimate proof of identity, the stand-in for its owner. On a credit card receipt, an IOU, or a stock certificate a signature constitutes a promise to pay – the essence of credit. The signature of the artist certifies the authenticity of a work, assuring the buyer that the aesthetic and social value created by the artist is contained within it. In Sean Landers' *Attn Miss Gonzales*, he signed each letter promising to pay his student loans, and ultimately a cheque (which he then ripped up). In *Sean Landers*, his signature itself constitutes the subject of the painting, rather than sitting discreetly in a corner or on the reverse side, as it would in a painting by Jackson Pollock or Frank Stella. Still, Landers makes us consider the extent to which the signatures (or signature styles) of these artists have become the real subject matter of their extremely expensive abstractions.

In November, 1999, a group of artists – Olafur Eliasson, Douglas Gordon, Mariko Mori, Chris Ofili, Gabriel Orozco, Elizabeth Peyton, Tobias Rehberger, Pipilotti Rist, Wolfgang Tillmans and Rirkrit Tiravanija – went to St Kitts in the West Indies for an 'art event' organized by Maurizio Cattelan with curator Jens Hoffmann, and sponsored by several corporations. The event had the outward look of the currently fashionable international biennials, from São Paulo to Kwangju to Liverpool to New York, with the artists flying to an exotic locale where they would create 'site-specific' work, drawing the roster of jet-set curators and bringing attention and prestige to the host country while they themselves enjoyed a holiday in a new place. But this event was a parody of all those institutional trappings; the artists came and made no work, held no exhibitions – they had the holiday without the work, spending their time hanging out and talking.

'It's like spitting in the hand of someone who pays your salary.
I'm not trying to be against museums or institutions.
Maybe I'm just saying that we are all corrupted in a way;
life itself is corrupted, and that's the way we like it.
I'm just trying to get a slice of pie, like everyone else.'
Maurizio Cattelan

'What better way to prove that you understand a subject
than to make money out of it?'
Harold Rosenberg, 1972

Thirty are Better than One
Andy Warhol, 1963

Credit multiplies available funds, though always at the risk of inflation. Andy Warhol applies the principle of inflation to the most famous artistic image of all time. There is only one Mona Lisa, but Warhol can sell what amount to letters of credit drawn on its time-tested value. As Leo Steinberg once complained about Robert Rauschenberg's use of silk screens of old master paintings in his art, he is drawing on a bank account not his own.

'For *Michael Jackson and Bubbles*, an editioned sculpture by Jeff Koons...the Astrup Fearnley Museum of Modern Art, Oslo, paid the remarkable price of $5.62 million at Sotheby's in 2001. That two further and identical casts of this sculpture exist should, in a logical market, have diluted its appeal but, in fact, this contributed to the object's status as an icon of our times. The catalogue cleverly exploited this situation by identifying the owners of the other versions as the San Francisco Museum of Modern Art and leading Greek collector Dakis Joannou. "To join such an attractive family warrants a premium" is the clever marketing message and, probably, the truth.'

Roger Bevan, Art Newspaper, 2002

PRODUCTION

Success in speculation, or the simple collection of interest for a loan, gives rise to the idea that money, wisely invested, can produce more money. But this is to forget that money's meaning rests on the social production of which it is an abstract representation: making money requires, eventually, the making and sale of actual commodities. Similarly, the notion that an artist's idea (or even, as with the Readymade, his choices) is enough to make a work of art forgets the labour of all the other people involved – the critics, dealers, museum curators, collectors and assorted hangers-on – in the transformation of the idea into a socially acknowledged art work. It also forgets the extent to which art's special value is due to its difference from most modern products in being made under the control of an individual defining his or her own means and methods of production. That art centrally involves the idea of someone making something is both its burden and its glory, sometimes mocked, at other times celebrated.

For a work commissioned by a British gallery in Birmingham, Santiago Sierra hired an Irish street person to stand on New Street and say, 'My participation in this piece could generate a profit of 72,000 dollars. I am being paid five pounds.'

'The use of individuals is premised on their abundance and market availability – I don't use them any differently from any other material. They can be ordered, altered, drawn, etc.... The only point of an action from the perspective of the workers is that his or her efforts will be monetarily compensated in exchange for their gruelling physical labour and loss of the free use of their bodies.'

Santiago Sierra

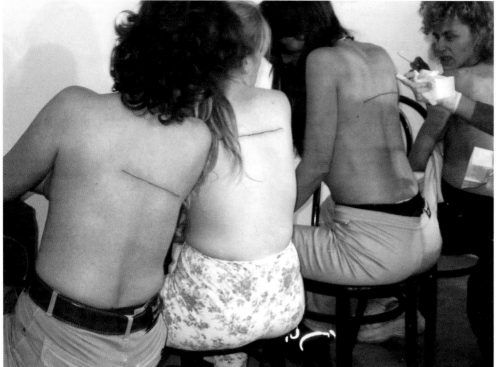

**160cm Line Tattooed on
Four People**
Santiago Sierra, 2000

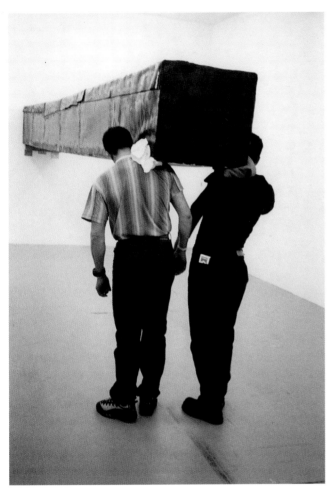

In 2000 Santiago Sierra hired four heroin-addicted prostitutes and paid them 12,000 pesetas, the price of one dose of heroin, to be tattooed. The following year Sierra hired four workers to hold up a large wood and asphalt object in a gallery in Zurich. One end was in a socket in the wall; the other end was supported by two workers at a time, paid 20 Swiss francs an hour for their labour. The men were political exiles not allowed legally to work in Switzerland. Even in today's shock-proof art world, many people find Sierra's work disturbing; his exploitation of oppressed workers, drug addicts and prostitutes uncomfortably mirrors the social position and conditions these people occupy. Whether or not his work participates in lowering still further their quality of life, he forces spectators – usually well-fed, well-to-do art lovers – to acknowledge conditions most people prefer to overlook, as well as their own complicity.

'Only sick music makes money today.'
Friedrich Nietzsche (1844–1900)

Object Measuring 600 x 57 x 52cm Constructed to be Held Horizontally to a Wall
Santiago Sierra, 2001

Here we walk into a room under construction, full of sawhorses and tools, work gloves and coke cans, as if a crew of workers had just stepped out for a break. On closer inspection, however, the objects are not quite what they seem: they are all trompe l'oeil creations, carefully fashioned sculptures made from styrofoam and plywood and paint and a host of other materials. Peter Fischli and David Weiss take work as the obvious subject of their installation – a rare topic in contemporary art. And work itself also suffuses the installation, given the sheer amount of labour it has taken to create such extremely realistic, detailed sculptures. The artists tie together 'ordinary' labour or production, depicted in the construction site, and the artistic labour required to create that representation.

Untitled
Peter Fischli and David Weiss, 2001

Scumak 2
Roxy Paine, 2002

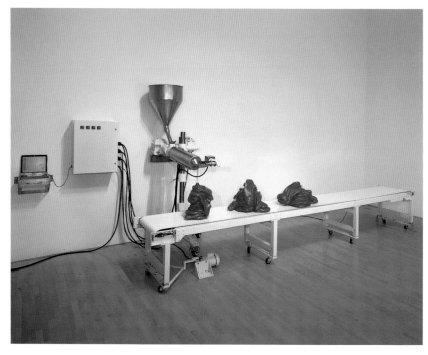

Scumak 2
Roxy Paine, 2002

Why knit a sweater when you can buy a perfect one made by a machine? Mechanical production has taken over virtually every activity once governed by the human hand; fine art has been one of the last bastions of craftsmanship and individual expression. But Roxy Paine has invented machines that create paintings and sculptures, so conquering even this last realm of human creativity. Artists shouldn't worry, however – there is more humour than beauty in this work. The machines are extremely elaborate, but all that high-tech knowhow produces only a series of simple abstract blobs. And they are slow as well – no fear here of assembly-line over-production. Still, these machines raise serious questions about how long it takes to make a work of art, and how an artist might go on 'automatic' after making several hundred sculptures or paintings.

PMU (Painting Manufacture Unit)
Roxy Paine, 1999–2000

PMU (Painting Manufacture Unit) (detail)
Roxy Paine, 1999–2000

For *Workbench* at the Schipper and Krome Gallery in Cologne, Philippe Parreno invited people to the gallery on May Day, the workers' holiday, to participate in his *usine à nuages* ('factory of clouds'). During the 1960s, as Parreno has noted, leftist intellectuals went to work in factories to organize for the revolution. The revolution didn't come; perhaps the intellectuals had the wrong idea. Perhaps they could learn from the workers, who value the relationships among themselves more than their product. Parreno invited people to demonstrate an alternative to factory labour – working on 'what pleased them', and engaging in 'non-lucrative activities'. Here they made teddy bears which when squeezed sang with the recorded voices of Korean workers.

Workbench
Philippe Parreno, 1995

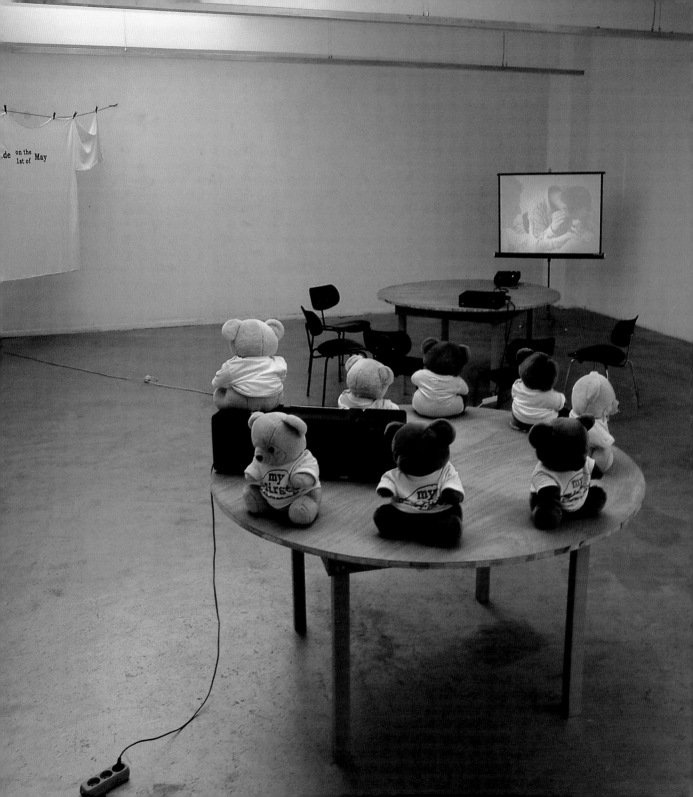

**101 Art Ideas You Can Do Yourself:
No. 22 Fill a desk drawer with gravel
and make a secret zen garden
(Idées artistiques à réaliser soi-même :
n°22 Remplissez un tiroir de bureau de
gravier et créez votre propre jardin zen
secret)**
Rob Pruitt, 1999

page ci-contre à gauche
**101 Art Ideas You Can Do Yourself:
No. 21 Pour a glass of water to look at
(Remplissez un verre d'eau pour le
contempler)**
Rob Pruitt, 1999

page ci-contre à droite
**101 Art Ideas You Can Do Yourself:
No. 19 Toilet paper the inside of
your house (Tapissez l'intérieur de
votre maison de papier toilette)**
Rob Pruitt, 1999

« Le magazine de Martha Stewart part du principe, me semble-t-il, que les gens ont envie de fabriquer des choses par eux-mêmes mais c'est, à mon avis, une illusion. Je ne crois pas un instant qu'une seule de ces choses ait été un jour réalisée par qui que ce soit. A mon avis, quand on voit les instructions pour réaliser soi-même un objet artisanal dans *Martha Stewart*, on les lit jusqu'au bout mais je parie que seulement 5% des lecteurs s'y mettent vraiment. J'ai voulu développer le projet de Martha Stewart en proposant la création d'objets encore plus humbles. Un simple verre d'eau peut être un magnifique projet. Il n'est pas nécessaire d'y consacrer beaucoup de temps ni d'argent. Les bonnes idées existent dans toute une gamme de complexités. » *Rob Pruitt*

La plupart des artistes contemporains emploient des assistants pour créer leurs œuvres et ceux-ci s'attellent généralement aux tâches les plus fastidieuses et pénibles : tendre et enduire les toiles, développer les photos, s'occuper des finitions, sabler ou vernir par exemple. Cette aide permet parfois à l'artiste d'augmenter tout simplement son rendement. Takashi Murakami, par exemple, a employé jusqu'à des dizaines d'assistants à la fois. Ces derniers ont parfois un savoir-faire particulier qui fait défaut à l'artiste – une technique de dessin réaliste, par exemple. Bernard Frize emploie lui aussi des assistants (« ses mains supplémentaires » comme il les appelle) mais d'une manière singulière car il fait appel à eux non pas pour le soulager de certaines corvées ni pour bénéficier de telle ou telle compétence mais pour l'aider à exécuter des toiles impossibles à réaliser tout seul. Ces œuvres « collectives » exigent que plusieurs personnes (généralement trois à cinq) travaillent simultanément – soit en raison des grandes dimensions de l'œuvre soit de son principe même d'exécution (un enchevêtrement de coups de pinceau réalisé en passant les brosses de main en main dans un sens puis dans l'autre). Pour un tableau tel que *Gabarit*, par exemple, une personne commence à passer le pinceau sur la surface à partir de la gauche puis le donne à une autre, située au centre, qui continue de passer la peinture vers la « colonne vertébrale » verticale au milieu de la toile ; cette personne donne le pinceau à une autre personne encore qui poursuit le passage vers la droite. Cette méthode de travail en collaboration (à l'opposé de celle du peintre solitaire qui se débat seul dans son atelier) met en évidence et rend concrète la nature sociale de toute production artistique.

« S'il est trop évident que le prix d'un tableau ne se détermine pas par la sommation des éléments du coût de production, matière première, temps de travail du peintre, [...] c'est peut-être qu'on définit mal l'unité de production ou, ce qui revient au même, le processus de production. On peut poser la question sous sa forme la plus concrète [...] : qui, du peintre ou du marchand, de l'écrivain et de l'éditeur ou du directeur de théâtre est le véritable producteur de la valeur de l'œuvre ? Parmi les producteurs de l'œuvre d'art, nous devons [même] inclure le public qui lui donne une valeur en se l'appropriant matériellement (les collectionneurs) ou symboliquement (les spectateurs, les lecteurs) et en identifiant de façon objective ou subjective une part de cette propre valeur à ces appropriations. »

Pierre Bourdieu, « La Production de la croyance : contribution à une économie des biens symboliques », 1977, et « The Field of Cultural Production », 1993.

Gabarit
Bernard Frize, 1998

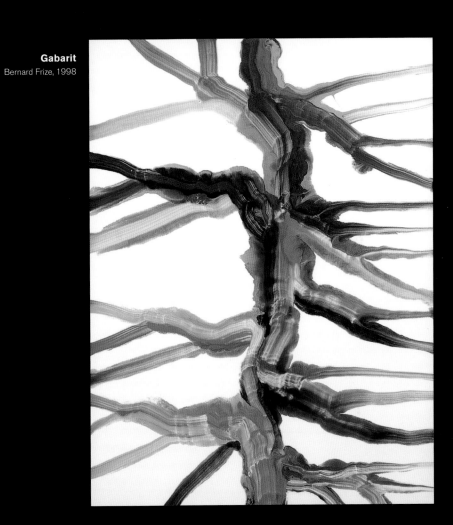

Der Pralinenmeister
(Le Maître chocolatier)
Hans Haacke, 1981

Peter Ludwig, magnat allemand du chocolat, est aussi l'un des plus grands collectionneurs d'art au monde. Une grande partie de sa collection est aujourd'hui hébergée au Ludwig Museum, construit en 1986 à Cologne avec des subventions gouvernementales. L'étude menée par

Hans Haacke sur les activités de Ludwig dans les domaines de l'art et du commerce se présente sous la forme de sept diptyques sérigraphiés associant photographies et textes ; la traduction des deux premiers panneaux ci-dessus est donnée page suivante.

1. Les objets d'art en prêt permanent sont exempts de taxes sur la propriété.
Peter Ludwig, fils de l'industriel Fritz Ludwig (cimenterie Ludwig) et de Mme Helene Ludwig (née Klöckner), naquit en 1925 à Coblence.

Après son service militaire (1943-1945), il fit des études de droit et d'histoire de l'art. En 1950, il obtint son doctorat avec une thèse sur « L'image de l'homme chez Picasso comme expression de la vision de la vie de sa génération ». Ce travail traitait des rapports entre la littérature contemporaine et l'œuvre de Picasso mais s'intéressait peu aux événements historiques.

En 1951, Peter Ludwig épousa une de ses amies étudiantes, Irene Monheim, et entra chez Leonard Monheim AG, l'entreprise de son beau-père à Aix-la Chapelle ; en 1952, il devint directeur associé et, en 1969, président. En 1978, il devint président directeur général de Leonard Monheim AG (Aix-la Chapelle). Il siège actuellement au conseil d'administration d'Agrippa Verscherungs-Gesellschaft et Wagonfabrik Uerdingen. Il est président de la filiale régionale de la Deutsch Bank AG pour la région de Cologne/Aix-la Chapelle/Siegen.

Peter et Irene Ludwig commencèrent à collectionner des œuvres d'art au début des années 1950. D'abord, ils s'intéressèrent surtout à l'art antique, médiéval et précolombien. A partir de 1966, ils se concentrèrent sur l'art moderne, le Pop Art, le photoréalisme, la Pattern Painting, l'art d'Allemagne de l'Est et le néo-expressionnisme. Depuis 1972, Peter Ludwig est professeur adjoint à l'université de Cologne et anime des séminaires d'histoire de l'art au Ludwig Museum.

Ses œuvres d'art moderne font l'objet de prêts permanents dans des institutions telles que le Ludwig Museum de Cologne, la Neue Galerie-Sammlung Ludwig et le Suermondt-Ludwig-Museum d'Aix-la Chapelle, les musées nationaux de Berlin-Est et Ouest, le Kunstmuseum de Bâle, le Centre Georges Pompidou à Paris et les musées nationaux de Sarrebruck et de Mayence. Les œuvres médiévales sont abritées au Schnütgen Museum d'Aix-la Chapelle et au musée national bavarois. Le Rautenstrauch-Joest Museum de Cologne expose les objets précolombiens et africains ainsi que des œuvres d'Océanie.

En 1976, le Wallraf-Richartz-Museum de Cologne (aujourd'hui Ludwig Museum) reçut une donation de Pop Art. Le Suermondt-Museum d'Aix-la Chapelle (aujourd'hui Suermondt-Ludwig Museum) reçut des œuvres médiévales en 1977. Une collection d'art grec et romain, incluant des objets prêtés à Cassel, Aix-la Chapelle et Wurzbourg, fut donnée à l'Antikenmuseum de Bâle (aujourd'hui Antikenmuseum de Bâle et Ludwig Museum). La fondation autrichienne Ludwig pour les Arts et les Sciences reçut, en 1981, une collection d'art moderne. Peter Ludwig est membre du comité des acquisitions du musée de Düsseldorf, de l'International Council of the Museum of Modern Art de New-York et du Advisory Council of the Museum of Contemporary Art de Los Angeles.

2. Regent
Sous la marque « Regent », le groupe Monheim distribue du chocolat au lait et des bonbons au chocolat assortis, essentiellement dans la chaîne de magasins bon marché Aldi et les distributeurs automatiques. La production se fait à Aix-la Chapelle, dans deux usines employant en tout 2 500 personnes. Les bureaux s'y trouvent aussi. Environ 1 300 employés travaillent dans l'usine de Sarrelouis, quelque 400 dans l'usine de Quickborn et environ 800 à Berlin Ouest. Monheim compte, en tout, 7 000 employés, le même nombre que dix ans plus tôt (les ventes ayant triplé durant la même période) dont 5 000 femmes. Il y a 4 500 travailleurs manuels dont les deux tiers sans qualification. L'entreprise emploie aussi 900 ouvriers saisonniers sans qualification.

Le syndicat Nahrung-Genuss-Gastätten a négocié des salaires horaires entre 6,02 Deutsche Mark (échelle F : chaîne d'assemblage avant dix-huit ans de travail) et 12,30 D.M. (échelle S : travail hautement qualifié). Selon l'accord syndical, le plus bas salaire atteint 1 097 D. M. mensuels et le plus haut, 3 214 D.M.

Les femmes forment l'écrasante majorité des 2 500 travailleurs immigrés. Elles viennent surtout de Turquie et de Yougoslavie mais des agents en recrutent aussi au Maroc, en Tunisie, en Espagne, en Grèce (prix « par tête » : 1 000 D.M. en 1973). Un autre contingent d'ouvrières étrangères traverse chaque jour les frontières depuis la Belgique et la Hollande voisines.

L'entreprise gère des hôtels pour ses employées étrangères dans ses sites industriels à Aix-la Chapelle et ailleurs. Il y a trois ou quatre femmes par chambre (les bâtiments sont subventionnés par l'agence fédérale du travail). Le loyer est automatiquement prélevé sur le salaire. Dans ces hôtels, l'entreprise a droit de regard sur les visites, et a, à plusieurs reprises, refusé l'entrée à des personnes. Le bureau de presse du diocèse d'Aix-la Chapelle et l'association Caritas ont jugé en ces termes les conditions de vie : « Dans la mesure où la majorité de ces femmes et jeunes filles n'ont de relations sociales que sur leur lieu de travail et à l'hôtel, elles vivent pour ainsi dire dans un ghetto. »

Les travailleuses étrangères qui mettent au monde un bébé sont obligées, dit-on, de quitter l'hôtel parce qu'il n'y a pas de crèche à Monheim et qu'elles ne peuvent se permettre de placer leur enfant chez une nourrice. Il leur reste la possibilité de le faire adopter. « Une grosse entreprise employant tant de femmes doit pouvoir ouvrir une crèche. » Le département du personnel a répondu que la société Monheim était « une usine de chocolat et pas une garderie », ajoutant qu'il serait impossible d'embaucher du personnel à cet effet. L'entreprise n'est pas un centre d'assistance sociale.

MAGASIN

Le mot magasin désignait, à l'origine, le lieu où l'on entreposait des marchandises à conserver ou à vendre. Plus tard, il s'appliqua surtout à l'endroit où l'on propose des produits à des clients. Le mot anglais équivalent, *store*, prit ce dernier sens à la fin du XVIII^e siècle aux États-Unis et il se répandit avec cette acception dans tous les pays de langue anglaise au siècle suivant. Ce glissement reflète l'émergence du capitalisme, un système dans lequel les gens doivent de plus en plus acheter ce dont ils ont besoin pour vivre. C'est en France, dans les années 1850, que furent créés les premiers grands magasins ; un siècle et demi plus tard, le « shopping » est au cœur de la culture moderne dans tous les pays riches.

Bientôt, des magasins proposèrent également des œuvres d'art : il s'agissait des galeries nées à la fin du XIX^e siècle dans tous les pays développés. La galerie allie la fonction de salle des ventes à celle de musée – c'est un magasin, au sens premier du terme – en présentant des œuvres à la fois pour la vente et pour la délectation esthétique. Ainsi s'exprime la dualité de l'art, à la fois marchandise et symbole de valeurs non commerciales.

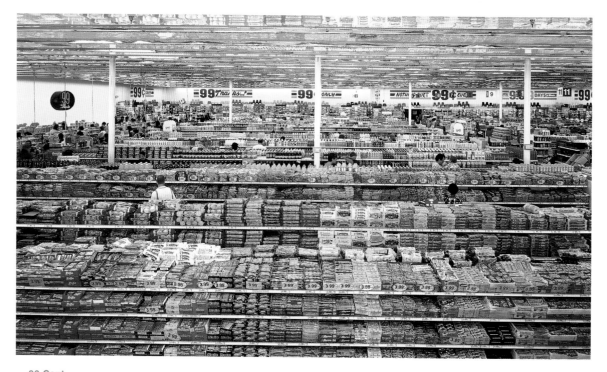

99 Cent
Andreas Gursky, 1999

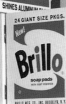
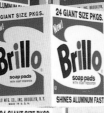
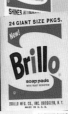
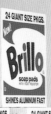
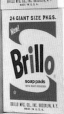
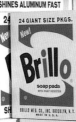
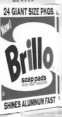
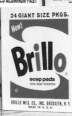
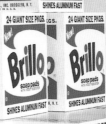
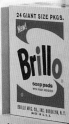
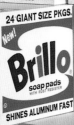
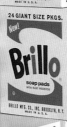
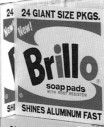
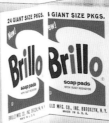
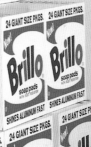

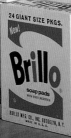
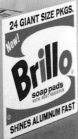
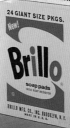
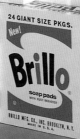

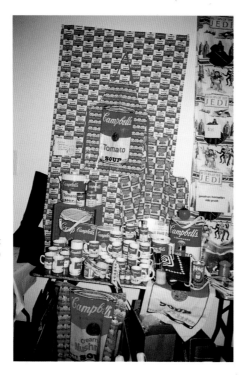

Flea Market
Rob Pruitt, 2000

Pendant trois jours, en juin 2000, Rob Pruitt a organisé un marché aux puces à la galerie Gavin Brown's Enterprise de New York. Pour annoncer l'événement, il a fait de la publicité dans les pages professionnelles du *Village Voice* et du *New York Times*, tout en le présentant dans les revues d'art comme une exposition collective. Parmi les « exposants » invités, il y avait des artistes (Karen Kilimnik, T.J. Wilcox), des marchands (Andrea Rosen, Gavin Brown), des curateurs (Laura Hoptman), des designers (Susan Cianciolo) ainsi que des personnalités new-yorkaises (Lady Bunny). Chacun disposait d'un stand ou d'un espace pour exposer et/ou vendre ce qu'il voulait. Certains proposèrent de vieux vêtements et des disques (marchandises typiques des vides-greniers), d'autres, des objets d'art. Cet événement soulignait la parenté entre l'art et les autres produits marchands (les participants affirmaient leur style et leurs goûts principalement en tant qu'acheteurs et vendeurs et non en tant que producteurs) mais il mettait aussi en évidence la distinction qu'opère l'art : sur ce marché aux puces, une vieille chemise prenait de la valeur uniquement en raison de sa proximité avec une célébrité ou un talent.

« Si une galerie n'est ni plus ni moins commerciale qu'une salle des ventes ou que n'importe quelle entreprise, alors l'art est une marchandise comme une autre. […] D'abord, nous n'aurons plus à avoir de scrupules quant au mariage de l'art et de l'argent. Nous n'aurons plus à nous demander s'il est possible de distinguer la valeur esthétique d'une œuvre de sa valeur commerciale. […] Pour vivre avec notre temps, nous devons regarder *Les Iris* (ou une reproduction) avec la pleine conscience du prix que le tableau a atteint, en essayant d'intégrer ce chiffre faramineux à la signification de cette œuvre aujourd'hui. »

Carter Ratcliff, « The Marriage of Art and Money », Art in America, 1988. Le célèbre tableau de Van Gogh, *Les Iris*, a été vendu aux enchères en 1987 pour un montant de 53,9 millions de dollars.

Flea Market
Rob Pruitt, 2000

Flea Market
Rob Pruitt, 2000

Aunt Dee's T-Shirt Shop is a video featuring an interview with the artist's aunt, who sells t-shirts at a small shop in an Ohio mall. Rather than mock the commercial or kitsch aspect of the enterprise, Andrea Bowers celebrates her aunt's spirit, and identifies with her as a woman engaged with individual expression. Like the female performers (such as Salt 'n' Pepa) that Bowers often draws (see page 34), Dee provides a model of an everyday, non-ideological feminism, independent and entrepreneurial.

Aunt Dee's T-Shirt Shop
Andrea Bowers, 2000

Infinito Botanica: San Antonio, Texas
Franco Mondini-Ruiz, 1995–98

In 1996, Franco Mondini-Ruiz was a lawyer living in San Antonio, Texas. He leased an old botanica, a Mexican shop selling everything from religious candles to magical herbs. Alongside the existing stock of the store, Mondini-Ruiz began introducing Chicano (Mexican-American) artifacts of his own choosing, as well as custom-made objects such as an Andy Warhol Brillo Box stuffed with toys and candy as a *piñata*, and works of art, his own and others'. The store itself became an on-going art project, in the tradition of Oldenburg's *Store* (see page 114). When he moved to New York City to become a full-time artist, Mondini-Ruiz was invited to restage the Botanica at the 2000 Whitney Biennial. In addition to an installation inside the museum from which people could choose and purchase objects (which he replenished continually during the exhibition), he operated a sidewalk vendor's table on the street outside, where he sold his trademark, refashioned kitsch at relatively low prices. The artist asserts the value and richness of his Chicano identity, as embodied in the objects he grew up among, transforming them into art by combining them in unexpected ways, creating meaning through his groupings and installations, and moving 'low' artifacts to the 'high' context of museums and galleries, while maintaining the aura of access and availability.

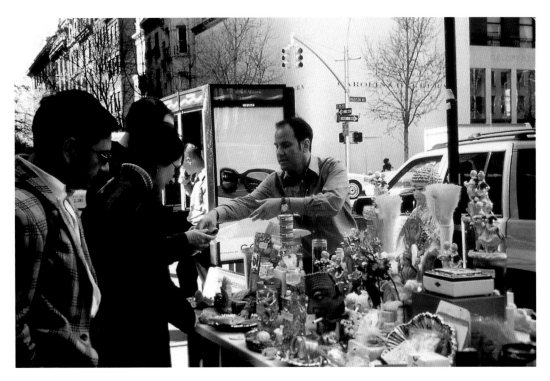

Infinito Botanica: NYC Whitney Biennial
Franco Mondini-Ruiz, 2000

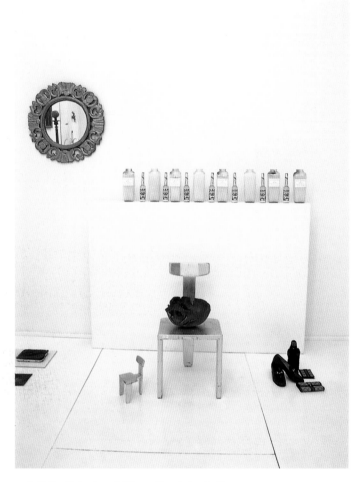

Infinito Botanica: ArtPace, San Antonio, Texas
Franco Mondini-Ruiz, 1996

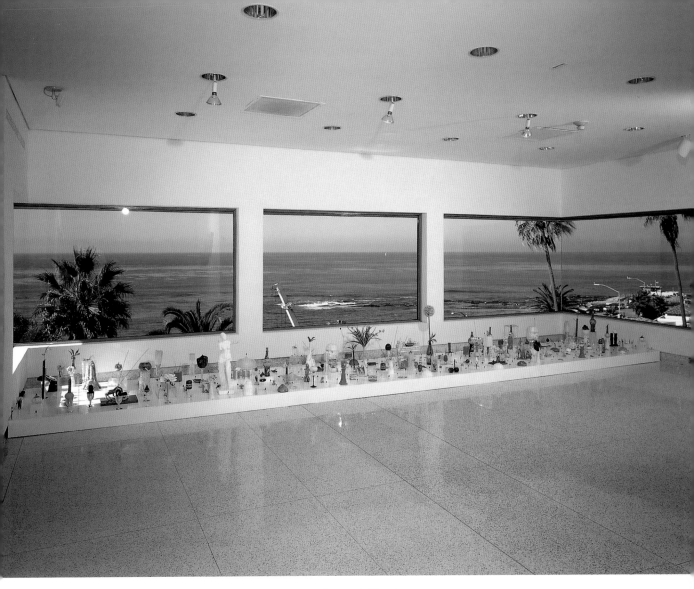

Infinito Botanica: Museum of Contemporary Art, San Diego, California
Franco Mondini-Ruiz, 2000

**(Forever Free)
Buy Black!**
Michael Ray Charles, 1997

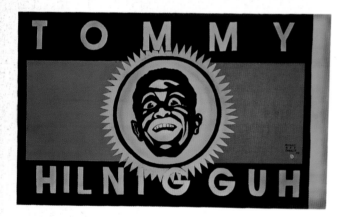

(Forever Free) Tommy Hilnigguh
Michael Ray Charles, 1999

Michael Ray Charles uses historical African-American stereotypes and collectible kitsch to make allegories of contemporary social conditions. In *Buy Black!* Charles combines a black-nationalist slogan with a reference to the piggybanks of the early 1900s that used racist caricatures. *Tommy Hilnigguh* borrows the logo of the clothing designer Tommy Hilfiger, turning its red, white and blue into the red, green and black of Africa, and putting an image of Al Jolson in black face at its centre. In so doing, the artist sharply satirizes Hilfiger's own complicated fusion of white, preppy fashion and black hiphop style, marketed to the black consumer. It is that consumer that Charles makes the target of the parody in *Art n American*, which depicts African-Americans surrounded by the detritus of contemporary shopping culture. Is this what people become in our world, or is this how corporations see us?

(Forever Free)
Art n American
Michael Ray Charles, 2000

For his 2002 video *Point of Sale*, Christian Jankowski hired a management consultant to work with both his New York dealer, Michele Maccarone, and George Kunstlinger, the owner of an electronics shop below the gallery. The consultant quizzed the two businesspeople about their respective fields, their financial goals and strategies, their clients. For the camera, Maccarone and Kunstlinger reversed roles, she discussing the finer points of voltage and industry, he providing an insider's view of art dealing. Furthering Warhol's prescient remarks, Jankowski blurs the boundaries between the art of business and the business of art.

Point of Sale
Christian Jankowski, 2002

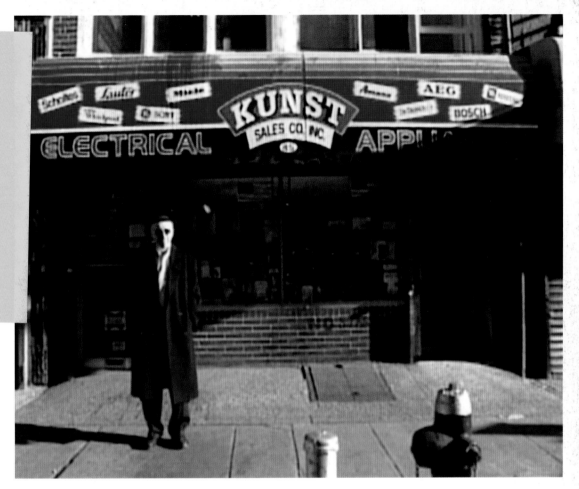

Point of Sale
Christian Jankowski, 2002

'Making money is art and working is art and
good business is the best art.'
Andy Warhol

Untitled (Supermarket)
Claude Closky, 1996–99

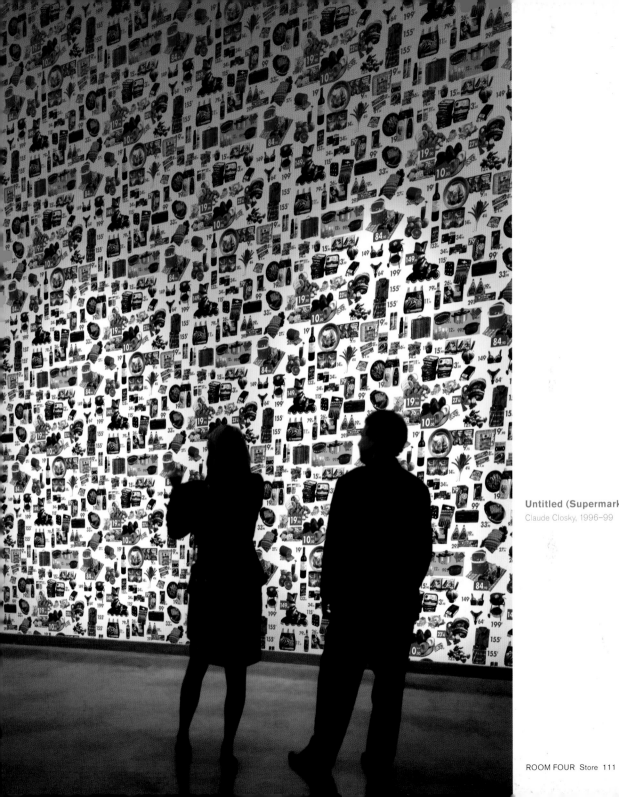

Untitled (Supermarket)
Claude Closky, 1996–99

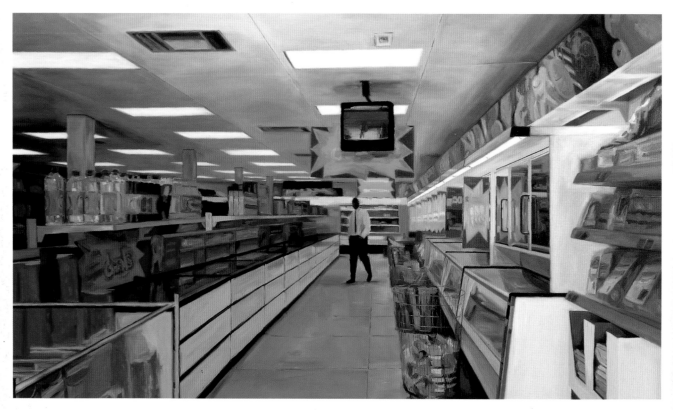

Iceland
Martin McGinn, 2001

Boxes
Martin McGinn, 2001

The Store, 107 East 2nd Street, New York
Claes Oldenburg, 1961

Claes Oldenburg was the first of the US Pop artists to exhibit when in 1961 he rented a storefront on New York's Lower East Side for several weeks. He sat in the shop every day amidst his wares: pastries, stockings, signs, airmail envelopes, the same cheap goods one might have found in many of the neighbourhood stores – except that Oldenburg had fashioned these ostensibly ordinary objects out of chicken wire and papier-mâché, plaster and oozing sloshes of paint. These small-scale sculptures were for sale. So how, as the artist might have asked, was his *Store* any different from an art gallery?

CIRCULATION

Money is not so much a technique for the distribution of goods as the secret substance whose growth the movement of goods is intended to facilitate: the food consumers eat is just a temporary form of the money they pay for it.

As a world within the world, art sets its own values in motion. Its physical substances serve as the incarnation not only, like all commodities, of economic value, but also of less well-defined cultural values: originality, historical significance, beauty, social superiority, resistance to convention, freedom. As such, art can generate cultural profits as well as monetary ones. The dealer gains social prestige, for instance, by selling to an important collector; the artwork, in turn, can endow the collector with its attributes of social consciousness, sexual daring, or glamour.

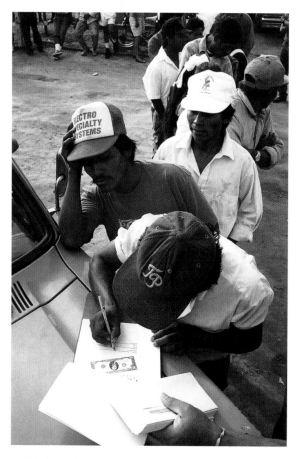

Over several weeks in the summer of 1993, Elizabeth Sisco, Louis Hock and David Avalos gave away a public grant of $4,500 to undocumented workers in San Diego, who received ten dollars per person. The artists distributed the money at street corners and parks where day labourers normally waited to be picked up for jobs. Each worker signed a receipt, which read, 'This ten dollar bill is part of an art project that intends to return tax dollars to taxpayers, particularly "undocumented taxpayers". The Art Rebate acknowledges your role as a vital player in an economic community indifferent to national borders.' The wording refers to the thousands of Mexicans who work legally in San Diego and pay taxes, but receive none of the social services they pay for. Under political pressure due to the controversial nature of the project, the National Endowment for the Arts audited the Museum of Contemporary Art, San Diego, commissioner of the work and co-sponsor or the 'Dos Ciudades' exhibition series in San Diego and Tijuana.

Arte Reembolso / Art Rebate
Elizabeth Sisco, Louis Hock and David Avalos, 1993

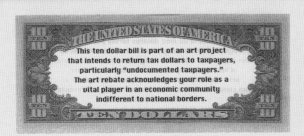

This ten dollar bill is part of an art project that intends to return tax dollars to taxpayers, particularly "undocumented taxpayers." The art rebate acknowledges your role as a vital player in an economic community indifferent to national borders.

- The economic growth of California and the Southwestern U. S. could never have happened without the labor of undocumented workers.

- Historically, the U.S. government, business and society have been willing to look the other way as long as they are enjoying the profits afforded by undocumented labor.

- Today, in a wrecked economy, the so-called "illegal alien" is once again blamed for the social problems of the region and portrayed as a drain on the economy. In fact, there is no credible statistical evidence that undocumented workers take more in social services than they give in combined local, state and federal taxes.

- Not only are the crucial economic contributions of the undocumented overlooked or denied, these workers pay federal income tax, social security, state income tax, DMV fees, sales tax and more.

- Undocumented workers are undocumented taxpayers.

- You pay taxes when you eat a taco at 'berto's, shop for socks at K-Mart, buy toilet paper, hand soap or razor blades at Lucky or fill up your tank at Thrifty Gas.

- Regardless of your immigration status, if you shop you pay taxes. Period.

REEMBOLSO ART REBATE

"Art Rebate" is a project by Elizabeth Sisco, Louis Hock and David Avalos. It is part of the "La Frontera/The Border" exhibition co-sponsored by the Centro Cultural de la Raza and the Museum of Contemporary Art, San Diego, and made possible, in part, through the generous support of the National Endowment for the Arts, a federal agency, The Rockefeller Foundation, the City of San Diego Commission for Arts and Culture, and the California Arts Council.

Undocumented Workers Taxpayers

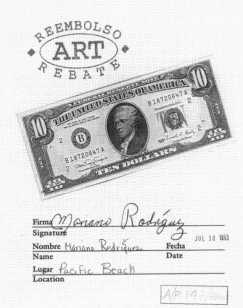

REEMBOLSO ART REBATE

Firma *Mariano Rodríguez*
Signature

Nombre *Mariano Rodríguez* Fecha JUL 30 1993
Name Date

Lugar *Pacific Beach*
Location

A/P 147/4500

'The art of government consists in taking as much money as possible from one class of the citizens to give to the other.'
Voltaire (1694–1778)

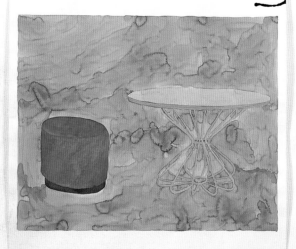

Have two pieces by Jorge Pardo from 1995, will trade for work by André Cadere.

Call Dave at 323 478-0079 or Jake at 44 20 8983 3878

Thanks (Three Day Weekend)
Dave Muller, 1994

Since 1994, Dave Muller has been staging what he calls *Three Day Weekends*. What started out as a way to exhibit his Cal Arts friends in teeny apartment shows has become a large part of his own art practice. Muller makes art about art – not about its formal conditions, but its social ones, the intimate connections of friendship and mutual interest that make up the art world. He recreates the announcements for exhibitions by friends or admired artists as watercolours. He also puts on temporary exhibits all over the world, showing work by friends and artists whose sensibility appeals to him. For *Thanks* in 1994, he had the artists name an object (such as a guitar pedal) they lusted after and would trade for the exhibited artwork. Some of the exhibitions are more notable for their odd locations, such as *People Are Animals*, staged in a freight elevator at Art Frankfurt. Muller doesn't so much subvert art institutions as try to create his own networks that weave in and out of those already established.

PEOPLE ARE ANIMALS

A Three Day Weekend event at ArtFrankfurt

March 24 -27, 2000

Mark Grotjahn
Amy Sarkisian
Anonymous
Dave Muller
Elizabeth Saveri
John Geary
Masi Eastman
Mary Weatherford

People are Animals (Three Day Weekend)
Dave Muller, 2000

opposite
**Gerry Bull, Space Research Corporation and Armscor of
Pretoria, South Africa c.1972–80 (5th version)**
Mark Lombardi, 1999

The late Mark Lombardi's delicate drawings map the
currents of influence and profit that move the world,
invisible to the average person. To prepare for his large-
scale works, he kept notes on global economic and
political affairs on over 10,000 index cards, following
the flow of power and money through current events.
Lombardi tracked reports of President George W.
Bush's longtime links to the bin Laden family oil money,
US government interests in Iraq, and, in *BCCI-ICIC-
FAB*, the Bank of Credit and Commerce International's
web of relations with Colombian drug money and arms
sales – and how it eventually defrauded millions of
investors. In May 2002, the *Wall Street Journal*
reported on the FBI's use of the drawing to investigate
the scandal: 'It turns out that years before the advent
of the most sweeping police investigation in history,
Mark Lombardi was, without knowing it, hard at work
mapping the shadowy figures behind global terrorism
and the financial connections linking them.'

Gerry Bull, Space Research Corporation and Armscor of Pretoria, South Africa c.1972-80
(3rd version)
Ink, © 1999

George W. Bush, Harken Energy and Jackson
Stephens c.1979–90 5th version
ML © 1999

**George W. Bush, Harken Energy and Jackson
Stephens c.1979–90 (5th version)**

Mark Lombardi, 1999

George H.W.
Bush
pres US 1989-93
vp US 1981-9

$100K

Repub
Nat Comm

Pamar
SIL
Calif

Robert
Bass

Bass
Bros
Ent's
Fw.

Sid R.
Bass

Jackson
Stephens

Sheik Isa
bin Khalifah
of Bahrain

Ghaith
Pharaon

Michael
Ameen

Agha Hasan
Abedi

Sheik
Khalifah

Bahrain
oil
deal

Main
Bank
Houston

Saudi
Bank
Paris

BCCI
S.A
-Lux-

Worthen
Nat Bk
-Ark-

Stephens
Inc.
-Ark-

John B.
Connally
gov TX 1467-8
Sec US Treas 1471-2

Saudi
Riyadh
Bank

Sheik Abdullah
Taha Bakhsh

Neth
Antilles
Co.

July 1990: Bush bails
out with profit

E.Z
Serve
-boutique-

URME
-Dubai-

Talat
Othman

Two weeks later
Saddam Hussein
invades Kuwait

$393K

93

36

36

38

84

90

Hawaii
real
estate

Saudi
Arab
Finance

Cartier
Int'l

Union
Bank of
Switz

Waste
Tech
Int.

Von
Roll AG
Switz

Anton
Rupert

Kaminati
Group
SaAfr.

Richmont
Group
Switz

Richmont
Oil
Denver

Mont
Blanc
co.

Rothmans
Int'l

J.P.
Morgan
-NY-

Ohio
toxic
incin.

Mikel
Faulkner

Money is as real as can be, even if it exists today mostly in the form of electronic pulses. Laura Kurgan's installation makes those pulses visible to the eye. Money, as Kurgan says, is 'a way of exchanging things that aren't similar,' and 'can also change hands faster than things. Sometimes money itself is exchanged.' In fact, global business increasingly has to do with the movement of money rather than goods around the world, changing form from one currency to another as it goes. In Kurgan's installation, computer monitors display a clock on which the changing relative values of the euro, yen and dollar fluctuate in real time. This piece, investigating 'the luminous immateriality of money and its mutable modes', makes visible the invisible powers that rule the social world in a way perhaps analogous to the religious art of the past.

Daten des globalen Devisenhandels:
Euro und Yen in Dollar angegeben,
1 . 5 . 02, gemeldet von Reuters.

Les marchés des changes sur le plan mondial:
équivalent en dollars, en euro et en yen,
1 . 5 . 02, communiqué de Reuters.

Worldwide foreign exchange data:
euro and yen expressed in dollars,
1 . 5 . 02, as reported by Reuters.

1.0 $

2

¥
102.15

00:00:08:00

€ 1.0049

6

placement géographique. The universally recognized temporal grid -- the clock -- allows transactions to occur in a common virtual space

Global Clock No. 2
Laura Kurgan, 2002

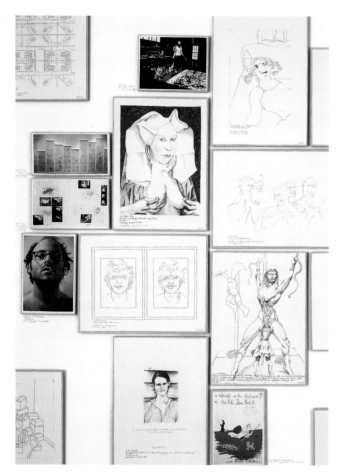

Artist, Collector, Curator, Spy
Danica Phelps, 2002

Pretending to be an art collector, Danica Phelps visited more than 600 art exhibitions between 6 September 2001 and 15 June 2002. When she found a piece that she wanted, she secretly took a digital photograph and made a drawing from that image. She then curated these drawings into mini-exhibitions grouped around certain themes. At the same time, she also exhibited the research and documents that had helped her reach her decisions as a 'collector', including reviews, price lists, press releases, notes, lists of galleries and postcards. Finally, Phelps attempted to acquire actual artworks by these artists, offering her drawings in exchange. She subsequently exhibited the works thus acquired and records of her attempted trades.

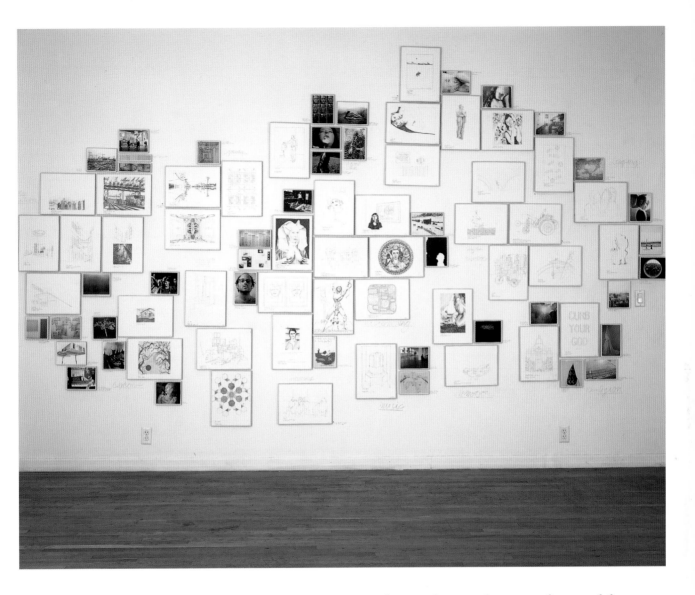

'Art as a form of free enterprise is joined...to the market as a form of free enterprise. The collector is freer as a collector than he is as a businessman.'
Meyer Schapiro

New York – New York
Paul Etienne Lincoln, 1986–present

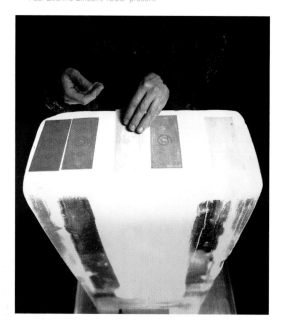

Paul Etienne Lincoln's on-going, massive sculptural project, *New York – New York*, combines a wide variety of found and homemade machines, including generators, electrical circuitry, and a rotary telephone. Together, this mechanical and electronic technology represents New York's role as the capital of the twentieth century, the centre of industry, stock market investment and invention. When the entire piece is installed and operational, energy circulates throughout the work, turning gears, setting off brass horns and phonographs, turning on lights, manufacturing steam and creating ice. In these images we see the products of the ice machine (which Lincoln calls *New York – Cold*): bonds and bills stamped with the musical score for a John Phillip Sousa march, the most traditional of American musical forms. The ice-money eventually melts, returning to a central pool where it will once again be converted into various forms of currency, the energy that makes the modern city run.

"Money talks' because money is a metaphor, a transfer, and a bridge. Like words and language, money is a storehouse of communally achieved work, skill, and experience. Money, however, is also a specialist technology like writing; and as writing intensifies the visual aspect of speech and order, and as the clock visually separates time from space, so money separates work from the other social functions. Even today money is a language for translating the work of the farmer into the work of the barber, doctor, engineer, or plumber. As a vast social metaphor, bridge, or translator, money – like writing – speeds up exchange and tightens the bonds of interdependence in any community. It gives great spatial expansion and control to political organizations, just as writing does, or the calendar.'

Marshall McLuhan, Understanding Media, *1964*

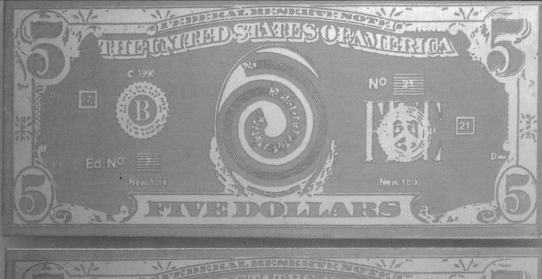

New York – Hot
Paul Etienne Lincoln, 1986–present

New York – Cold
Paul Etienne Lincoln, 1986–present

opposite
New York – New York (model)
Paul Etienne Lincoln, 1986–present

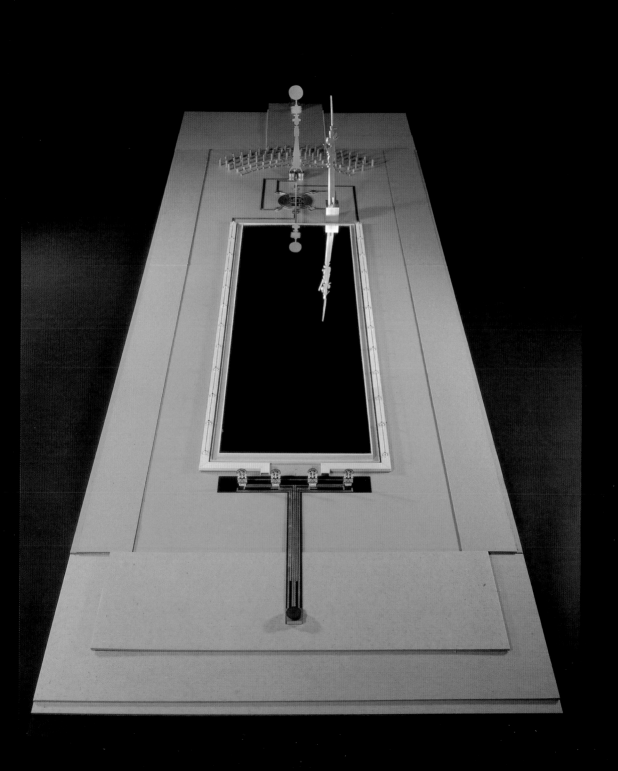

Smorgasbord (United States)
Barton Lidice Benes, 2002

Smorgasbord (Italy)
Barton Lidice Benes, 2002

UNITED STATES

ITALY

Barton Lidice Benes here turns paper money into the primary thing that it is used to buy: food. His work thus reverses the deceptively simple ability of wheat, apples, corn and tomatoes to be transformed into money, an ability which ties together the system of capital through exports and imports around the world.

Smorgasbord (Vietnam)
Barton Lidice Benes, 2002

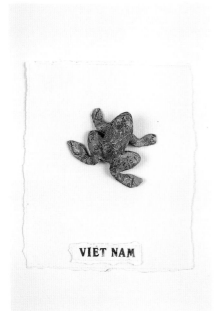

Smorgasbord (Mexico)
Barton Lidice Benes, 2002

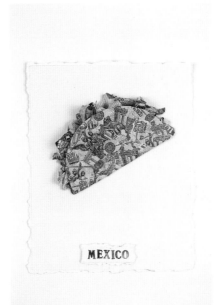

Smorgasbord (Russia)
Barton Lidice Benes, 2002

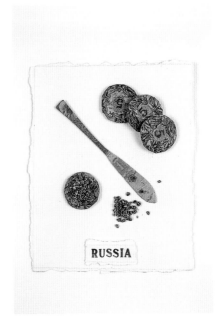

right and opposite

Free Trade

Neil Cummings and Marysia
Lewandowska, 2002–3

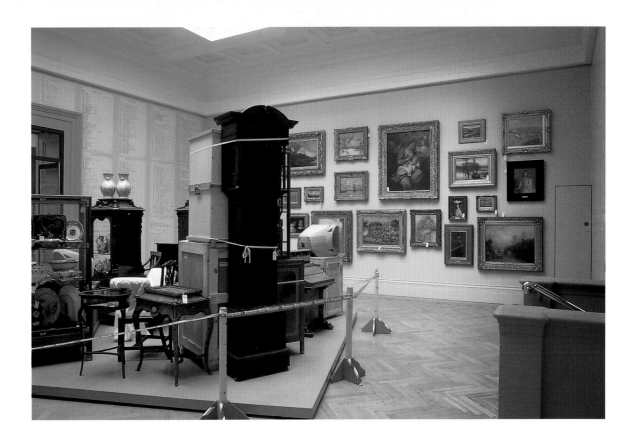

In 1839 Manchester, England was the home of the Anti-Corn Law League, which represented the interests of industrial capital against aristocratic landowners. The victory for free trade achieved by the eventual abolition of the Corn Laws, which had raised food prices by taxing imported wheat, helped Manchester to become the import/export centre of England and, ultimately, the British Empire. This commercial success was expressed in cultural terms. The Blair brothers, wealthy cotton merchants, used their fortune to amass a collection of 30,000 objects, including 5,000 paintings, which was bequeathed to the Manchester Art Gallery in 1941. Neil Cummings and Marysia Lewandowska's 2002–3 installation displayed over 300 objects identifiable as elements of the Blair collection (together with their original prices) in one room of the Gallery. 'Displayed in transit,' they comment, 'the objects are momentarily arrested, en route elsewhere – from store to exhibition?' Here art and artifacts take their place amidst 'the huge quantity of all manner of goods that moved continually through Manchester,' one of the first centres of what is now called globalization.

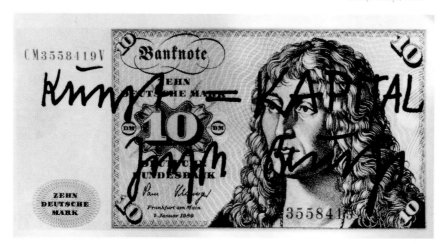

'For I spend all my time going about trying to persuade
you, young and old, to make your first and chief
concern not for your bodies nor for your possessions,
but for the highest welfare of your souls, proclaiming
as I go, Wealth does not bring goodness, but goodness
brings wealth and every other blessing, both to the
individual and to the state.'

Plato, Socrates' Defence (Apology)

BUSINESS

In modern society, the production and distribution of goods is a means for making money. It is not money but business – the investment of money to make more money – that makes the world go round.

Artists have always had ambivalent feelings about business, courting businessmen as customers while mocking their focus on money-making, valuing their own status as self-employed artisan-entrepreneurs while seeking state and corporate subsidy, trading evermore abstracted whiffs of bohemian libertinism for the security of contracts and cash in the bank. Some maintain a stance of anger or simple distance from the power that pays them; some are happy to serve the desire for cultural completion – or redemption – that having money creates; some achieve the feat of being paid for biting the hand that feeds them.

'If you want to know what God thinks of money, just look at the people he gave it to.'
Dorothy Parker

above and opposite

Merger

Daniel Lefcourt, 1999–2001

**Queue, Paddington DHSS,
West London, 1985**
Paul Graham, 1985

left
**Waiting Area, Hackney DHSS,
East London, 1985**
Paul Graham, 1985

opposite
**A Lawyer with Laundry, New York,
New York, October 1988**
Joel Sternfeld, 1988

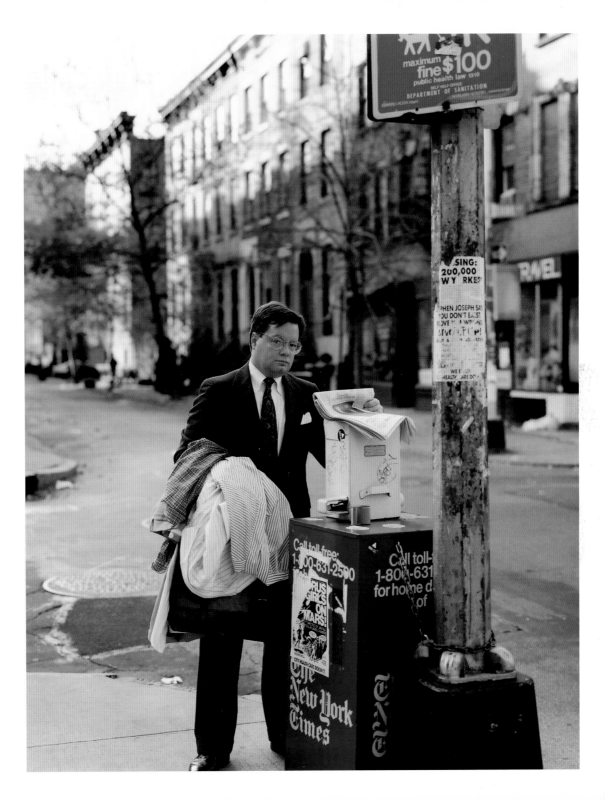

For *Money*, created in 1969 for an exhibition in the Whitney Museum, New York, Robert Morris proposed that the museum provide a small sum of money that he would invest in 'blue chip' art to be quickly resold in Europe at inflated prices for the museum's profit. As the museum's trustees refused to provide the money unless the project was guaranteed risk-free, the artist was forced to substitute a modest investment in sheltered bonds, carried out under the supervision of one of the trustees. The piece, consisting of correspondence between Morris and the trustees, is the record of a business proposition – and of the art-loving trustees' determination that their investment in an artist's work should make a profit for their institution.

Money
Robert Morris, 1969

Brooklyn
Danica Phelps, 2000

Danica Phelps has been keeping track of all her expenses since 1996. She charts her daily activities in Brooklyn, and at the bottom of each entry or drawing, she notes her financial transactions in dollars, red for expense, green for income, and grey for credit. Alongside accounts of her expenditures (tampons, lobster) and sales (of artwork) are drawings by other artists, such as the portraitists in Central Park, as well as drawings by Phelps of works by other artists. Here the story of an individual life conforms less to the genre of the diary, which records emotional exchange, than to that of the corporate account book, which keeps track of in- and out-flow. What does this suggest about the nature of that individual life? Both that people can be thought of in business terms, and that the details of business can carry emotional freight as much as any expressionist outpouring.

Brooklyn: Portraits
Danica Phelps, 2000

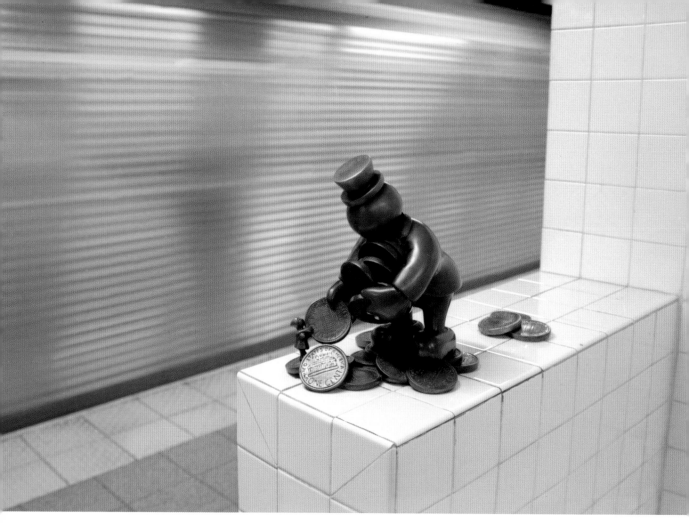

Life Underground (14th Street/8th Ave.)
Tom Otterness, 2001–2

Tom Otterness makes public sculpture in traditional bronze that subverts the genre, often taking as his subject the role of money in social life. Working both for public settings, such as the New York subway station seen here, and private contexts, he depicts misers, beggars, thieves and tycoons, among other types. In the series *Free Money* (see page 149), chubby capitalists celebrate their good fortune, dancing away on a big bag of money, or squeeze out their last penny. Otterness's disarmingly cheerful, cartoon style allows him to get away with some very pointed social commentary.

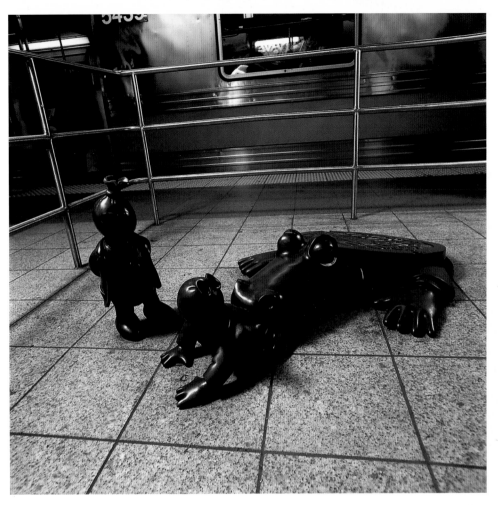

Life Underground (14th Street/8th Ave.)
Tom Otterness, 2001–2

Poverty
Peter Saul, 1968

'In any country where talent and virtue produce no advancement, money will be the national god. Its inhabitants will either have to possess money or make others believe that they do. Wealth will be the highest virtue, poverty the greatest vice. Those who have money will display it in every imaginable way. If their ostentation does not exceed their fortune, all will be well. But if their ostentation does exceed their fortune they will ruin themselves. In such a country, the greatest fortunes will vanish in the twinkling of an eye. Those who don't have money will ruin themselves with vain efforts to conceal their poverty. That is one kind of affluence: the outward sign of wealth for a small number, the mask of poverty for the majority, and a source of corruption for all.'

Denis Diderot, 'Observations on the Drawing Up of Laws', 1774

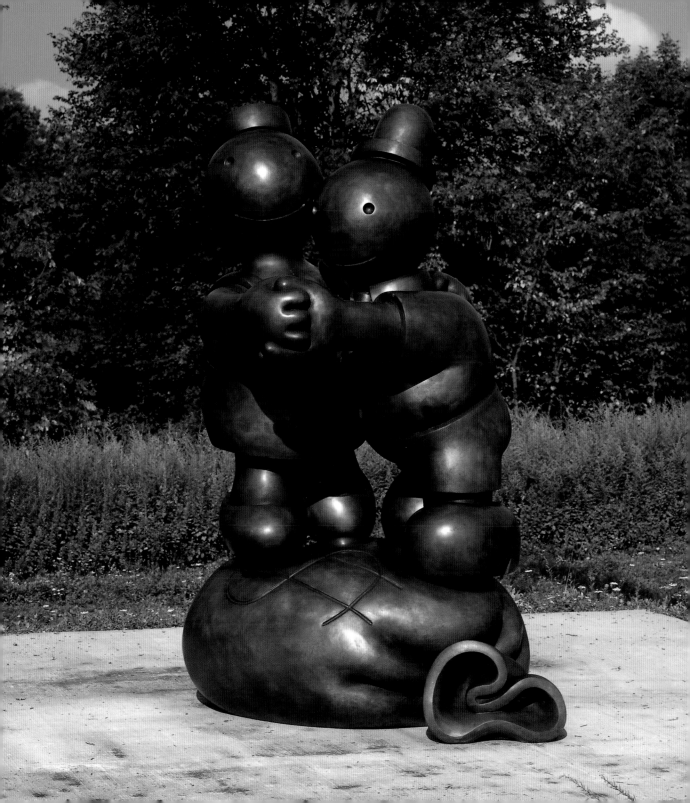

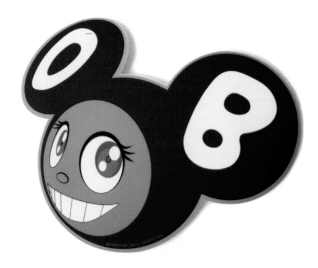

DOB Mousepad
Takashi Murakami, in production since 1999

Takashi Murakami draws on Japanese anime and manga imagery for his sculptures and paintings. In 1993, he created the character Mr DOB, who combines features of Japanese and Hong Kong animation with aspects of American cartoon characters, notably Mickey Mouse. Murakami makes paintings and sculptures of the character; he also licenses the image for keychains, dolls, mousepads and t-shirts that are sold at relatively low prices through his website and speciality stores like those in museums. Unlike other artists whose images end up on t-shirts, Murakami doesn't despise such souvenirs as kitsch, but produces them himself and controls the imagery and design.

The enchanted forest of flowers, mushrooms and fantastic creatures suggests a whole world produced by Murakami for his character to inhabit. The artist moves easily between high art and mass-produced objects, emphasizing both as things that are bought and sold, but that nonetheless resonate creatively and psychologically. Perhaps more than any other contemporary artist, Murakami maintains a high art reputation, selling his paintings for hundreds of thousands of dollars, while also mass-marketing his creations.

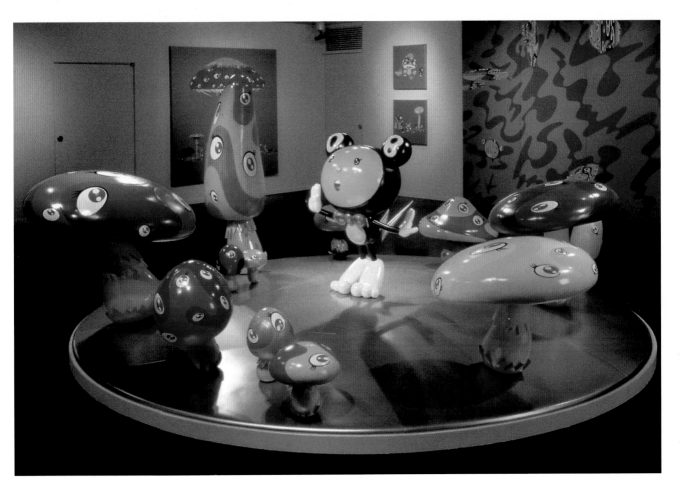

DOB in the Strange Forest
Takashi Murakami, 1999

above and opposite

**We... You were doing so well
(with the contract). Why this now?
Paintant**

Fabian Marcaccio, 2002

This large-scale work both criticizes the politics of business and inquires into the nature of representation. Its source is a photograph of an International Monetary Fund meeting, an image that Fabian Marcaccio repeats and alters in successive paintings that wrap around the gallery walls. The original photograph featured framed pictures decorating the room; in each painting, these small pictures grow progressively larger, floating around the depicted boardroom. The image itself never reveals its meaning: as the artist enlarges it, bringing it closer to the viewer, it gets fuzzier and more out of focus. Marcaccio is interested in the defects that run through political, economic and artistic representations. These faults are the very essence of representation.

Economic Concentration Camp

Fabian Marcaccio, 2002

opposite

Semantic Fabric Paintant

Fabian Marcaccio, 2002

'Endless money forms the sinews of war.'
Marcus Tullius Cicero, Philippics

Sarah Morris shot the eighteen-minute film *Capital* in Washington, DC over the course of four days in September 2000. She cuts quickly between a range of DC sites and scenes: the Mall, the White House Press Office, the World Bank, uniformed members of the Secret Service, the presidential motorcade, the Watergate Complex, the Kennedy Center, the Department of Energy, the J. Edgar Hoover Building, among many others. These places represent power, and also access to the inner workings of government unimaginable only a few years later, after a change in administrations and the attacks on the World Trade Center and the Pentagon. Still, the film does suggest a tension and unease, present in the US capital even then.

above and opposite

Capital

Sarah Morris, 2000

Along with artists Pierre Huyghe and Dominique Gonzalez-Foerster, Philippe Parreno purchased exclusive rights to Annlee, a Japanese anime character. Such a figure would normally be licensed to people working commercially in comics, cartoons or advertising. Huyghe and Parreno were intrigued by the idea of taking her out of this setting and seeing what they might do with the essentially empty sign of her image, which had no determined personality. Since then they have invited a number of other artists to participate in making videos and sculptures that use Annlee. The artists have borrowed not only an image from the mass media, but also a mode of artistic production.

above and opposite
Anywhere Out of the World
Philippe Parreno, 2000

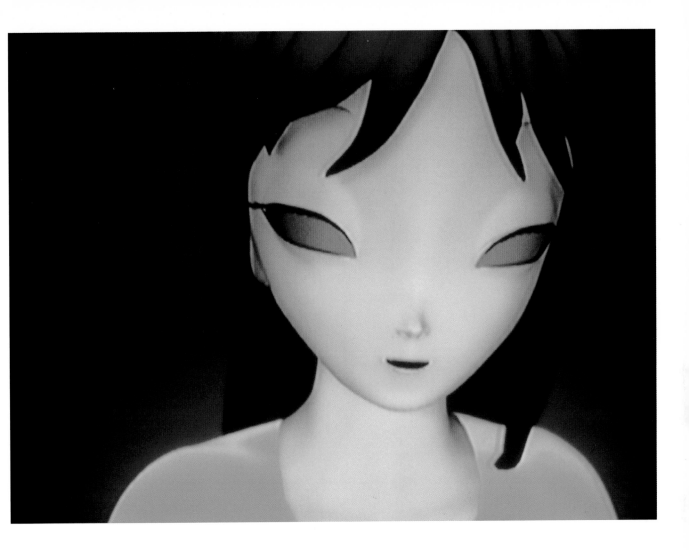

'My name is Annlee. I am a product, freed from the marketplace.
I belong to whoever is able to fill me with imaginary material.'

Annlee

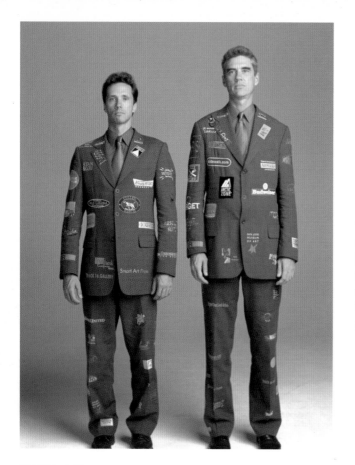

The Art Guys are Michael Galbreth and Jack Massing, a collaborative duo based in Texas. For one year they invited corporations to sponsor them directly, rather than sponsoring the exhibitions or institutions with which they might have been associated. They wore suits bearing their patrons' logos, like an artistic equivalent of professional racing car drivers.

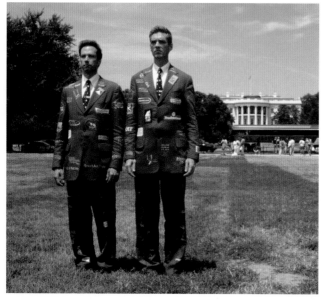

Suits
The Art Guys, 1998–99

ALTERNATIVES

It's hard to imagine a world without money – a world without capitalism. Wage labour and commodity production seem so natural after four hundred years that people are almost unable to consider alternative ways of producing and distributing goods.

Yet the inadequacies of modern society perpetually stimulate projects, fantasies, or simple stabs in the direction of other ways of social being. Thus some artists experiment with giving things away, even in a context defined by buying and selling. Others try to create experiences of collective creativity. Modern society insists on human individuality and difference, but in fact the very network of monetary transactions that creates conflicting needs also ties people together in webs of shared experiences and interests. These may emerge in moments of group action, such as strikes and protests – or in the fascination with an art work that, although experienced individually, can link people in a shared relation to both the work and its maker.

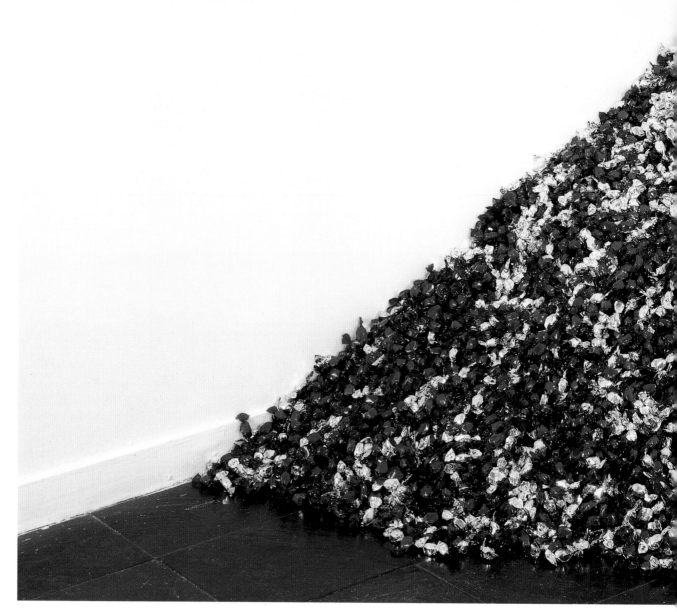

Untitled (USA Today)
Felix Gonzalez-Torres, 1990

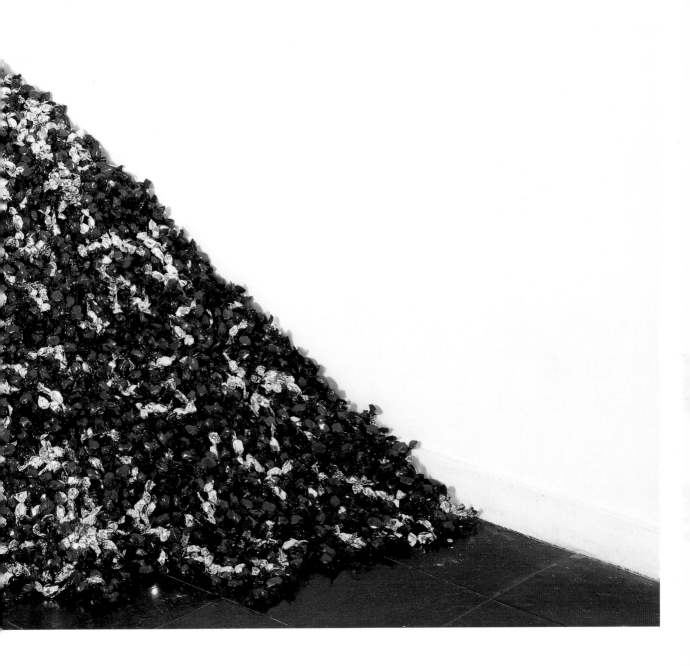

Untitled (Free)
Rirkrit Tiravanija, 1992

The late Felix Gonzalez-Torres was well-known for sculptures made out of candy and large-edition silkscreens, from which any viewer could take a piece. Similarly, Rirkrit Tiravanija uses the gift, the gesture of a free offering, to reconfigure the relationships between the artist, the viewer and the intermediary institution, such as the gallery or the museum. His work has often been described with the adjective 'generous', a term he first earned with his best-known piece, *Untitled (Free)*, for which he made pad thai every day for a month in an art gallery; anyone was free to walk in and eat lunch with the artist and whoever else showed up. Here the art 'viewer' receives a tangible, palatable gift from the artist, and his consumption of the meal is itself part of the art work. Tiravanija followed up this early work with other 'social sculptures' that invite the viewer to participate in a manner intended to be more inclusive than the average art experience. In *Untitled (Rehearsal Studio No. 6 Silent Version)*, Tiravanija built a music recording studio, which he then allowed the public to use for the run of the exhibition. Tiravanija is interested in subverting traditional monetary relationships, both inside and outside the art world. He invites the viewer to take a piece of his art – not to mention a meal – without the need to buy anything. The collector who purchases his work gets the leftovers.

Untitled (Free)
Rirkrit Tiravanija, 1992

Cocaine Buffet
Rob Pruitt, 1998

For the opening night of a group show at Gavin Brown's Enterprise Gallery, New York, Rob Pruitt laid a sixteen-foot mirror on the floor with a line of cocaine running down the middle. Invited to partake, gallery visitors hung back at first, but then as the first takers stepped forward, the cocaine disappeared in a matter of minutes. Like Gonzalez-Torres and Tiravanija, Pruitt creates a more direct relationship between the artist and the viewer, in which the latter receives something tangible. With a slightly sardonic twist, however, Pruitt tinges his 'generosity' with what might be a nod to what people are really hoping for at a gallery opening.

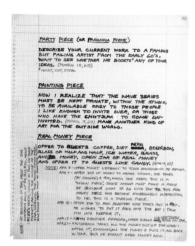

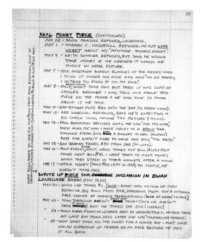

Lee Lozano was a painter and a conceptual artist working in New York in the 1960s and early 1970s. Deeply political, she moved from a post-minimalist painting practice to actions such as *General Strike*, 1969, in which she withdrew from the commercial art world, including galleries, eschewing any activity that did not involve 'total personal and public revolution.' In *Real Money Piece*, 1969, she recorded what transpired as she offered a jar full of money to a range of visitors, including artists Keith Sonnier, Dan Graham and Brice Marden. Some took money, some refused, and some contributed to the jar. The work was a fascinating social and psychological experiment into people's feelings about money which circumvented the usual modes of selling and buying that underlie even the most personal of relationships.

'At beginning of this piece the jar contains bills of $5, $10, $20, about $585.'s worth, coiled in two or three packets around the inside of the jar, unbound. The money comes from Rolfe Ricke from sale of painting 'Switch.'

Offer to guests coffee, diet pepsi, bourbon, glass of half and half, ice water, grass, and money. Open jar of real money and offer it to guests like candy. (Apr 4, 69)'

Lee Lozano, Real Money Piece, *1969*

Searching Karl Marx on Amazon.com
Rainer Ganahl, 2000

Karl Marx imagined a world that would no longer be ruled by money; he believed, moreover, that capitalism itself was creating both the possibility and the necessity for such a world, in which people themselves, not the profit-driven forces of the market, would decide what to produce and how to distribute it. Rainer Ganahl has made reading and discussing Marx's ideas a part of his artistic work, meeting with groups of people, often art students, at the invitation of galleries and museums. Just as Marx looked forward to the day when humanity would break with the current mode of social organization, Ganahl seeks modes of art-making that he may initiate but not control and that stimulate others to their own creative thinking. Reflecting on the discussions he has organized, he observed that, 'as naïve as it sounds, and contrary to many of the totalizing concepts of today's social fabric that see people solely as unconscious and manipulated consumers, it is surprising how little it takes to stimulate change.'

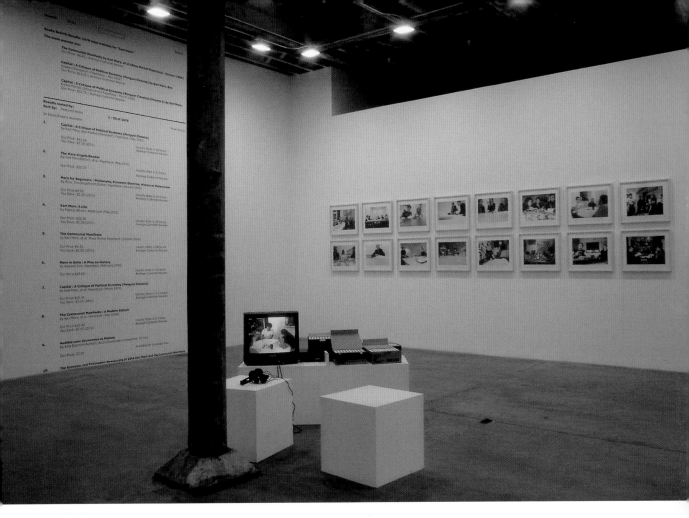

Capital
Rainer Ganahl, 2000

Reading Karl Marx, London, UK
Rainer Ganahl, 2001

top
Reading Karl Marx, Frankfurt, Germany
Rainer Ganahl, 2000

Reading Karl Marx, Kingston, UK
Rainer Ganahl, 2001

top
Reading Karl Marx, Brooklyn, USA
Rainer Ganahl, 2000

'Hand in hand with...this expropriation of many capitalists by a few [comes] the transformation of the means of labour into forms in which they can only be used in common [and] the entanglement of all peoples in the net of the world market.... Along with the constant decrease in the number of capitalist magnates, who usurp and monopolize all the advantages of this process of transformation, the mass of misery, oppression, slavery, degradation and exploitation grow; but with this there also grows the revolt of the working class, a class constantly increasing in numbers, and trained, united, and organized by the very mechanism of the capitalist process of production. The monopoly of capital becomes a fetter upon the mode of production, which has flourished alongside and under it. The centralization of the means of production and socialization of labour reach a point at which they become incompatible with their capitalist integument. This integument is burst asunder. The knell of capitalist private property sounds. The expropriators are expropriated.'

Karl Marx, Capital, *vol. 1*

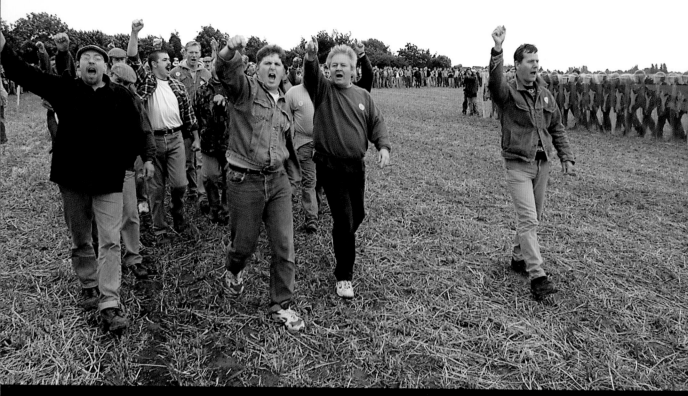

above, opposite and overleaf
The Battle of Orgreave
Jeremy Deller, 2001

In 1984, in Yorkshire, England, the National Union of Mineworkers went on strike. In June, during the course of the one-year strike, a particularly violent confrontation took place between the miners and the police, many of whom were on horseback and equipped with full riot gear. Drawing upon extensive research, artist Jeremy Deller recreated the event in June 2001, under the direction of Howard Giles, an historical re-enactment expert. Their cast included both re-enactment buffs and local men, some of whom had been involved in the original conflict. A local audience of thousands watched, and filming was directed by Mike Figgis. Broadcast on national television, the film intercuts still photos from 1984 with footage of Deller's version, with commentary on its importance for labour history, the media's role in the ensuing cover-up, and the lingering effect on local families. Deller hoped to help the public remember an extremely painful episode in the history of the area and in individual lives: 'I wanted to remind people that something had happened there – not the locals, because they knew exactly what had happened. If anything, it was about digging up a hastily buried corpse and giving it a proper postmortem…. I wanted it to be as unsentimental and un-ironic as possible and yet wear its heart on its sleeve. Living history is a good term to use.' Despite the ultimate defeat of the miners, Deller reminds us not only of the government's violence, but the workers' rebellion – the fact that resistance to the conditions of work and wage labour is possible.

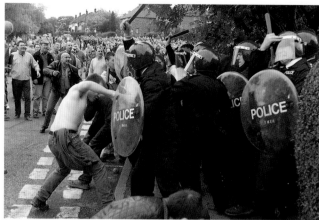
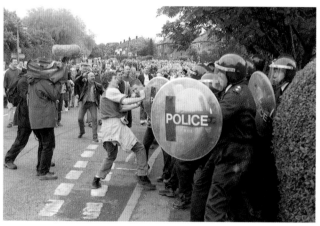
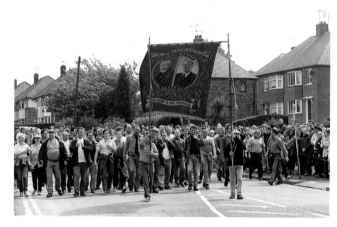
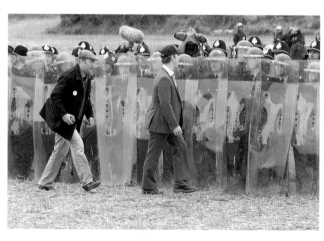

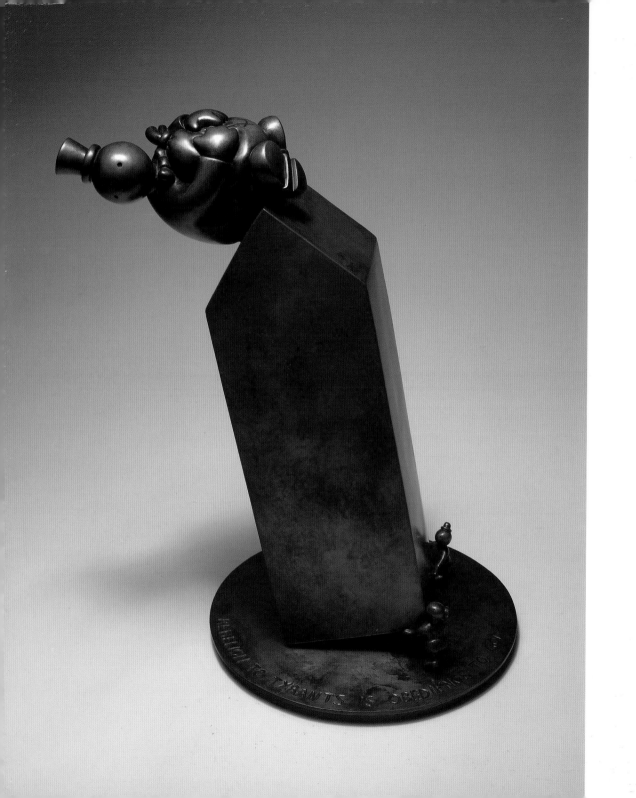

this page
Waiting for Tear Gas
Allan Sekula, 1999–2000

opposite
Rebellion to Tyrants
Tom Otterness, 2002

Only 1017 Days Left
Joseph Beuys, 1984

Most of the time capitalism seems as though it has been here forever and will last forever; it's hard to grasp that this social system is only about four hundred years old. Working for money, buying and selling commodities, chasing business profit: these seem like basic facts of nature, just the way things are. Joseph Beuys's simple blackboard message reminds us that history goes on, that over time the most solidly entrenched social institutions change and break down. He isn't claiming that the end is near – there are still 1017 days of capitalism left. But only that many. Though Beuys himself has passed on, his words of hope remain.

TALK

Rainer Ganahl, Paul Mattick, Raymonde Moulin, Lane Relyea, Richard Shiff, Katy Siegel

TALK

Rainer Ganahl is an artist based in New York

Paul Mattick is Professor of Philosophy at Adelphi University and Editor of the *International Journal of Political Economy*

Raymonde Moulin directs the Centre de Sociologie des Arts at L'Ecole des Hautes Etudes en Sciences Sociales, Paris

Lane Relyea teaches art theory and criticism at Northwestern University, Evanston, Illinois

Richard Shiff is the Effie Marie Cain Regents Chair in Art History at the University of Texas, Austin

Katy Siegel is Associate Professor of Art History at Hunter College and the Graduate Center, CUNY, and a Contributing Editor to *Artforum*

KS: Do artists today in general see their relationship to the art market and to money differently from artists in the past, even the recent past? How does the market in its contemporary form(s) affect the art that is produced, in terms of the shape of careers, media employed, production values, subject matter, and in terms of attitudes of turning to or reacting against the market?

RS: One of the beautiful things about works of art is that they are commodities that don't get consumed. That is, they get used, but not used up. Looking at them doesn't deplete them. If you get tired of one of them, someone else will be happy to have it, unless your loss of interest relates to a general fashion, in which case others will be just as uninterested (although there is likely to be a museum willing to empty your private vault, even of the unfashionable items). Works of art are usually quite portable and easy to warehouse, *relative to their market value*; a million dollars of art requires a lot less upkeep than a million dollars of soya beans. This makes art almost as good an object of exchange as is a jewel or a monetary instrument or plain cash lucre. Because art – or, I should say, marketable art –

is a currency in particular demand and relatively limited supply, its value often increases disproportionately to other commodities and currencies, which gives it still another advantage, making it still more desirable, increasing its value still more.

At the core of this market phenomenon of supply and demand seems to be the socio-cultural prestige value of art. Without that social factor, the commodity value of art would be very uncertain. Cash, if you have enough of it, also confers a certain status, but an equal value of art probably confers much greater status. The business of teaching the newly affluent how to appreciate art has been a substantial industry for at least a century. I'm suggesting that a million dollars in art is worth more to society, and therefore to the possessor, than a million dollars of anything else. A million dollars worth of electricity or of water might be more crucial to survival at a certain moment, but it doesn't confer social status.... Enron spent a lot of money on art.

How did the whole system get started? I suppose that when bourgeois power supplanted aristocratic power (at different times in different places – it's still happening), the bourgeois gentleman was willing to pay a premium for things that had always been privately owned only by aristocrats. Having your own painting was as much a sign of social standing as wearing your own top hat.

None of that is either unfamiliar or particularly original. Nor is the resistance to this kind of self-fulfilling market momentum on the part of any number of artists. For as long as there has been a kind of free market in art, there have been a certain number of artists who have become extremely wealthy as a result of their productivity; in recent decades, there have also been an increasing number of artists who have gone the way of resistance by making art that can't easily be marketed – because it is perishable, because it is obscene, because it is ugly, whatever. If only unmarketable art were being made, it might turn out that the market would accept the unmarketable stuff, *faute de mieux*.

The art business has grown very big, like the old business in gold. Artists can't by themselves put a stop to it. The growth

of the market in secondary and tertiary collectable items, such as vintage clothing, is a reflection of the demand for marketable commodities analogous to art, about which one can acquire expertise (which isn't necessary in the case in collecting gold bullion), and therefore claim a certain social distinction.

Personally, I don't see why an artist who takes pride in his or her aesthetic and conceptual practice shouldn't just forget about the market and let it do what it does. Some artists start off rich; some start off poor. Some collect other artists, and some do not. Of those who collect, some sell what they collect when they see the opportunity for a substantial profit (in effect, exchanging a work of art for, say, a Fifth Avenue co-op, several Ferraris, or a prenuptial agreement), and others keep looking at what they have. A top violinist or surgeon or trial lawyer might command a premium for his or her services, but such a person isn't necessarily working for the money, as opposed to the pleasure derived from the work itself and its mastery. Sometimes the money just helps you to do the work better.

The art business has grown very big, like the old business in gold. Artists can't by themselves put a stop to it.

RG: For me as an artist there are many 'art markets', although I have only rarely been touched by the one that is defined in strictly monetary terms and culminates in art auctions. I even have the impression that my type of conceptually oriented work gets more attention when that market dips and its exuberance deflates. My entire *modus operandi* is organized around practices that are independent of classical market exchanges. Developing alternative models of success, presentation, communication, circulation and exchange for what I do as 'art' is crucial for me. If I let myself be reduced to the simple model of 'art goes to dealer, then to collector', I would never have made it through the past twelve years of active production and exhibition.

There are many alternative models, not only for artists but

also for dealers and curators with little money. Let me just give you one example of a project that maintains an ironic distance from the market. Right now, I am showing in an artist-run gallery located inside the Essex Fruit Market on New York's Lower East Side. The organizers of the gallery, which is called Cuchifritos, cut an affordable deal with the market-owners and opened a small space next to the fruit-vendors and kiosks. The area is still mostly inhabited by artists who have not yet been forced out by the process of gentrification under way at the moment. My work in a group show is a sculpture entitled *4 Weeks, 5 Days a Week, 6 Hours a Day – Basic Korean* (120 hours on 60 VHS tapes, 1997). I filmed myself studying Korean, a practice that doesn't need a market and which results in success for me even if I don't sell the work. I have learned something, so it makes sense even without any art context (although I should say that the work was originally commissioned and paid for by the Kwangju Biennial, a market-independent organization). I think that none of the participants in Cuchifritos – not the gallery, nor the curator, nor me as the artist and the original producer and curator of my piece – were thinking about 'market forces'. We were, rather, driven by ideas, necessities, and limited resources. But the real estate market has registered these activities positively and is already following. The art community is there already. If we waited for collectors or commercial galleries, we would turn mouldy like uneaten tomatoes – or *cuchifritos*.

LR: As a critic I've never had to price an artwork and I've certainly never had enough money to buy an artwork, so the determination of a work's market value has always remained pretty occult to me. Until the other week. One of the young artists in the residency programme I ran in Houston was asked to donate a work to an auction, and she needed to price it. She's been out of school for less than a year and had never dealt with selling work before, so she asked my advice. I had no idea, so I called a reputable gallerist in town, who asked very straightforward questions, like the dimensions of the work, what it was made of, and whether it was part of an edition. Five minutes later she called back with a price. I felt elated by the experience: no more mystery, it was a matter of simple mathematics, of following a formula, something like dimensions times materials equals X.

But then the auction took place, and while a lot of work didn't sell, the young artist in my residency programme sold her work for twice the asking price. I can't help but think that part of the reason was her participation in the programme, which has garnered much notice of late for helping launch the careers of several young art stars (Julie Mehretu, Trenton Doyle Hancock, Shazia Sikander and others). I guess this is my point: it seems that young artists don't really break into the institutional art world any more so much as come up through it. There are certain graduate programmes, then residency programmes like those at Skowhegan and the Whitney, and then museum-run project programmes devoted to discovering young talent, etc. In every May issue of *Artforum* you now see ads for thesis shows at Hunter, Columbia and other schools, which is very new. It's fairly easy to explain in market terms why a gallery advertises, but why a school advertises is more complicated. As schools and residency programmes have been more tightly interwoven into the institutional art world (think of MoMA's annexing of P.S.1), it makes sense that galleries and their selling of artwork matter less in determining the value of art. Galleries are just one increasingly small part of an ever-larger system that deals not only with old but also very new work.

It's easier for me to think in terms of an art economy rather than a market. Success isn't just quantified in terms of how much a work sells for; it also is measured by how often an artist appears on the visiting-artist rosters at art schools, or how often one is commissioned to do site-specific projects at *Kunsthallen* and contemporary art spaces. Perhaps this relates to why artists themselves draw more attention now than their work; their celebrity has a value of its own, as does their functioning – are they articulate about their work, do they have connections, do they look glamorously arty? And although I'm not sure why, I think this has something to do with the recent demise of criticism, the fact that magazines like *Artforum* hardly publish criticism any more, but are instead filled with news about artists and curating and curators. Criticism seems to have had a crucial role, both practically and ideologically, in the rise of art markets both in Paris and in New York. In today's generally mixed, international art economy, competition doesn't work the same way. The Basel Art Fair is on the face of it a purely market phenomenon, but is it really that different from the Venice Biennale or Documenta? Institutions compete over funding, over works that come up for sale, over discovering the next new thing – but their prime directive is to perpetuate themselves. And to the degree that institutions are more and more interlocked in an international system, that system will seek to keep itself intact through the perpetuation of its core constituent parts. In such a situation it seems almost old-fashioned to relate art to a market. Just listen to the ever-popular Dave Hickey: his pining for the good ol' days of the art market is explicitly nostalgic.

It seems that young artists don't really break into the institutional art world any more so much as come up through it.

RS: Yes, it's all very complex, and probably has been for quite a while – at least, as I've said, from the time of the bourgeois revolutions (linked to the various industrial revolutions). During the mid-nineteenth century, Rosa Bonheur made herself notorious, therefore a celebrity, and did very well with monied collectors and the open market. Being in a notable collection is an endorsement. Before that, having the support of a gallery is an endorsement. Before that, having an academic degree or institutional franchise of some sort is an endorsement (think of the old Prix de Rome). Lane rightly implies that artists may well endorse their institutions just as the institutions endorse the artists. My university seeks out its most successful graduates in the arts and gives them lifetime achievement awards or, in the case of those who never earned them, academic degrees. It's good marketing for the university, less essential for the artists, given their stage of career; but, in effect, the older artist-graduate-awardee ends up endorsing the current artist-graduate, who can stand on the same platform in the shadow of the great one. It can all be translated into market value in a salesroom situation, so long as there is also demand. Sometimes the demand amounts to little more than mimetic rivalry: one collector wants precisely what the other collector wants, because the other collector wants it. Auctions are designed to take advantage of human nature.

My brief encounters with major collectors indicate that they know a great deal about each other. Just like artists.

I don't know whether the avoidance of the deeper kinds of criticism on the part of certain magazines and journals is so significant. The nature and style of a given magazine evolves. In past decades, there were art magazines that did reporting/editorializing but little criticism, and others that did criticism with little reporting/editorializing/gossiping. It's still that way, but the names of the magazines have changed – or, the magazine that used to do criticism might now do reporting. The readership for criticism has always been smaller than the readership for reporting, so there's an economic/market incentive to publish the latter without there necessarily being a sociological explanation. Baudelaire's criticism was short on reliable information, long on ideas. His readership was pretty small and the living he made wasn't great, hardly enough to support his bad habits. I imagine that John Russell and Calvin Tomkins have mastered the bourgeois economy far better than Baudelaire did, which is no condemnation of their style of writing – theirs is simply a different genre from Baudelaire's. (I end up comparing a famous nineteenth-century critic to two recent writers because the practitioners of the non-critical genre tend to be forgotten, whether they were good at it or not. I could cite some nineteenth-century examples, but the names would mean nothing.)

This, too, isn't a statement about absolute value, but merely reflects the inherent conservatism of big ideas. We remember Baudelaire's big ideas not because they were so good, but because we still believe them, for better or worse. The little ideas of the journalists (literally, the day-by-day people) are faddish, fashionable and forgettable, whether good or bad. If I can't remember what I enjoyed doing or dreamed about during the summer of 1975, I'm not likely to remember what a journalist wrote about what was fashionable that season. Those are just the little things. Since the big ideas, to the contrary, last so long, I suppose we don't need very many of them, there isn't much demand for them, and not much room at the top of that little heap of high-class critical minds. Is it the same in art? A lot of high-paid but forgettable artists versus a few with big ideas that we can't help but remember?

PM: It's really interesting to see these three points of view represented: that of the artist, the historian and the critic (although Richard and Lane both alternate between the two latter roles). Their responses share at least one feature in remarking on the change in scale and structure of the art world in recent years. Not only are there more artists and galleries than ever, the art economy, as Lane calls it (as opposed to the art market), increasingly comprehends and depends upon auction houses, schools, residency programmes, commercial art fairs, museum project rooms, and international biennials.

In his practice, Rainer links some of these various forces; an artist with a Chelsea gallery, he also shows in a Lower East Side alternative exhibition space, and his work was funded by the Kwangju Biennial in Korea. Even though the latter two venues are not explicitly linked to commercial sales, the New York venues, as he points out, serve as the leading edge of real estate inflation and gentrification in depressed but increasingly hip neighbourhoods, much like SoHo thirty years ago. And the Kwangju Biennial, like all the new international biennials of recent years (Istanbul, Johannesburg, Liverpool), promotes the national economy of its host country. Today's *New York Times* (6 June 2002) tells a similar story relating an artists' studio district in Shanghai, the Shanghai Biennial, and a SoHo-like real estate development that now threatens the artists with displacement (the whole cycle in the span of only three years!).

Why does art have this power to link money and property and economic development? Richard's first response points us in one direction: the social capital embodied in art. While some of art's value clearly comes, as he says, from its potential to rise exponentially in value, art is not just like any other speculative commodity. It confers a prestige similar to classical music – opera, ballet, and other forms that often cost money rather than make it. Richard suggests that the bourgeois gentleman sought to take over the trappings of the aristocratic life. Now that capitalism has decisively triumphed on a global scale, does art still have this social meaning? What new ones can it have?

RS: Going back to the accelerated growth of the artistic economy, I have the impression that in recent years greater

and greater numbers (although maybe not a greater percentage) of serious-minded artists make a decent living at what they're doing. And since everyone now knows that this is possible, that's an incentive to work harder at marketing yourself – getting a functional gallery, sticking to an exhibition schedule, keeping accurate records, using durable materials (unless the point of the art is to fall apart), and so forth. It's also a disincentive to experiment beyond a certain point of moderate success. You might lose your market. We've seen a lot of complaint during the past three or four decades about artists (of older generations) being obsessed with being original. The most meaningful version

The bourgeois gentleman sought to take over the trappings of the aristocratic life. Now that capitalism has decisively triumphed on a global scale, does art still have this social meaning? What new ones can it have?

of that complaint has come from writers who give a theoretical rationale to the argument. But perhaps not an artistic rationale. Theory is the business of theorists. Artists don't have to pay attention to it. But many artists did pay attention to the no-more-originality argument (more attention than they gave to many other serious bits of critical theory). I wonder whether there wasn't some bad faith here, motivated by the promise of early market success. If you decide – for noble, theoretical reasons – that there's no purpose in searching for the new solution, and that doing a critique or an ironical version of an old solution is what the situation now calls for, then it certainly makes repeating the ideas and the look of other artists more palatable. You can do it for intellectual, even political reasons, and you don't have to take big chances with the market. Simply aligning your thematic programme with the general aims of a good political cause would enable you to feel that you'd succeeded in a serious artistic mission. Breaking new ground, taking risks, searching for answers to questions you can't answer – all that stuff would no longer

be assumed to be part of a serious artistic profile. No more Angst, just Money.

RM: I very much appreciate Rainer Ganahl's description of his experience as an artist. It illustrates a type of artistic activity and career of which we also have examples in Europe.

I agree completely with Lane Relyea's observations: art schools and artist-in-residency programmes play an ever more important role in the launching of artistic careers. I think also that the role of art institutions has increased during the last thirty years.

My hypothesis is that the construction of the value of artworks and of artists' reputations takes place where the artistic field is articulated with the market. The artistic field is the site of the making and revision of aesthetic evaluation and social recognition. The market is the scene of business transactions and the elaboration of prices. While each has its own system of determining value, these two networks are closely interdependent.

The gauging of artistic value is carried out in the cultural network, by specialists: museum curators, exhibition curators, historians of contemporary art, critics, professors, experts of all sorts. In the marketplace, the principal actors are the leading galleries, limited in number, which help to mark out the pathways in the artistic field. In the course of the 1980s, a second category of economic actors, the megacollectors, contributed to the elaboration of the social and economic hierarchy of artists and artworks. During the recent globalization of the market, the great auction houses have developed a sector dealing in contemporary art. They have acquired a market power that has strengthened their influence in the constitution of the financial value of works. The interactions between economic and cultural actors are even more evident because today more than before the international contemporary art world is characterized by the interchangeability and versatility of roles. Every actor is in fact required to act at the intersection of two universes – the artistic and the economic. Let us take the example of the megacollector, of which Charles Saatchi, London advertising man, is a striking European figure. This type of collector

plays, alternately, all the roles: dealer (he buys and resells), exhibition curator, institutional administrator, and patron (gifts, foundations, private museums). Spaces, too, play multiple roles. The most important of the contemporary art fairs, that of Basel, is, in the words of its director and its principal sponsor, at once a 'temporary art marketplace' and a 'limited-time museum'. This interchangeability, in the roles of both actors and spaces, contributes to the dynamism of the artistic scene, at the price of a certain fogging of signals.

One last, related remark: new technologies and new methods of production of artworks (an economy of intermediation is being replaced by an economy of production) together with artistic interdisciplinarity are calling into question the received definition of art. It is henceforth the signature of the artist which defines an action or an object as artistic and which gives it its character as irreplaceable. The artist is the producer of the social definition of the good he creates: art is what he makes, whether he is called Beuys or Warhol. It is the artist himself who enters into the circuit of supply and demand. In order to safeguard the rarity and the price of art, the international organizational system of artistic life filters out a small number of chosen ones, whose names it valorizes and whose reputations it constructs.

KS: Raymonde, you raise the question here of how the changes in the art economy affect the nature of the art that is being produced. What is the connection between these changes and 'new methods of production of artworks'? What do you mean in speaking of an 'economy of intermediation' being replaced by an 'economy of production', and how does this change the definition of art?

RM: The dealer functions as an *intermediary* when he or she buys a work from an artist, takes care of promoting it, and sells it. The gallery intervenes in this way after the act of creation, playing the role of intermediary between artists, art-lovers and collectors. New forms of artistic supply (installations, video installations, video performances, very large-scale photographs or paintings) necessitate a schema of *production* new to the plastic arts, though familiar in the culture industries, particularly in show business. This new production schema implies that a producer, public or private,

or a group of producers, make available to an artist the financial means required to realize a project. An often-cited example is that of the financial package (around a million dollars) that had to be assembled to produce Mariko Mori's project at the Venice Biennale in 1999. The producer (institution or dealer) thus intervenes not only in the choice of artists but also in the choice of projects. Power over financing is a determining factor in the rise to a dominant position of producers in the international market. The new technologies employed by artists change the way in which art enters the economy. This is what I meant by saying that we are witnessing a slide towards an economy of 'production' (as opposed to intermediation).

New forms of artistic supply necessitate a schema of *production* new to the plastic arts, though familiar in the culture industries, particularly in show business.

PM: There has been some discussion here of two central areas of artistic activity, one oriented more directly to the market, via galleries and auction houses, one subsidized by institutions such as museums, biennials, foundations. There are also regional markets, and markets defined by particular publics. Think, for example, of the success of an artist like Thomas Kinkade, who has made a fortune selling reproductions of his neo-Victorian paintings. How are these related to the socially dominant art world? What does the world of art look like, from an economic and aesthetic perspective, when we look at it as a whole?

RM: There are a number of markets for contemporary art, local and regional markets as well as the international art market. The dispersion of sites for creation, display and, eventually, sale does not, however, exclude a high level of concentration of the world market. We can see that the cultural and economic actors in charge of discovering, selecting, producing and evaluating works of art derive their authority from their recognition by the international mainstream. The cosmopolitanism of exhibition curators and

their insertion into Western 'informal academies' remain the most important givens. The existing networks (institutions, galleries, foundations, etc.) perpetuate the hegemony of the central core and continue to control the construction of values and reputations. The fact of working and living in New York constitutes a condition favourable to success on the highest level, especially for artists from peripheral countries.

RG: To this elaborate explanation of the versatile roles of cultural and economic actors I would like to add the importance of art magazines and art publishing. I see them as very influential in constructing artistic, social and cultural capital for artists, galleries, museums, curators, collectors, critics, biennials, exhibition circuits, foundations, and so on. With published journalism and/or criticism worthy or not worthy of its name and history we touch upon another important factor in selling art work that even more complicates the idea of a 'market' and its PR-driven forces – the critical and explanatory context of art works.

On the question of whether artists adapt to the market or react against it, I always observe that the main cluster of interest and power shifts constantly. Whenever there is a paradigm that sells – sex or the abject, conceptualism or pseudo-conceptualism, cynicism or the pathetic, 3D-fun or 3D-stupidity as a category, installation art or video, art from the UK or art from China – most of the interdependent actors, players and its institutions gravitate somehow towards and with it and absorb whatever there is. From art magazines to art schools, from galleries to auctions, new trends are difficult to ignore. What is called 'the market' is a very complex and multi-layered system of personal and institutional, critical, cultural and economic factors – often not even limited to the art world. Retrospectives of art and other cultural phenomena give us a clue about former market and taste formations. How is it possible not to be influenced?

The influence of market forces and taste formations can take all kinds of forms, ranging from direct emulation or naive copying to unconscious or conscious participation and critical reflecting, including 'stubborn' ignorance and great or futile counter-gestures. Often, as an artist, one finds oneself in a shift that is shared and followed by others

without any direct communication. Are artists fully aware of dominant influences? Are other players conscious about every change? I doubt it. Questions and concerns that move artists are often in the air, in the media, in politics, in the streets. Let me give a small example: in 2001, when I started an eight-month project using my own dreams, I realized that the project was in fact not just about my dreams nor the old and new European currencies (the initial inspiration had been the former 50 Austrian Schilling bill which bears a portrait of Sigmund Freud) but also about my personal and psychological history, paranoia, love, politics, terrorism and the private at a time when it is becoming more difficult to uphold such a notion. Interestingly enough, I see other artists whose work has previously rarely paid

Questions and concerns that move artists are often in the air, in the media, in politics, in the streets.

any attention to their own conditions now addressing personal and intimate issues. This could constitute a trend that might or might not be turned into sales for this or that artist. What was also interesting was the reaction of my dealer who showed this work in NYC. When he saw the finished installation, he yelled at me: 'This is not a *Kunsthalle*, this is a commercial gallery, with this hanging I will never be able to sell anything!' He wanted me to rehang. I didn't, not because I didn't want to sell or because I wanted to make an anti-market statement; I simply wanted to show the entire project in the most practical way, while he wanted to increase the apparent importance of some singled-out works.

RS: There is a lot of art-historical literature being produced concerning the art market and the art economy in the past, not only the late twentieth-century past but the early twentieth century, the nineteenth century, and even the eighteenth century. Most of this literature makes the market forces and the market manipulations of the past, as well as artists' responses, seem very familiar to today's observer. There were megacollectors in 1905 and in 1860. There were attempts to create trends, fads and fashions in 1950 and in

1840. There were major efforts to link artistic value to artistic authorship in 1880 and in 1780. And so on. At least this is the kind of thing the scholars tell us.

But I wonder, do their studies reflect the reality of past conditions or the reality of current conditions projected back onto the past, because we understand only we what know from our own experience? Or are they even a fantasy view of an economic situation that no one seems to understand any better than they understand the stock exchange? One thing is evident: the art market has become a force that most segments of the art world are very self-conscious about. It often becomes the subject matter of art. Is the real issue here the art market itself? Or is it some social value that the market (and one's position in it) has obliquely come to represent? When I think of the difference between the market for Thomas Kinkade and the market for Andreas Gursky (both work with a technological system that generates multiples, controlled editions, etc.), I have to come back to complicated issues of class, education, prestige, social hierarchy, etc.

PM: Richard raises an extremely interesting question. Why are we so interested in the market now? Has the art market come to represent obliquely some social value, which then appears in artists' and art historians' interest in its workings? I would like to propose a (very tentative) answer.

It seems to me that there has been a general decline in the social value of 'culture' over the last thirty years. As part of this, the idea of fine art as something separate from 'everyday' or 'ordinary life' – and not just separate but better, finer, higher – has been unravelling. I see two processes at work in this transformation, one long-term and the other more recent. The movement of economic, political, and therefore cultural power to the United States during and after the Second World War had large, general consequences inside and outside the US. It's not just that 'New York stole modern art', but that the meaning of art itself changed. For the American art-loving elite, art was always associated with Europe and so with the aristocratic past. With the centre of art-making relocated to the United States, art has become associated with a fully modern, purely bourgeois state.

The idea that art represents not a link to the superior, non-commercial culture of the past but is the expression of the business spirit of modernity appeared in particular in the often-noted use of culture for Cold War purposes, from the exhibition of Abstract Expressionism and Louis Armstrong concerts to the CIA sponsorship of Adorno's Frankfurt Institute after the war.

More recently, the end of the Cold War and the apparent triumph of the so-called West have reinforced the association of art with business culture, to which there now seems no alternative. This is related to a general alteration in ideology: the decline of the idea of the welfare state and of government responsibility for culture, and the promulgation of the myth

Over the last thirty years the idea of fine art as something separate from 'everyday' or 'ordinary life' – and not just separate but better, finer, higher – has been unravelling.

of pure market forces. Art, once part of the state-sponsored and regulated Great Society, must take its place in the new privatized system, in which the state more frankly serves only the needs of giant corporations.

Art accordingly is less of a separate sphere than before. Hence its drift towards the dominant cultural form, industrialized entertainment. This is to be seen, for instance, in the movement Raymonde Moulin describes as a shift towards 'production' in the show-business sense, away from the model of the individual in his studio…. And hence the willingness on all sides (those who would critique art as well as those who promote it) to recognize (or even celebrate) the place of the market in art. After all, the market is no longer something to be ashamed of; for the dominant producers of ideology, it is the most powerful and also the most benign of social forces…

RG: Bringing together art and money is almost as non-authenticating as love and money or truth and power, and

yet they are in many ways intrinsically connected. The sociologist Niklas Luhmann has developed a system theory that sees not just power, truth and love but also money and art as symbolically generalized communication media. From this theoretical perspective, money is nothing but a medium. If money touches art it communicates value and power, truth and love, beauty and a location that is close to a centre or becomes one. The comments made earlier about the logic of locations and success perfectly confirm the way the topography of money and power, interest and influence communicate. Even at an organizational level this logic can be applied: Kassel becomes the centre of art-related things only as long as a lot of money guarantees for a big event, a big temporary art infrastructure. The question here remains how we might break out of such a totalizing logic. How can we communicate different things on different channels with different means, in different media, with and for different players? The line is very thin between hopeless dreaming and dreamless hopelessness confronted with the reality of a status quo that appears to have changed only its terms of reference over the last two hundred years.

But actual transformations are nonetheless remarkable and important. Concerning the dialectic between periphery and centre, one has to also add that geographic, ethnic or cultural outsiders are now welcome. New York, London, Paris, Cologne/Berlin and Basel are open for international business. Even artists from places without a local market – Albania, China, Cuba, Iran, Baltic countries, etc. – can be very quickly integrated and absorbed by central social actors and institutions, once someone is added to the name-drop list of important curators, magazines, biennials, museums, galleries and collectors – almost in that order. Features that once disqualified an artist turn into aids to promotion and marketing. This opening of the formerly closed centres reflects definitely – as Paul points out – the demise of programming according to national identities and interests, but is replacing it now with commercial ones, accompanying the fake doctrine of the free market. In this regard, the European support system still makes more differences and insists, for example, on some residency before it gives money to its immigrant or migrant artists. I would also like to observe that there is no longer a medium that is underprivileged.

Until not too long ago, video and conceptual artists and those using photography and installations complained that their works couldn't be collected and didn't attract any serious market value. But this situation also has dramatically changed. Just like with artists from the cultural periphery, once a set of (market) criteria concerning fame and public visibility were fulfilled, videos, installations and photography have attracted massive interest, and some of their prices exploded like those of internet stocks.

Geographic, ethnic or cultural outsiders are now welcome. New York, London, Paris, Cologne/Berlin and Basel are open for international business.

In short, cultural actors and promoters with ever expanding practices and infrastructures for ever larger and more diverse audiences and media have made the art world dramatically more diverse and international. The entire cultural industry is undergoing a process of globalization and 'consolidation', which is behind the massive explosion of museums, cultural theme parks and biennial spectacles. For any urban planner or politician the art economy turns into an important factor.

For me as an artist in this complicated and irritating field, it has become even more exciting and challenging to define a position and a practice that is worth working and living for. The question is not how to become successful, since we all know by now that success soon equals ruin and artistic bankruptcy. The question is what art work still makes sense and what notion of success I can permit for myself that differs from the strangling ones presented to us.

LR: If artists today are enjoying the benefits of a more capacious art market, making more money and playing it safe, it also could be the case that they are left a bit more isolated and vulnerable too, as patronage grows more impersonal, corporate and multinational. Lawrence Alloway, who was keenly perceptive of the emerging institutional art system, remarked about this as early as 1964: 'Once

discovery used to carry with it certain assurances and safeguards for the artist and his public; now discovery is a form of classification with no reduction of the risks and solitude artists work in.'

Rainer brings up a very important point about the collapse between centre and periphery in terms of both art media and the nationalities of art world actors. One major source attributing value to modern art has been critical discourse, and throughout modernism that discourse has often cohered around some concept of history. As with history writing in general, art history and criticism have often narrated the story of nationalities, casting such actors as 'the School of Paris', 'the New York School' or 'the American Action Painters'. And just as often these historical narratives have linked geographic identity to medium, namely painting, and have slid back and forth between the two, at times favouring medium to the point of constructing its tradition as (somewhat) transnational, at other times focusing on geographic location to the point of naming borders in terms of specific streets ('It's below 34th Street that the fate of American art is being decided,' once wrote Clement Greenberg). But now both sides in this mutually reinforcing equation have lost stature. Commonalities of medium, identity, stage and purpose have been dispersed, and the resulting atomized milling around of unanchored free agents is more conducive to the market than to critical dialogue. Today we have shows like Thelma Golden's 'Freestyle', a 'post-identity' exhibition devoted to African-American art, as well as 'post-medium' exhibitions devoted to painting. Art is now made by a cavalcade of celebrities who just happen to be black or Maoist or use photography or paint. Medium-based histories are replaced by no history, the notion of the medium replaced by digitization's pure non-medium. And in the meantime a sense of static system grows more dominant in representations of art and the art world and the world in general.

Critical discourse has taken a beating as a result: it has no story to tell, no consistent criteria to apply, no logic to thread together its succession of ideas. And on the pragmatic level, critics play no role in the situation Raymonde describes, the sponsoring of institutionally based art production. Critics are intermediaries, not underwriters or producers of art. Curators have taken over the role of critics; curators discover and promote art by having their employer-institution subsidize its creation. Unlike critics, curators have institutions bankrolling their travel, and so curators are the only ones who can now keep up with the itineraries of the most interesting artworks as they travel the globe. They now do what critics once were thought to do, which is to produce synoptic, informed judgments through a comparison of the period's most important art. This is why *Artforum* has become a curators' magazine. Criticism exerts ever less influence over the attribution of value to art. But here's the irony. Of course no one is going to write 'Tradition and the Individual Talent' today, and not only because the idea of tradition is so difficult to make relevant. The idea of medium is also too problematic – and it's for a medium, is it not, that the individual shows a talent in the first place. Today's individual artist is talented at – what? You could sound cynical and say: the system, the art game, institutionality, bureaucracy. But is it that different from saying that today's artist is trained in and needs to show talent for discourse itself? For proof, look at the ubiquity of the group crit and of artist-talks in art schools. It is now standard practice in MFA programmes for students to produce a written thesis in order to graduate. And this only contributes to integrating art schools more fully into the circuitry of the art world.

Curators have taken over the role of critics; curators discover and promote art by having their employer-institution subsidize its creation.

RG: Lane highlights very accurately that today's art is made by a 'cavalcade of celebrities' bound neither by specific media nor by any history. But is there really no specific medium involved? I'd say that artists are very much dependent on one mega-medium that also explains why history becomes an anathema or is reduced to a supply box for strategic citations and comparisons. This mega-medium for today's artists and curators consists of the media per se,

which not just fabricates but also depends on a celebrity industry. It also elucidates why curators, artists as 'big names' and exhibition ventures as such – and not the art itself – make up the 'show', the medium and the message. For every new, spectacle-oriented format, artists are expected to be placed and staged as actors, tourists, entertainers, curators, shrinks, architects, geniuses, CEOs, social engineers, storytellers, inventors, designers, fools, decorators, DJs, cooks, bar men, criminals, philosophers, terrorists, politicians, fashion models, librarians, porn stars, babysitters, radio show hosts, investors, dishwashers, scientists, and even painters and sculptors. This list could be endless and illustrates that art tries to cater to the needs and agendas of profitable mass audiences, interested in some form of amazement.

Artists are actually not isolated any more, if they can live up to the demands of our rapidly changing attention industries. If an artist manages to work the media and its related forces to manipulate it in his/her favour as he/she used to work art materials, his/her market will become exuberant. Just recently, Maurizio Cattelan reiterated apologetically several times to a group of fans at an opening in New York: 'I just play the system, I just play the system well.' He certainly does. Mainstream media and their conversion power capitalize on him very well as they do with others once they pass the crucial line of celebrity status. For celeb-artists, the money-making and name-promoting activities increase in a dramatically expanding theatre of new opportunities with the rich and famous of the world. Whether it is a gravestone of a CEO, the display of fashion or the aestheticization of politics, today's market forces are endlessly wide and reach beyond the simple logic of selling art and making money.

KS: Rainer's comments on the positive and negative effects of globalization are apposite. As much as certain critics (including, sometimes, myself) may be happy to go and see oil paintings made by five middle-aged masters living in New York, the opening of the art world in terms of nationality and medium is unquestionably a positive process.

Still, he points out an irony that consistently arises when I think about contemporary art or go to exhibitions. He has

recently returned from Kassel, Germany, where he saw Documenta, the largest of the periodic international art exhibitions in the West. The event is one, as he describes it, of consecration – a confluence of money, curatorial power and artistic fashion, at which art world people and corporate supporters converge to network. Yet the curator of this particular Documenta and the art he chose (as in the previous Documenta) insist on the radical political nature of the exhibition. How is this possible? And, more to the point,

Curators, artists as 'big names' and exhibition ventures as such – and not the art itself – make up the 'show', the medium and the message.

as I often ask my students: in a time when, more than ever, we acknowledge the close relationship between art and money, and the nature of the market, why do we expect the best or most avant-garde art to resist that market? 'We' doesn't only mean intellectuals and artists. In a strange way, what the market itself wants, and buys, is art that appears critical of capitalism. Why?

RG: In response to Katy's question, I want to comment on a piece in Documenta 11 that complicates the issue. The speed and power of mediatized spectacle and market forces in general can also reify discursive enclaves and critical practices. Thomas Hirschhorn attempted to set up a sort of critical public sphere in a rundown suburb of Kassel, away from the main activities of Documenta. In his trademark junk style, he produced a kind of Youth Cultural Centre for underprivileged immigrant kids, including electronic entertainment and video studios. The generous funding for this project was seemingly used for a convincing purpose – but only if we ignore some disturbing facts. The tremendous appeal of Documenta shuttled many people daily to visit this pre-programmed social experiment, turning this zone for the poor and wretched into a zoo. Also, I ask myself why the artist insisted on his particular aesthetic. After their first social life in the hands of the consuming classes, cardboard, shopping bags and tapes are often

used/recycled by the have-nots, by the homeless, by travellers without destiny and migrants without countries to go to. This gave Hirschhorn's use of these materials a strategic and convincing rationale. But with his overwhelming success and his seller's market, these pauper materials, this flirtation with the abject and the direct display of critical knowledge has — at least for me — started to contradict itself. His experiment in Kassel will last as long as the duration of the exhibition. For four months, the lives of these people will probably be consumed by the uncomfortable attention of international art tourists, a gaze that usually oscillates between urban Orientalism and social compassion. There might also remain in the youngsters who were entertained a frustrating taste for the gadgets, usually beyond their reach, of better-off kids, and for the benevolent infrastructure that more or less will disappear when the show comes down. Who really will profit from this? Who will be entertained or even learn something? The media and the public so far have embraced it for its critical looks and easy-going attitudes. But for me, Hirschhorn's success at Documenta represents a failure and exemplifies Katy's statement that the 'market wants and buys art that appears critical of capitalism.' I'd put an emphasis on 'appears'.

In a time when, more than ever, we acknowledge the close relationship between art and money, and the nature of the market, why do we expect the best or most avant-garde art to resist that market?

The problem isn't that Thomas Hirschhorn is selling in blue-chip galleries in London and New York. The problem is that he seems to ignore the painful fact that with these shifts in his market position the meaning of his (material) discourse changes too. To my mind, it becomes fake, 'corporate', and, as at Kassel, it probably borders on social exploitation. It almost is reminiscent of politicians who want to be photographed in minority contexts in order to score better votes. Criticality and social engagement can under these new conditions become anecdotal, promotional, strategic and/or naive.

Prevailing models of success (like Hirschhorn's) are contagious and hyper-attractive since they come with social and practical consequences. Doing painting or conceptual art when people want painting or conceptual art is socially, practically, and economically rewarding. Criticizing somebody with a high approval rating can be socially counter-productive for the criticizer. Here too, the market rules forcefully. (And are not more people currently under threat because of their economic situation than because of terror and counter-terror associated with belief systems that, like religion, are highly political?) Market forces and their models of success — and I adhere to expanded notions of the market — are very powerful and attractive and difficult to withstand or to counter. In fact, they confront us with the very notion of politics. The field of art is a last wonderful (and endangered) domain where aesthetic, social, and intellectual practices compete without direct coercion and violence. Having this enclave be completely taken over by corporate power or by state politics will not just turn art into blockbuster entertainment or push it into the abyss, it will reduce us to remote-controlled freaks. If we want a society that is relatively open, we need to retain competing ideas and competing aesthetics that are not coerced by a single market model.

THE ARTISTS

THE ART GUYS
Jack Massing, b. 1960, Buffalo, New York (USA);
Mike Galbreth, b. 1956, Philadelphia,
Pennsylvania (USA)

Select exhibitions
'The Art Guys: Goods and Services' (solo exh.),
Blue Star Art Space, San Antonio, Texas, 1996
'Kit and Caboodle' (solo exh.), Scottsdale
Museum of Contemporary Art (SMoCA),
Scottsdale, Arizona, 1999
'The Art Guys Again and Again' (solo exh.),
Tacoma Art Museum, Tacoma, Washington, 1999
'SUITS: The Clothes Make The Man' (solo exh.),
The Museum of Fine Arts, Houston, Texas, 2001
'What's The Big Idea?' (solo exh.), Cornell DeWitt
Gallery, New York, 2003

Select publications
Hickey, Dave et al., *The Art Guys: Think Twice*,
Contemporary Arts Museum (exh. cat.), Houston,
1995
Verhovek, Sam Howe, 'In Performance: Life
Imitates Art Imitating Life', *New York Times*,
9 Aug 1995
Kamps, Toby, 'A Close Look at The Art Guys',
Art News, Jan 1998
Hickey, Dave and Haila Dewan, *SUITS: The
Clothes Make The Man* (exh. cat.), New York,
2000
Greenwood, Cynthia, 'The Art Guys Go Civic',
Houston Chronicle, 18 Jan 2004

BORIS BECKER
b. 1961, Cologne (Germany)

Select exhibitions
Galerie Ulrich Fiedler (solo exh.), Cologne, 1995
Kunstmuseum (solo exh.), Bonn, 1998
Galerie Conrads (solo exh.), Düsseldorf, 1999
Städtische Galerie Wolfsburg (solo exh.), 2001
'Fakes' (solo exh.), Kunstverein Bochum, 2002

Select publications
Hochbunker, Cologne, 1989
Düsseldorf in frühen Photographien 1855–1914,
Munich, 1990
Wohnhäuser, Cologne, 1993
Salzau im Mai 1993, Cologne, 1994
Konstruktionen, Berlin and Cologne, 1995

BARTON LIDICE BENES
b. 1942, Westwood, New Jersey (USA)

Select exhibitions
'Moneyworks' (solo exh.), Barbara Fendrick
Gallery, New York, 1988
'Money Madness' (solo exh.), North Dakota
Museum of Art, Grand Forks, 1994
'Lethal Weapons' (solo exh.), University of New
Mexico Art Museum, Albuquerque, 1997
'Reliquaries' (solo exh.), Borås Konstmuseum,
Borås, Sweden, 2000–1
'Barton Lidice Benes: Curiosa' (solo exh.),
Lennon, Weinberg Inc., New York, 2002

Select publications
Brody, Jacqueline, 'On and Off the Wall: Barton
Benes' (interview), *The Print Collector's
Newsletter* 9: 6, 1979
Haglund, Elisabet, *Barton Lidice Benes
Reliquaries*, Borås Konstmuseum (exh. cat.),
Borås, 1999
Cox, Meg, 'Barton Benes Shows It Does Take
Money to Make Money', *The Wall Street Journal*,
6 Aug 1984
Benes, Barton Lidice, *Curiosa*, intr. John Berendt,
New York, 2002
Barton Lidice Benes: Souvenirs, Stefan
Andersson Gallery (exh. cat.), Umeå, Sweden,
2003

JOSEPH BEUYS
b. 1921, Krefeld (Germany); d. 1986, Düsseldorf
(Germany)

Select exhibitions
'Coyote' (solo exh.), René Block Gallery, New
York, 1974
Retrospective (solo exh.), Guggenheim Museum,
New York, 1980
'Das Kapital Raum 1970–71', Biennale, Venice,
1980
'7,000 Oaks', Documenta 7, Kassel, 1982
'Palazzo Regale' (solo exh.), Naples, 1985

Select publications
Kuomi, Carin, *Joseph Beuys in America: Energy
Plan for the Western Man*, New York, 1993
Cooke, Lynn and Karen Kelly (eds.), *Joseph
Beuys: Arena Where I Would Have Got If I Had
Been Intelligent*, New York, 1994
Thistlewood, David (ed.), *Joseph Beuys:
Diverging Critiques*, Liverpool, 1995
Borer, Alain, *The Essential Joseph Beuys*,
Cambridge, 1997
Ray, Gene (ed.), *Joseph Beuys: Mapping the
Legacy*, New York, 2002

J.S.G. BOGGS
b. 1955, New Jersey (USA)

Select exhibitions
'smart money (HARD CURRENCY)' (solo exh.),
Tampa Museum of Art, Tampa, Florida, 1990
'Boggs Bills' (solo exh.), The Horn Gallery at
Babson College, Babson Park, Massachusetts,
1999
'Drei Millionen Euro' (solo exh.), KunstBunker,
Nürnberg, 2001
'Art & Money' (solo exh.), Gallery 0 Zwei, Berlin,
2001
'Digitalis' (solo exh.), A.J. Japour Gallery, Miami
Beach, Florida, 2003

Select publications
Chambers, Bruce W., *Old Money: American
Trompe L'Oeil Images of Currency* (exh. cat.),
Berry-Hill Gallery, New York, 1988
*J.S.G. Boggs, smart money (HARD
CURRENCY)* (exh. cat.), Tampa Museum of Art,
Tampa, Florida, 1990
Carey, Preston K., 'Ethics, Art, & Money in the
Work of J.S.G. Boggs', Center for the
Advancement of Applied Ethics, 3 Dec 1992
Bernhard, Brendan, 'Making Money: The
Conceptual Art of J.S.G. Boggs', *LA Weekly*,
6–12 Aug 1999
Wechsler, Lawrence, *Boggs – A Comedy of
Values*, Chicago, 1999

ANDREA BOWERS
b. 1965, Wilmington, Ohio (USA)

Select exhibitions
'Spectacular Appearances' (solo exh.), Santa
Monica Museum of Art, 1998
'Everybody Now' (group exh.), Leubsdorf Gallery,
Hunter College, New York, 2001
'Casino' (group exh.), SMAK, Ghent, Belgium,
2001
'Arena' (solo exh.), Sara Meltzer Gallery, New York,
2002
Whitney Biennial (group exh.), New York, 2004

Select publications
Kraus, Chris and Katy Siegel, *Andrea Bowers*,
New York, 2002
Siegel, Katy, 'First Take: Andrea Bowers', *Artforum*
39: 5, Jan 2001
Knode, Marilu, 'Andrea Bowers', *Retake*, Neuer
Aachener Kunstverein, 2002
Bowers, Andrea, 'Top Ten', *Artforum* 40: 8, April
2002
Wallis, Simon, 'Andrea Bowers', *Remix:
Contemporary Art and Pop*, Liverpool, 2002

ANDREW BUSH
b. 1957, St. Louis, Missouri (USA)

Select exhibitions
'Commodity Image' (group exh.), International Center of Photography Midtown, New York, 1993
'Recent Acquisitions' (group exh.), LA County Museum, Los Angeles, 1995
'A Thin Line' (group exh.), Bard College, Annandale-on-Hudson, New York, 1998
'Prop Portraits' (solo exh.), Julie Saul Gallery, New York, 1998
'Vector Portraits' (solo exh.), Angles Gallery, Los Angeles, California, 2002

Select publications
Bush, Andrew, *Bonnettstown: A House In Ireland*, New York, 1989
Blind Spot, Issue Seven, 1996
Schwendener, Martha, *Art in America*, Dec 1996
'Days of Getting, Spending and Photography, Too', *The New York Times*, 30 May 1993
'Recent Acquisitions – A Selection: 1993–1994', *The Metropolitan Museum of Art Bulletin*, Fall 1994

MAURIZIO CATTELAN
b. 1960, Padua (Italy)

Select exhibitions
'Projects 65: Maurizio Cattelan' (solo exh.), Museum of Modern Art, New York, 1998
'Blown Away, 6th Caribbean Biennial' (group exh.), Golden Lemon, St Kitt, British West Indies, 1999
Museum für Gegenwartkunst (solo exh.), Zurich, 2000
Museum Boijmans Van Beuningen (solo exh.), Rotterdam, 2001
Museum Ludwig (solo exh.), Cologne, 2003

Select publications
Cattelan, Maurizio and Jens Hoffmann, *6th Caribbean Biennial*, Dijon, 1999
Hoptman, Laura et al., *Maurizio Cattelan* (exh. cat.), Basel, 1999
Maurizio Cattelan, London, 2000

MICHAEL RAY CHARLES
b. 1967, Lafayette, Louisiana (USA)

Select exhibitions
'Michael Ray Charles' (solo exh.), Albright Knox Gallery, Buffalo, New York, 1997
'Michael Ray Charles' (solo exh.), Contemporary

Art Center, Cincinnati, Ohio, 1998
'Bamboozled' (solo exh.), Tony Shafrazi Gallery, New York, 2000
Galerie Enrico Navarra (solo exh.), Paris, 2001
'Standard 8' (solo exh.), Cotthem Gallery, Brussels, 2002

Select publications
Charles, Michael Ray, *Forever Free*, Tony Shafrazi Gallery, New York, 1998
Myers, B.E., 'Thug Life', *XXL* 3: 3, June 1999
Siegel, Katy, 'Consuming Art', *Art 21: Art in the Twenty-First Century*, New York, 2001
Thon, Ute, 'Wilkommen in Klischee', *Art: das Kunstmagazin*, Feb 2002
Heartney, Eleanor, 'Speaking for Themselves', *Art in America*, Feb 2002

CLAUDE CLOSKY
b. 1963, Paris (France)

Select exhibitions
'Weekend' (solo. exh.), The Deep Gallery, Tokyo, 1999
'2000 Calendar', internet site created for Walker Art Center, Minneapolis, 2000
'World News' (solo exh.), Galerie Jennifer Flay, Paris, 2002
'Television' (solo exh.), Location 1, New York, 2003
Galerie Chouakri-Brahms (solo exh.), Berlin, 2004

Select publications
Cuvelier, Pascaline, *Claude Closky – Le Parvis, janvier/février 1996*, Le Parvis, Paris 1996
Zahm, Olivier, *Claude Closky – Magazines*, Purple Books, Paris, 1998
Paul, Fréderic, *Claude Closky*, Hazan, Paris, 1999
Closky, Claude, *Tableaux comparatives*, Point d'Ironie, Paris, 2003
Closky, Claude, *Les Euros*, M19, Paris, 2003

MINERVA CUEVAS
b. 1975, Mexico City (Mexico)

Select exhibitions
'Mejor Vida Corp.' (solo exh.), Museum Rufino Tamayo, Mexico City, 2000
'MVC_Biotec' (solo exh.), Secession, Vienna, Austria, 200
'Exchange Rates of Bodies and Values' (group exh.), Kunst Werke, Berlin, Germany/P.S.1, New York, 2002.
'Hardcore' (group exh.), Palais de Tokyo, Paris, France, 2003

'Poetic Justice', XX Istanbul Biennial (group exh.), Istanbul, Turkey, 2003

Select publications
Picture of You (exh. cat.), Americas Society, New York, 2002.
Exchange and Transform (exh. cat.), Munich, 2002
Exchange Rates of Bodies and Values (exh. cat.), Berlin, 2003
Hardcore (exh. cat.), Palais de Tokyo, Paris, 2003
XX Istanbul Biennial (exh. cat.), 2003

JEREMY DELLER
b. 1966, London (UK)

Select exhibitions
'Unconvention', (group exh.), Centre for Visual Arts, Cardiff, 2000
'Protest and Survive', (group exh.), Whitechapel Gallery London, 2000
'Battle of Orgreave' (solo event), Orgreave, South Yorkshire; co-production Artangel, 2001
'New Works: 03.3', Art Pace, San Antonio, Texas, 2003
'The Literacy Project' (solo exh.), Gavin Brown's Enterprise, New York, 2004

Select publications
Cream: Contemporary Art in Culture 1, London, 1998
Farquharson, Alex, 'Jeremy Deller, The Battle of Orgreave', *Frieze* 61, Sept 2001
Bush, Kate, 'Jeremy Deller, The Battle of Orgreave', *Artforum* vol. 40, no. 4, Dec 2001
Erickson, Karl, 'Jeremy Deller', *Flash Art* 223, March–April 2002

FISCHLI & WEISS
Peter Fischli, b. 1952, Zurich (Switzerland); David Weiss, b. 1946, Zurich (Switzerland)

Select exhibitions
Venice Biennale (solo exh.), Swiss Pavilion, Venice, 1995
'In a Restless World' (travelling solo exh.), Walker Art Center, Minneapolis, 1996
Musée d'Art Moderne de la Ville de Paris (solo exh.), Paris, 1999
Museum Boijmans Van Beuningen Rotterdam (solo exh.), 2003

Select publications
'Collaboration Peter Fischli/David Weiss', *Parkett* 17, 1988

Armstrong, Elizabeth, Arthur Danto and Boris Groys, *Peter Fischli and David Weiss: In a Restless World* (exh. cat.), Minneapolis,1996
Fischli and Weiss, *Garten*, Oktagon, 1998
Bossé, Laurence and Boris Groys, *Peter Fischli and David Weiss* (exh. cat.), Cologne and Paris, 1998
Fischli and Weiss, *Will Happiness Find Me?*, Cologne, 2003

TOM FRIEDMAN
b. 1965, St. Louis, Missouri (USA)

Select exhibitions
Feature Inc. (solo exh.), New York, 2000
'The Greenhouse Effect' (solo exh.), Serpentine Gallery, London, 2000
'Tom Friedman' (travelling solo exh.), Museum of Contemporary Art, Chicago, Illinois, 2000–1
Fabric Workshop and Museum (solo exh.), Philadelphia, 2001
Fondazione Prada (solo exh.), Milan 2002

Select publications
Waste Management (exh. cat.), Arts Gallery of Ontario, Toronto, 1999
Corrin, Lisa and Ralph Corrin, *The Greenhouse Effect*, Serpentine Gallery, London, 2000
Platt, Ron, *Tom Friedman* (exh. cat.), Southeastern Center for Contemporary Art, Winston-Salem, North Carolina, 2000
Hainley, Bruce at al., *Tom Friedman*, London, 2001
Tom Friedman (exh. cat.), Fondazione Prada, Milan 2002

KATHARINA FRITSCH
b. 1956, Essen (Germany)

Select exhibitions
San Francisco Museum of Modern Art (solo exh.), San Francisco, 1996
'Multiples' (solo exh.), Kunstforum Bâloise, Basel 2000
Tate Modern (solo exh.), London, 2001
Museum of Contemporary Art (solo exh.), Chicago, 2001
Kunstsammlung im Standehaus (solo exh.), Düsseldorf, 2002

Select publications
Heyden, Julian, *Katharina Fritsch 1979–1989* (exh. cat.), Frankfurt, 1981
Katharina Fritsch: Museum (exh. cat.), Venice/Düsseldorf, 1995

Katharina Fritsch (exh. cat.), Basel/San Francisco, 1996
Pfleger, Susanne, *Katharina Fritsch* (exh. cat.), Wolfsburg, 1999
Blazwick, Iwona, *Katharina Fritsch* (exh. cat.), London, 2002

BERNARD FRIZE
b. 1954, Saint Mande (France)

Select exhibitions
'aplat: Bernard Frize' (solo exh.), Musée d'Art Moderne de la Ville de Paris, Paris, 2003
'Bernard Frize' (solo exh.), Stedelijk Museum voor Actuele Kunst, Ghent, 2002
'Size Matters' (solo exh.), Carré d'Art Musée d'Art Contemporain de Nîmes, Nîmes, 1999
'Bernard Frize' (solo exh.), Musée de Rochechouart, Rochechouart, 1991
'Bernard Frize' (solo exh.), Maison de la Culture et de la Communication, St. Etienne, 1986

Select publications
aplat: Bernard Frize (exh. cat.), Paris, 2003
Hands On (exh. cat.), Birmingham, UK, 2003
Bernard Frize (exh. cat.) Ghent, 2002
Bernard Frize: Size Matters (exh. cat.), Nîmes, 1999
Michel Gauthier, Bernard Frize (exh. cat.), Issoire, 1997

RAINER GANAHL
b. 1961, Budenz (Austria)

Select exhibitions
'Educational Complex' (group exh.), Generali Foundation, Vienna, 1996
'Offene Handlungsräume' (group exh.), Austrian Pavilion, 48th Venice Biennale, Venice, 1999
'Reading Karl Marx' (solo exh.), Baumgartner Gallery, New York, 2001
'Money and Dreams' (solo exh.), Baumgartner Gallery, New York, 2002
'Gesellschaft für aktuell Kunst' (solo exh.), Bremen, 2003

Select publications
Ganahl, *Rainer, Imported – A Reading Seminar*, Semiotext(e), New York, 1998
Ganahl, Rainer, *Ortssprache – Local Language*, Kunsthaus Bregenz, Bregenz, 1998
Ganahl, Rainer, 'Discontent in Austria', *Camera Austria International* 72, 2000
Ganahl, Rainer, *Reading Karl Marx*, Bookworks, London, 2001

Manacorda, Francesco, 'Homeland Security – l'arte come strumento di riflessione politica', *Flash Art* (Italian Edition), Nov 2003

FELIX GONZALEZ-TORRES
b. 1957, Guaimaro (Cuba); d. 1996, New York (USA)

Select exhibitions
The Solomon R. Guggenheim Museum (solo exh.), New York, 1995
Sprengel Museum (solo exh.), Hanover, Germany; Kunstmuseum St. Gallen, St. Gallen, Switzerland; Museum Moderner Kunst, Vienna, 1997
'Felix Gonzalez-Torres' (solo exh.), Serpentine Gallery, London, 2000
'Felix Gonzalez-Torres' (solo exh.), Andrea Rosen Gallery, New York; simultaneous exhibition at Sadie Coles HQ, London, with global satellite billboards in Athens, Berlin, Bogota, Cambridge, Dublin, Kirkwall, London, Milan, New Delhi, New York, Rio de Janeiro, São Paulo, Tokyo, Warsaw, Zurich, 2002

Select publications
Bartman, William S., (ed.), *Felix Gonzalez-Torres*, New York, 1993
Watney, Simon, 'In Purgatory: The Work of Felix Gonzalez-Torres', *Parkett* 39, 1994
Elger, Dietmar (ed.), *Felix Gonzalez-Torres Catalogue Raisonné*, New York, 1997
Spector, Nancy, *Felix Gonzalez-Torres*, New York, 1999
Corrin, Lisa, *Felix Gonzalez-Torres*, London, 2000

PAUL GRAHAM
b. 1956, Stafford (UK)

Select exhibitions
'New Europe' (solo exh.), Fotomuseum, Winterthur, 1993
'Empty Heaven' (solo exh.), Kunstmuseum, Wolfburg, 1995
'Hypermetropia' (solo exh.), Tate Gallery, London, 1996
'Paintings' (solo exh.), Anthony Reynolds Gallery, London, 2000
'American Night' (solo exh.), P.S.1, New York, 2003

Select publications
Paul Graham, *Beyond Caring*, London, 1986
Paul Graham, *Troubled Land: The Social Landscape of Northern Ireland*, London, 1987

Wearing, Gillian, Andrew Wilson and Carol Squiers, *Paul Graham*, London, 1996
Paul Graham: End of An Age, Scalo, 1999
Mack, Michael (ed.), *Paul Graham: American Night*, Göttingen, 2003.

ANDREAS GURSKY
b. 1955, Leipzig (Germany)

Select exhibitions
'Andreas Gursky, Photographs from 1984 to the Present' (solo exh.), Kunsthalle, Düsseldorf, 1998
'Andreas Gursky: Photographs 1994–1998' (solo exh.), Kunstmuseum, Wolfsburg, 1998
'Andreas Gursky' (solo exh.), Matthew Marks Gallery, New York, 1999
'Andreas Gursky' (solo exh.), The Museum of Modern Art, New York, 2001
'Antipodes' (solo exh.), White Cube, London, 2003

Select publications
Andreas Gursky: Photographs 1984–1993 (exh. cat.), Hamburg, 1994
Andreas Gursky: Images (exh. cat.), Liverpool, 1995
Andreas Gursky: Fotografien, 1984–1998 (exh. cat.), Ostfildern, 1998
Andreas Gursky: Fotografien 1984 bis heute (exh. cat.), Düsseldorf, 1998
Galassi, Peter. *Andreas Gursky* (exh. cat.), New York, 2001

HANS HAACKE
b. 1936, Cologne (Germany)

Select exhibitions
'Hans Haacke' (solo exh.), Museum of Modern Art, Oxford, 1978
'Museum des geldes: Über die seltsame Natur des Geldes in Kunst, Wissenchaft unde Leben' (group exh.), Städtische Kunsthalle, Düsseldorf, 1978
'Hans Haacke' (solo exh.), Tate Gallery, London, 1984
'Hans Haacke: Nach allen Regeln der Kunst' (solo exh.), Kunsthalle Bern, 1985
Generali Foundation (solo exh.), Vienna, 2001

Select publications
Hans Haacke (exh. cat.), Oxford, 1978
Wallis, Brian (ed.), *Hans Haacke, Unfinished Business,* New York, 1986
Bourdieu, Pierre and Hans Haacke, *Free Exchange*, Stanford, 1995

Breitweiser, Sabine (ed.), *We Are Who We Are,* Vienna, 2002
Hans Haacke, London, 2004

CHRISTIAN JANKOWSKI
b. 1968, Göttingen (Germany)

Select exhibitions
'Mein erstes Buch' (solo exh.), Portikus, Frankfurt, 1998
'Christian Jankowski' (solo exh.), Mercer Union, Toronto, 2002
Carnegie-Museum (solo exh.), Project Room, Pittsburgh, PA, USA , 2003
Museum für Gegenwartskunst (solo exh.), Basel, 2003
Centro d'Arte Contemporanea (solo exh.), Rome, 2003

Select publications
Mein erstes Buch (exh. cat.), Portikus, Frankfurt am Main, 1998
La Biennale di Venezia (exh. cat.), Venice, 1999 pp. 290–93
Play (exh. cat.), De Appel Foundation, Amsterdam, 2001
Lehrauftrag (exh. cat.), Neuer Aachener Kunstverein, Klosterfelde, Berlin, 2002

LAURA KURGAN
b. 1961, Cape Town (South Africa)

Select exhibitions
'You Are Here: Museu' (installation), Museu d'Art Contemporani, Barcelona, 1995–96
'Close Up at a Distance' (installation), List Visual Arts Center, MIT, Cambridge, Mass., 1997
'Inadvertent Memory' (internet-based installation), www.visualmanifesta.com, 2000
'Global Clock No. 2' (installation), Swiss National Exposition, Biel/Berne, 2000
'New York, September 11, 2001. Four Days later...' (installation), ZKM, Karlsruhe, 2001

Select publications
Kurgan, Laura, 'You Are Here: Kuwait', *Documents* 1 : 2, pp. 53–57, 1992
You Are Here: Architecture and Information Flows (exh. cat.), Museu d'Art Contemporani, Barcelona, 1995
Kurgan, Laura, 'Close Up at a Distance', *The Art of Detection: Surveillance in Society* (exh. cat.), List Visual; Arts Center, MIT, Cambridge, Mass., 1997
Kurgan, Laura, 'Spot 083–264', in Robert Bruce

Silberman, *World Views: Maps and Art* (exh. cat.), Frederick R. Weisman Art Museum, Minneapolis, 1999
Kurgan, Laura, 'Residues: ICTY Courtroom No. 1', *Alphabet City*, New York, June 2000

SEAN LANDERS
b. 1962, Palmer, Massachusetts (USA)

Select exhibitions
'Young Americans: New American Art in the Saatchi Collection: Part I', Saatchi Gallery, London (group exh.), 1996
Postmasters Gallery (solo exh.), New York, 1990
Aperto 1993, in conjunction with the Venice Biennale, section curated by Nicholas Bourriaud, 1993
Stuart Regen Project (solo exh.), Los Angeles, 1994
Andrea Rosen Gallery (solo exh.), New York, 2004

Select publications
Landers, Sean, *[sic]*, New York, 1993
Avgikos, Jan, 'Sean Sucks...Not: Portrait of the Artist as a Young Artist', *Artforum* vol. 33, no. 2, April 1994
Landers, Sean, 'Genius Lessons', *Spin*, 1996
Decter, Joshua, 'Stupidity as Density: American Idiot Culture', *Flash Art*, Oct 1996
Dannat, Adrian, 'Appropriating Picasso "because I want to be as great as him"', *The Art Newspaper*, May 2003

DANIEL LEFCOURT
b. 1975, New York (USA)

Select exhibitions
'Greater New York' (group exh.), P.S.1, New York, 2000
'Everybody Now: The Crowd in Contemporary Art' (group exh.), Leubsdorf Art Gallery, Hunter College, New York, 2001
'The Low End Theory' (group exh.), Minnesota Center for Photography, Minneapolis, 2003
'Fresh Meat' (group exh.), CEPA Gallery, Buffalo, New York, 2003
'Animations' (group exh.), Kunst Werke Berlin, Berlin, 2003

Select publications
McQuaid, Cate, review, *The Boston Globe*, 9 Dec 1999
Siegel, Katy, *Everybody Now* (exh. cat.), Hunter College, New York, 2001

Glueck, Grace, review, *New York Times*, 30 Nov 2001
Animations (exh. cat.), Berlin, 2003

MARYSIA LEWANDOWSKA AND NEIL CUMMINGS
b. 1955, Szczecin (Poland), b. 1958, Aberdare (Wales)

Select exhibitions
'Pour les Curieux' (installation and performance), Musée d'Art et d'Histoire, Geneva, 1998
'Modern Chairs 1910–1970' (installation), Whitechapel Gallery, London, 2001
'Capital' (installation and performance), Tate Modern, London, 2001
'Welcome' (installation), Galleria Zderzak, Cracow, 2002
'Free Trade' (installation and performance), Manchester Art Gallery, Manchester, 2002–3

Select publications
Marysia Lewandowska and Neil Cummings, *Lost Property*, London, 1996
Neil Cummings and Marysia Lewandowska, *The Value of Things*, Basel, 2000
Give and Take (exh. cat.), London, 2001
Marysia Lewandowska and Neil Cummings (eds.), *Capital* (exh. cat.), London, 2001
Marysia Lewandowska and Neil Cummings (eds.), *Free Trade* (exh. cat.), Manchester, 2003

PAUL ETIENNE LINCOLN
b. 1959, London (UK)

Select exhibitions
'Ignisfatuus' (solo exh.), The Conservatory, Druid Hill Park, Baltimore, 1996
Munster Sculpture Biennial (group exh.), Westfalisches Landesmuseum, Munster, Germany, 1999
'The Enigma of Marie Taglioni' (solo exh.), Church of St Paulinus, Catterick, England, 1999
'The Metropolis of Metaphorical Intimations: New York New York, Die Berliner Zuckerbarin' (solo exh.), Hamburger Bahnhof, Berlin, 2003
'Paul Lincoln: Preludes' (solo exh.), Alexander and Bonin, New York, 2004

Select publications
Lincoln, Paul Etienne, *In tribute to Madame de Pompadour and the Court of Louis XVI*, London, 1984
Lincoln, Paul Etienne, *The World and Its Inhabitants*, London, 1992

Lincoln, Paul Etienne, *Equestrian Opulators at the House of Approximate Odds*, North Yorkshire, 2000
Siegel, Katy, 'City Lights: Paul Etienne Lincoln's New York – New York', *Artforum* vol. 39, no. 1, Sept 2000
Banz, Claidia (ed.), *The Metropolis of Metaphorical Intimations*, Berlin, 2003

MARK LOMBARDI
b. 1951, Manlius, New York (USA); d. 2000, New York (USA)

Select exhibitions
'Mark Lombardi: Crossing the Line, 1994–98' (solo exh.), Museum of Contemporary Art, Washington, DC, 1998
'Silent Partners' (travelling solo exh.), Pierogi, Brooklyn, New York, 1998–2000
'Vicious Circles: Drawings' (solo exh.), Deven Golden Fine Art, New York, 1999
'Mark Lombardi: In Memory' (solo exh.), Gallery Joe, Philadelphia
'Global Networks' (travelling solo exh.), Independent Curators International, 2003–5

Select publications
Frances, Richard, 'Art at the Edge of the Law', *Artforum* 40: 2, 2001
Frances, Richard, 'Conversations, Charted', *Cabinet Magazine* 2, 2001
Lombardi, Mark, 'The "Offshore" Phenomenon: Dirty Banking in a Brave New World', *Cabinet Magazine* 2, 2001
Tan, Lin, *Preparatory Drawings: 1994–2000* (exh. cat.), New York, 2003
Hobbs, Robert, *Mark Lombardi Global Networks* (exh. cat.), New York, 2003

LEE LOZANO
b. 1930, Newark, New Jersey (USA), d. 1999, Dallas, Texas (USA)

Select exhibitions
Bianchini Gallery (solo exh.), New York, 1966
Galerie Rolf Ricke (solo exh.), Cologne, 1969
The Whitney Museum of American Art (solo exh.), New York, 1970–71
'Lee Lozano/MATRIX 135' (solo exh.), Wadsworth Athenaeum, Hartford, Connecticut, 1998
'Lee Lozano, Drawn from Life: 1961–1971' (solo exh.), P.S.1, New York, 2004

Select publications
Lippard, Lucy, *Six Years: the Dematerialization of*

the Art Object from 1966 to 1972, New York, 1973
Rondeau, James, *Lee Lozano/ MATRIX 135* (exh. cat.), Hartford, 1998
Lawing, Eric, K.T. Mullins, and Gilbert F. Carpenter, 'Lee Lozano: the Sixties', (exh. brochure), Greensboro, 1988
'Making Waves: Katy Siegel Talks with David Reed about the Legacy of Lee Lozano', *Artforum* 40: 2, Oct 2001
Molesworth, Helen, 'Tune in, turn on, drop out: The rejection of Lee Lozano', *Art Journal* 61:4, Jan 2002

PIERO MANZONI
b. 1933, Soncino (Italy); d. 1963, Milan (Italy)

Select exhibitions
Galleria Pater (group exh.), Milan, 1957
Galleria Bergamo (group exh.), Milan, 1958
Galleria Pater (solo exh.), Milan 1958
'Il nuovo concetto artistico' (solo exh.), Galleria Azimut, Milan, 1961
'Piero Manzoni' (solo exh.), Serpentine Gallery, London, 1998

Select publications
Piero Manzoni (exh. cat.), Amsterdam, 1970
Piero Manzoni – Paintings, Reliefs, and Objects (exh. cat.), London, 1998
Battino, Freddy and Luca Palazzoli, *Piero Manzoni: Catalogue Raisonné*, Milan, 1991
Manzoni, Piero et al., *Piero Manzoni*, London, 1998
Spahn, Barbara, *Piero Manzoni (1933–1963). Seine Herausforderung der Grenze von Kunst und Leben*, Munich, 1999

FABIAN MARCACCIO
b. 1963, Rosario, Santa Fe (Argentina)

Select exhibitions
'Fabian Marcaccio–Jessica Stockholder' (two-person exh.), Sammlung Goetz, Munich, 1998
'Greg Lynn/Fabian Marcaccio, "The Tingler"' (two-person exh.), Secession, Vienna, 1999
'Paintant Stories' (solo exh.), Kunstverein, Stuttgart, Germany, 2000
'Documenta XI' (group exh.), Kassel, Germany, 2002.
'Janeila's 5 Moves' (solo exh.), Gorney Bravin Lee, New York, 2002

Select publications
Siegel, Katy, '1000 Words: Fabian Marcaccio

Talks About Confine Paintant', *Artforum* vol. 42, no. 3, Nov 2003

Hentschel, Martin and Udo Kittelman, ed. *Fabian Marcaccio: Paintant Stories* (exh. cat.), Kerber Christof Verlag 2000

Damianovic, Maia, *Transformal* (exh. cat.), Vienna, 1996

Rubinstein, Meyer Raphael, *The Altered Genetics of Painting*, New York, 1993

Schwabsky, Barry, *Mutual Betrayal* (exh. cat.), Amsterdam, 1993

MARTIN McGINN
b. 1955, Gillingham, Kent (UK)

Select exhibitions
'Martin McGinn' (solo exh.), Galleri Wallner, Malmö, Sweden, 2000
'Phobia' (solo exh.), Houldsworth, London, 2001
'Death to the Fascist Insect that Preys on the Life of the People' (group exh.), Anthony D'Offay, London, 2001
'Shopping: A Century of Art and Culture' (group exh.), Schirm Kunsthalle and Tate Liverpool, 2002
'Late Night Shopping' (solo exh.), Saatchi Gallery, London, 2002

Select publications
Martin McGinn (exh. cat.), London, 2002

CILDO MEIRELES
b. 1948, Rio de Janeiro (Brazil)

Select exhibitions
'Information' (group exh.), Museum of Modern Art, New York, 1970
'Eureka/Blindhotland' (solo exh.), Museu de Arte Moderna, Rio de Janeiro, 1975
'Cildo Meireles (solo exh.), IVAM of Valencia, Spain, 1995
'Cildo Meireles' (solo exh.), New Museum of Contemporary Art, New York, 1999–2000
'Cildo Meireles: Occasion' (solo exh.), Portikus, Frankfurt, Germany, 2004

Select publications
Amor, Monica, 'Cildo Meireles', *Art Nexus*, Bogota, April 1997
Farmer, John Alan, 'Through the Labyrinth: An Interview with Cildo Meireles', *Art Journal*, Sept 2000
Mosquera, Gerardo et al., *No es sólo lo que ves: pervirtiendo el minimalismo*, Madrid, 2001
Cildo Meireles, London, 1999
Ramirez, Mari-Carmen, *Encounters –*

Displacements: Luis Camnitzer, Alfredo Jaar, Cildo Meireles (exh. cat.), Austin, Texas, 1992

FRANCO MONDINI-RUIZ
b. 1961, San Antonio, Texas (USA)

Select exhibitions
'Infinito Botanica' (solo exh.), Bard College, Annandale-on-Hudson, New York, 1999
Whitney Biennial (group exh.), Whitney Museum of Art, New York, 2000
'Ultra Baroque: Aspects of Post-Latin American Art' (group exh.), Museum of Contemporary Art, San Diego, 2000
'Nacho de Paz' (solo exh.), Fredrieke Taylor Gallery, New York, 2003
'Thinking Green' (solo exh.), Queens Museum of Art, New York, 2004

Select publications
Ultra Baroque: Aspects of Post-Latin American Art (exh. cat.), Museum of Contemporary Art, San Diego, 2000
Siegel, Katy, 'Consuming Art', *Art 21: Art in the Twenty-first Century*, New York, 2001
Mondini-Ruiz, Franco, *Historia de un Amor (A Tex-Mex Love Story)*, New York, 2004

ROBERT MORRIS
b. 1931 Kansas City (USA)

Select exhibitions
Green Gallery (solo exh.), New York, 1963
'Labyrinths–Voice–Blind Time' (solo exh.), Leo Castelli Gallery and Sonnabend Gallery, New York, 1974
'Robert Morris: Selected Works 1970–1980' (solo exh.), Contemporary Arts Museum, Houston, 1981
'Robert Morris: Selected Work 1961–1988' (solo exh.), Margo Leavin Gallery, Los Angeles, 1989
'Robert Morris: The Mind/Body Problem' (solo exh.), Guggenheim Museum, New York, 1994

Select publications
Tucker, Marcia, *Robert Morris* (exh. cat.), New York, 1970
Compton, Michael and David Sylvester, *Robert Morris* (exh. cat.), London, 1971
Danoff, I. Michael et al., *Robert Morris: Works of the Eighties* (exh. cat.), Chicago and Newport Beach, California, 1986
French, Christopher C. (ed.), *Robert Morris: Inability to Endure or Deny the World* (exh. cat.), Washington, DC, 1990

Robert Morris: The Mind/Body Problem (exh. cat.), New York, 1994

SARAH MORRIS
b. 1967, London (UK)

Selected exhibitions
'Sarah Morris' (solo exh.), Museum of Modern Art, Oxford, 1999
'Sarah Morris' (solo exh.), Kunsthalle Zurich, 2000
'Wild Walls', MAK Center, Schindler House, Los Angeles, 2001
'Correspondence', Hamburger Bahnhof, Museum für Gegenwart, Berlin, 2001
Palais de Tokyo (solo exh.), Paris, 2002
Museum of Contemporary Art (solo exh.), Miami, 2002

Select publications
Sarah Morris: Modern Worlds (exh. cat.), Oxford, 1999
Burghi, Bernard, *Sarah Morris* (exh. cat.), Zürich, 2000
Jones, Ronald, *Sarah Morris: Capital*, Cologne, 2002
Painting Pictures – Painting and Media in the Digital Age (exh. cat.), Kerber Christof Verlag, 2003
Prinzhorn, Martin, 'Almost Abstraction and Sarah Morris', *Parkett* 61, 2001

DAVE MULLER
b. 1964, San Francisco (USA)

Select exhibitions
'Dave's Not Here (Three Day Weekend)' (group exh.), Los Angeles, 1994
'Clothes, Polaroids, Movies, & Music' (solo exh.), Blum and Poe, Santa Monica, 2001
'How to Secede (Without Really Trying)' (solo exh.), The Approach, London, 2000
'Dave Muller: Connections' (solo exh.), Center for Curatorial Studies Museum, Bard College, Annandale-on-Hudson, New York, 2002
'Dave Muller' (solo exh.), Murray Guy, New York, 2003

Select publications
Beasley, Mark, 'Dave Muller Interviewed', *Untitled* 22, 2000
Intra, Giovanni, 'Dave Muller: Free Software', *Art/text*, 2000
Grabner, Michelle, 'Dave Muller and Three Day Weekend', *New Art Examiner*, 2000
Rugoff, Ralph, 'Working Weekend: The Art of Dave Muller', *Artforum* 39: 9, May 2001

Dave Muller: Connections (exh. cat.), Annandale-on-Hudson, 2002

TAKASHI MURAKAMI
b. 1962, Tokyo (Japan)

Select exhibitions
'Takashi Murakami: A Very Merry Unbirthday!' (solo exh.), Hiroshima City Museum of Contemporary Art, Hiroshima, Japan, 1993
'Takashi Murakami: Made In Japan' (solo exh.), Museum of Fine Arts, Boston, 2001
'Takashi Murakami: Summon monsters? open the door? heal? or die?' (solo exh.), Museum of Contemporary Art, Tokyo, 2001
'SUPERFLAT' (group exh.), The Museum of Contemporary Art, Los Angeles, 2001
'Takashi Murakami: Kaikaikiki, Kawaii! Vacances d'été' (solo exh.), Fondation Cartier pour l'Art Contemporain, Paris and Serpentine Gallery, London, 2002

Select publications
Murakami, Takashi, *The meaning of the nonsense of the meaning* (exh. cat.), New York, 1999
Murakami, Takashi, *SUPERFLAT* (exh. cat.), Tokyo, 2000
Murakami, Takashi, *Summon monsters? open the door? heal? or die?* (exh. cat.), Saitama, 2001

CLAES OLDENBURG
b. 1929, Stockholm (Sweden)

Select exhibitions
'The Street' (solo exh.), Ruben Gallery, New York, 1960
'The Store' (solo exh.), Green Gallery, New York, 1961
'Bedroom Ensemble' (solo exh.), Sidney Janis Gallery, New York, 1964
'Lipstick (Ascending) on Caterpillar Tracks' (solo exh.), Beincke Plaza, Yale University, New Haven, CT, 1969–70
'Claes Oldenburg: An Anthology' (solo exh.), Guggenheim Museum, New York, 1995–96

Select publications
Oldenburg, Claes and Emmett Williams, *Store Days*, New York, 1967
Rose, Barbara, *Claes Oldenburg* (exh. cat.), New York, 1970
Von Bruggen, Coosje, *Claes Oldenburg* (exh. cat.), Frankfurt, 1991
Celant, Germano, et al, *Claes Oldenburg: An Anthology* (exh. cat.), New York, 1995

Celant, Germano, Claes Oldenburg, *Coosje van Bruggen* (exh. cat.), Venice, 1999

TOM OTTERNESS
b. 1952, Wichita, Kansas (USA)

Select exhibitions
'Tom Otterness' (solo exh.), PPG Plaza, Pittsburgh, 1986
'The Tables' (travelling solo exh.), Valencia: IVAM Centre del Carme, 1991
'Recent Drawings and Small Objects' (solo exh.), Gallery of Art, Krannert Art Museum, Champaign, Illinois, 1994
'Recent Sculpture' (solo exh.), Doris Freedman Plaza, New York, 1995
'Free Money and Other Fairy Tales' (solo exh.), Marlborough Gallery, New York, 2002

Select publications
Kirshner, J.R., *The Tables: Tom Otterness* (exh. cat.), IVAM Centre del Carme, Valencia, 1991
Malsch, F., 'Tom Otterness', *Kunstforum International*, 1992
Tom Otterness (exh. cat.), Krannert Art Museum, Urbana-Champaign, 1994
Princenthal, Nancy, 'Circulatory Systems: Tom Otterness's Prints', *Print Collectors Newsletter*, March–April 1994
Free Money and Other Fairy Tales (exh. cat.), New York, 2002

ROXY PAINE
b. 1966, New York (USA)

Select exhibitions
'Roxy Paine' (solo exh.), Christopher Grimes Gallery, Los Angeles, 2001
'Roxy Paine' (solo exh.), Museum of Contemporary Art, North Miami, Florida, 2001
The Whitney Biennial in Central Park (group exh.), New York, 2002
'Roxy Paine: Second Nature' (solo exh.), Rose Art Museum, Brandeis University, Waltham, Massachusetts and Contemporary Arts Museum, Houston, Texas, 2002
'Roxy Paine' (solo exh.), James Cohan Gallery, New York, 2002

Select publications
In Vitro Landscape, Walther Koenig, Cologne, 1999
Staple, Polly, 'The Greenhouse Effect', *Art Monthly*, May 2000
Rothkopf, Scott, *Roxy Paine* (exh. cat.), James

Cohan Gallery, New York, 2001
Roxy Paine: Second Nature (exh. cat.), Contemporary Arts Museum, Houston, Texas, 2002
Molesworth, Helen (ed.), *Work Ethic* (exh. cat.), Baltimore Museum of Art, Baltimore, Maryland, 2003

PHILIPPE PARRENO
b. 1964, Oran (Algeria)

Select exhibitions
'Dominique Gonzalez-Foerster, Pierre Huyghe, Philippe Parreno' (group exh.), Kunstverein, Hamburg, 2000
'No Ghost Just a Shell: Anywhere Out of the World' (group exh.), Air de Paris, Paris, 2000
'Anywhere Out of the World' (group exh.), Institute of Visual Culture, Cambridge, 2001
'El sueño de una cosa' (solo exh.), Moderna Museet, Stockholm, 2001
'Philippe Parreno: Alien Seasons' (solo exh.), ARC, Musée d'Art Moderne de la Ville de Paris, Paris, 2002
'Sky of The Seven Colors' (solo exh.), Center for Contemporary Art, CCA Kitakyushu, 2003

Select publications
Bourriaud, Nicolas, 'Philippe Parreno: Real Virtuality: Interview with the artist', *Art Press* 208, Dec 1995
Dominique Gonzalez-Foerster/Pierre Huyghe/Philippe Parreno (exh. cat.), Paris, France, 1998
Bossé, Laurence et al., *Philippe Parreno: Alien Affection* (exh. cat.), Paris, 2002
Obrist, Hans Ulrich, 'The Tale of The One Thousand Signs', *Parkett* 66, 2002
Nobel, Philip, 'Sign of the Times', *Artforum International* 41: 5, Jan 2003

DANICA PHELPS
b. 1971, New York (USA)

Select exhibitions
'From Barcelona to Krems' (solo exh.), Galerie Stadpark, Krems, Austria, 2000
'Artist, Collector, Curator, Spy' (solo exh.), LFL Gallery, New York, 2002
'Walking 9–5 Amsterdam' (solo exh.), Annet Gelink Gallery, Amsterdam, 2002
'Integrating Sex into Every Day Life' (solo exh.), LFL Gallery, New York, 2003
Allston Skirt Gallery (solo exh.), Boston, 2004

Select publications

Torres, David, *Vida Politica* (exh. cat.), Barcelona, 2000

Cattelan, Maurizio et al., *Charley* 2, Dijon, 2002

Gioni, Massimiliano, 'New York Cut Up', *Flash Art*, June 2002

Linke, Rosalija, 'Danica Phelps', *Sterz*, Nov 2002

Cameron, Dan, 'Living Inside the Grid', New Museum of Contemporary Art, New York, 2003

ROB PRUITT
b. 1964, Washington, DC (USA)

Select exhibitions

'101 Art Ideas You Can Do Yourself' (solo exh.), Gavin Brown's Enterprise, New York, 2000

'Flea Market' (solo exh.), Gavin Brown's Enterprise, New York, 2000

'Two Friends and so on' (group exh.), Marc Foxx, Los Angeles, 2001

'Pandas and Bamboo' (solo exh.), Gavin Brown's Enterprise, New York, 2001

'Air de Paris' (solo exh.), Paris, 2002

Select publications

Sladen, Mark, ed. *The Americans* (exh. cat.), London, 2001

Dailey, Meghan, 'Rob Pruitt', *Artforum* vol. 40, no. 9, May 2001

Griffin, Tim, 'A Man, A Plan, A Panda', *Time Out New York*, 1 March 2000

Pruitt, Rob and Steve Lafreniere, 'Elizabeth Peyton', *Index*, July 2000

Kelsey, John and Bernadette, 'Rob Pruitt & Jonathan Horowitz', *Made in USA*, Fall/Winter 1999

CHUCK RAMIREZ
b. 1962, San Antonio, Texas (USA)

Select exhibitions

'Coconut' (solo exh.), Sala Diaz, San Antonio, 1997

'Piñatas' (solo exh.), Finesilver Gallery, San Antonio, 2002

'Long Term Survivor' (solo exh.), Art Pace, San Antonio, 2000

'New Work' (solo exh.), inova – Institute of Visual Arts, Milwaukee, Wisconsin, 2002 (solo exh.), Dee/Glasoe, New York, 2002

Select publications

Aztlán Hoy (exh. cat.), Madrid, 1999

Ward, Liz, 'Quarantine', *ArtLies*, March 2001

Dunbar, Elizabeth, *Not So Cute and Cuddly: Dolls and Stuffed Toys in Contemporary Art* (exh. cat.), Wichita, Kansas, 2003

Siegel, Katy, 'Chuck Ramirez', *Artforum* 41: 5, Jan 2003

PETER SAUL
b. 1934, San Francisco (USA)

Select exhibitions

Allan Frumkin Gallery (solo exh.), Chicago, 1961

'Peter Saul' (solo exh.), Aspen Museum of Art, Aspen, Colorado, 1989

'Peter Saul: Political Paintings' (solo exh.), Frumkin/Adams Gallery, New York, 1990

'Peter Saul: Paintings 1963–1965' (solo exh.), Turner, Byrne, & Runyon, Dallas, Texas, 1995

'Eye Infection: Work By Robert Crumb, Mike Kelley, Jim Nutt, Peter Saul and H.C. Westermann' (group exh.), Stedelijk Museum, Amsterdam, 2001

Select publications

Peter Saul: Political Paintings (exh. cat.), New York, 1990

Peter Saul: Heads (exh. cat.), New York, 2000

Eye Infection: Work By Robert Crumb, Mike Kelley, Jim Nutt, Peter Saul and H.C. Westermann (exh. cat.), Amsterdam, 2001

ALLAN SEKULA
b. 1951, Erie, Pennsylvania (USA)

Select exhibitions

'Fish Story' (solo exh.), Witte de With, Rotterdam, 1995

'Dead Letter Office' (solo exh.), Palais des Beaux-Arts, Brussels, 1998

'Freeway to China' (solo exh.), Open Eye, Liverpool, 1999

'Titanic's Wake' (solo exh.), Galerie Michel Rein, Paris, 2001

'Performance Under Working Conditions' (solo exh.), Generali Foundation, Vienna, 2003

Select publications

Sekula, Allan, *Geography Lesson: Canadian Notes*, Cambridge, Mass., 1997

Allan Sekula: Dismal Science: Photoworks 1972–1996 (exh. cat.), Normal, Illinois, 1998

Cockburn, Alexander, *Five Days That Shook The World: The Battle for Seattle and Beyond*, London, 2001

Buchloh, Benjamin H.D., *Fish Story*, Hamburg, 2002

Breitweiser, Sabine (ed.), *Allan Sekula: Performance Under Working Conditions* (exh. cat.), New York, 2003

SANTIAGO SIERRA
b. 1966, Madrid (Spain)

Select exhibitions

'250 cm line tattooed on six paid people' (solo exh.), Espacio Aglutinador, Havana, Cuba, 1999

'Santiago Sierra, Works 2002–1990' (solo exh.), Ikon Gallery, Birmingham, England, 2002

'Hiring and arrangement of 30 workers in relation to their skin colour' (solo exh.), Kunsthalle Wien, Vienna, 2002

'Santiago Sierra' (solo exh.), Contemporary Arts Center, Cincinnati, Ohio, 2003

Spanish Pavilion (solo exh.), 50th Venice Biennale, Venice, 2003

Select publications

Medina, Cuauhtemoc, 'Cronica del sudor ajeno. Una accion de Santiago Sierra', *Curare* 15, 2000

Biesenbach, Klaus, 'Santiago Sierra Talks About His work', *Artforum* 41: 2, Oct 2002

Santiago Sierra, *Works 2002–1990* (exh. cat.), Birmingham, 2002

Santiago Sierra (exh. cat.), Vienna, 2002

Santiago Sierra (exh. cat.), 2003

ELIZABETH SISCO, LOUIS HOCK, DAVID AVALOS
b. 1954, Cheverly, Maryland (USA); b. 1948, Los Angeles, California (USA); b. 1947, San Diego, California (USA)

Select exhibitions

'La Frontera/The Border, Art about the Mexico/ United States Border Experience', public event, San Diego, 1993

'La Frontera/The Border, Art about the Mexico/ United States Border Experience' (group exh.), Centro Cultural de la Raza and Museum of Contemporary Art, San Diego, 1993

'Work Ethic' (group exh.), Baltimore Museum of Art, 2003

San Juan Triennial, Puerto Rico, 2004

Select publications

Kanjo, Kathryn (catalogue coordinator), *La Frontera/The Border, Art about the Mexico/United States Border Experience*, San Diego, 1993

Mydans, Seth, 'Aliens Get Handouts; Artists Call It Art', *New York Times*, 12 Aug 1993

Sullivan, Edward J. (ed.), *Latin American Art in the Twentieth Century*, London, 1996

Welchman, John C., 'Public Art and the Spectacle of Money: An Assisted Commentary on *Art Rebate/Arte Reembolso*', in Erika Suderberg (ed.), *Space, Site, Intervention: Situating Installation Art*, 2000

Barron, Stephanie, Sheri Bernstein and Ilene Susan Fort (eds.), *Made in California: Art, Image, and Identity, 1900–2000*, Berkeley, 2000

JOEL STERNFELD
b. 1944, New York (USA)

Select exhibitions
'American Prospects: The Photographs of Joel Sternfeld' (solo exh.), Museum of Fine Arts, Houston, Texas, 1987
'Campagna Romana: The Roman Countryside' (solo exh.), Pace/MacGill Gallery, New York, 1991
'Joel Sternfeld' (solo exh.), Dartmouth College, Hanover, New Hampshire, 1985
'Stranger Passing' (solo exh.), The San Francisco Museum of Modern Art, San Francisco, 2001
'Treading on Kings: Protesting the G8 in Genoa' (solo exh.), Photographers' Gallery, London, 2002

Select publications
Sternfeld, Joel, *American Prospects*, New York, 1987
Sternfeld, Joel, *Campagna Romana: The Roman Countryside,* New York, 1992
Sternfeld, Joel, *Walking the High Line,* Göttingen, Germany, 2001
Sternfeld, Joel, *Stranger Passing,* Boston, Mass., 2001
Sternfeld, Joel, *Treading on Kings: Protesting the G8 in Genoa,* Göttingen, 2002

RIRKRIT TIRAVANIJA
b. 1961, Buenos Aires (Argentina)

Select exhibitions
'Pad Thai' (solo exh.), Paula Allen Gallery, New York, 1990
'Rirkrit Tiravanija: Untitled 1999 (reading from right to left)' (solo exh.), Wexner Center, Columbus, Ohio, 1999.
'Rirkrit Tiravanija' (solo exh.), Kunstverein Wolfsburg, Germany, 2001
'Rirkrit Tiravanija' (solo exh.), Secession, Vienna, Austria, 2002
'Rirkrit Tiravanija: Demo Station no. 4' (solo exh.), Ikon Gallery, Birmingham, UK, 2003

Select publications
Bourriaud, Nicolas and Eric Troncy, 'Rirkrit Tiravanija' (interview), *Documents sur l'art contemporain*, 5 Feb 1994
Flood, Richard and Rochelle Steiner, 'En route', *Parkett* 44, 1995
Hainley, Bruce, 'Where are we Going? and What are we Doing? Rirkrit Tiravanija's Art of Living', *Artforum* 34: 6, Feb 1996
Tiravanija, Rirkrit, *Documents sur l'art* 9, Summer 1996
Tiravanija, Rirkrit, *Supermarket*, New York, 1999

ANDY WARHOL
b. 1928, Pittsburgh (USA); d. 1987, New York (USA)

Select exhibitions
'Campbell's Soup Cans' (solo exh.), Ferus Gallery, Los Angeles, 1962
'Warhol' (solo exh.), Stable Gallery, New York, 1964
'Andy Warhol' (travelling solo exh.), Moderna Museet, Stockholm, 1968
'Andy Warhol 'Dollar Signs'' (solo exh.), Leo Castelli Gallery, New York, 1982
'Andy Warhol Photographs' (solo exh.), Robert Miller Gallery, New York, 1987

Select publications
Warhol, Andy et al. (eds.), *Andy Warhol* (exh. cat.), Stockholm, 1968
Coplans, John, *Andy Warhol*, Greenwich, Connecticut, 1970
Koch, Stephen, *Stargazer: Andy Warhol's World and His Films*, New York, 1973
Smith, Patrick S., *Andy Warhol's Art and Films*, Ann Arbor, Michigan, 1986
Frei, Georg and Neil Printz (eds.), *Paintings and Sculpture 1961–63* (catalogue raisonné), London, 2002

FURTHER READING

Ackerman, Martin S., *Smart Money and Art. Investing in Fine Art*. Barrytown, New York, 1986

Ardenne, Paul, 'The Art Market in the 1980s', *International Journal of Political Economy* 25:2, Summer 1995

Becq, Annie, 'Creation, Aesthetics, Market: Origins of the Modern Concept of Art', Paul Mattick (ed.), *Eighteenth-Century Aesthetics and the Reconstruction of Art*, New York, 1993

Becq, Annie, 'Artistes et marché', Jean-Claude Bonnet, *La carmagnole des muses. L'homme de lettres et l'artiste dans la Révolution*, Paris, 1988

Becq, Annie, *Genèse de l'esthétique française moderne. De la raison classique à l'imagination créatrice*, Paris, 1994

Bellet, Harry, *Le marché de l'art s'écroule demain à 18h30*, Paris, 2001

Benhamou-Huet, Judith, *The Worth of Art. Pricing the Priceless*, New York, 2001

Bourdieu, Pierre and Alain Darbel, *L'amour de l'art. Les musées d'art européens et leur public*, Paris, 1969; abridged trans., *The Love of Art: European Art Museums and Their Public*, Oxford, 1997

Bourdieu, Pierre, 'The Production of belief: contribution to an economy of symbolic goods', idem., *The Field of Cultural Production*, New York, 1993

Bourdieu, Pierre, *The Rules of Art. Genesis and Structure of the Literary Field*, Stanford, 1995

Bourdieu, Pierre, *Distinction: A Social Critique of the Judgement of Taste*, Cambridge, 1984

Brewer, John, *The Pleasures of the Imagination: English Culture in the Eighteenth Century*, Chicago, 2000

Dorléac, Laurance Bertrand, *Le commerce de l'art de la Renaissance à nos jours*. Besançon, 1992

Gee, Malcom, *Dealers, Critics, and Collectors of Modern Painting. Aspects of the Parisian Art Market Between 1910 and 1930*, New York, 1981

Glenn, Constance W., *The Great American Pop Art Store. Multiples of the Sixties*, Santa Monica, 1997

Goldthwaite, Richard A., *Wealth and the Demand for Art in Italy, 1300–1600*, Baltimore, 1993

Green, Nicholas, 'Dealing in Temperaments: Economic Transformation of the Artistic Field in France During the Second Half of the Nineteenth Century', *Art History*, March 1987

Jensen, Robert. *Marketing Modernism in Fin-de-Siècle Europe*, Princeton, 1994

Mainardi, Patricia, *The End of the Salon. Art and the State in the Early Third Republic*, Cambridge, 1993

Marx, Karl, *Capital*, Vol. I, trans. Ben Fowkes, Harmondsworth, 1976

Marx, Karl, *Capital*, Vol. II, trans. David Fernbach, Harmondsworth, 1978

Marx, Karl, *Capital*, Vol. III, trans. David Fernbach, Harmondsworth, 1981

Mattick, Paul, *Art in Its Time. Theories and Practices of Modern Aesthetics*, London, 2003

Moulin, Raymonde, *Le marché de la peinture en France*, Paris, 1967; abridged trans., *The French Art Market: A Sociological View*, New Brunswick, 1987

Moulin, Raymonde, *De la valeur de l'art. Recueil d'articles*, Paris, 1995

Moulin, Raymonde, *L'artiste, l'institution et le marché*, Paris, 1992

Moulin, Raymonde, 'The Museum and the Marketplace. The Constitution of Value in Contemporary Art', *International Journal of Political Economy* 25:2, Summer 1995

North, Michael, *Art and Commerce in the Dutch Golden Age*, trans. Catherine Hill, New Haven, 1997

Quemin, Alain, *L'art contemporain international: entre les institutions et le marché*, Paris, 2002

Reitlinger, Gerald, *The Economics of Taste. The Rise and Fall of the Picture Market, 1760–1960*, New York, 1961

Robson, Deirdre A., *Prestige, Profit, and Pleasure. The Market for Modern Art in New York in the 1940s and 1950s*, New York, 1995

Schapiro, Meyer, 'On the Art Market', *Worldview in Painting – Art and Society*, New York, 1999

Schwartz, Barthelémy, *Un art d'economie mixte*, Paris, 1997

Siegel, Katy, 'Consuming Art', *Art 21: Art in the Twenty-First Century*, New York 2001

Siegel, Katy, 'Making the Nineties: The Private Collector', in *Supernova*, San Francisco, 2003

Simmel, Georg, *The Philosophy of Money*, trans. Tom Bottomore and David Frisby, London, 1978

Solkin, David H., *Painting for Money. The Visual Arts and the Public Sphere in Eighteenth-Century England*, New Haven, 1993

Sullivan, Nancy, 'Inside Trading: Postmodernism and the Social Drama of *Sunflowers* in the 1980s Art World', George E. Marcus and Fred R. Meyers (eds.), *The Traffic in Culture: Refiguring Art and Anthropology*, Berkeley, 1995

Veblin, Thorstein, *The Theory of the Leisure Class*, New York, 1994

Verger, Annie, 'The Art of Evaluating Art. How To Assess the Incomparable?' *International Journal of Political Economy* 25:2, Summer 1995

Warnke, Martin, *The Court Artist. On the Ancestry of the Modern Artist*, Cambridge, 1993

Warhol, Andy, *The Philosophy of Andy Warhol (From A to B and Back Again)*, New York, 1975

Woodmansee, Martha, *The Author, Art, and The Market. Rereading the History of Aesthetics*, New York, 1994

Wu, Chin-Tao, *Privatising Culture. Corporate Art Intervention Since the 1980s*, London, 2002

ILLUSTRATION LIST

Measurements are given in centimetres, followed by inches, height before width before depth.

1 Claude Closky, *Untitled (Supermarket)*, 1996–99 (detail). Wallpaper, silkscreen print, dimensions variable. Courtesy of the artist and Galerie Jennifer Flay, Paris

2 Neil Cummings and Marysia Lewandowska, *Free Trade*, 2002–3 (detail). Installation, mixed media. © Neil Cummings and Marysia Lewandowska. Courtesy of chanceprojects

3 Rob Pruitt, *Flea Market*, 2000 (detail). Performance. Courtesy Gavin Brown's Enterprise, New York

4–5 Sarah Morris, *Capital*, 2000 (detail). 16mm/DVD (duration 18 mins, 18 secs). Courtesy Jay Jopling, London

6 Daniel Lefcourt, *Merger*, 1999–2001 (detail). Digital C-print. Courtesy Daniel Lefcourt

10 Tim Noble and Sue Webster, *$*, 2001. Mixed media, 183 x 122 x 25.4 (72 x 48 x 10). © The artists. Courtesy Modern Art, London

13 Sol LeWitt, *Wall Drawing #896*, 1999. First drawn by Sachiko Cho, Mark Dickey, John Hogan, Aron Murkis, Hidemi Nomura, Jeff Pook, Emily Ripley, Anthony Sansotta, Todd Weinstein. Lascaux acrylic paint. Collection of Christie's, New York. © ARS, NY and DACS, London 2004

19 Antoine Watteau, *L'Enseigne de Gersaint*, 1720. Oil on canvas, 163 x 308 (64 1/8 x 121 1/4). Château de Charlottenburg, Berlin

20 Edgar Degas, *Portraits in an Office (New Orleans)*, 1873. Oil on canvas. Art Resource. Courtesy Musée des Beaux Arts, Pau. Photo Erich Lessing

23 Quentin Matsys, *The Moneylender and his Wife*, 1514. Oil on wood. 70.7 x 67 (27 3/4 x

26 3/8). Art Resource. Courtesy Louvre, Paris. Photo Erich Lessing

24 Victor Dubreuil, *Is It Real?*, before 1890. Oil on canvas, 78.2 x 91 (12 1/8 x 14 1/8). Courtesy Oberlin College

25 Marcel Duchamp, *Tzanck Check, 3 December 1919*. Ink on paper, 21 x 38.2 (8 1/4 x 15 1/16). The Vera, Silvia and Arturo Schwarz Collection of Dada and Surrealist Art in the Israel Museum, Jerusalem. © Succession Marcel Duchamp/ ADAGP, Paris and DACS, London 2004

31 Katharina Fritsch, *Herz mit Silber, Ahren und Schlangen*, 2001. Plastic, aluminium and paint, 400 x 400 (157 x 157). Courtesy Matthew Marks Gallery, New York. © DACS 2004

32 Andreas Gursky, *Prada II*, 1997. C-print, 165.1 x 315 (65 x 124). Courtesy Monica Sprueth Gallery/Philomene Magers, © DACS 2004

33 Chuck Ramirez, *Godiva 2*, 2002. Ink Jet print, 152.4 x 198.1 (60 x 78). Courtesy of the artist, Elizabeth Dee Gallery, New York and Finesilver Gallery, San Antonio

34 Andrea Bowers, *Pope Fans Reaching Toward British Open Fan*, 2000. Graphite, coloured pencil and gold foil on paper, 223.5 x 129.5 (88 x 51). Courtesy of the artist and Sara Meltzer Gallery

35 Andrea Bowers, *Hot, Cool and Vicious*, 2000. Graphite, coloured pencil and silver foil on paper, 101.6 x 66 (40 x 26). Courtesy of the artist and Sara Meltzer Gallery

37 Barton Lidice Benes, *Reliquarium*, 1996. Currency, plaster, wood, glass, 61 x 33 (24 x 13). Courtesy Lennon, Weinberg, Inc., New York

38 Cildo Meireles, *Missão/Missões (How to Build Cathedrals)*, 1987. Mixed media installation. Photo George Holmes. Jack S. Blanton Museum of Art, The University of Texas at Austin. Museum purchase with funds provided by Peter Norton Family Foundation, 1998

41 Rainer Ganahl, *Das Zählen der letzten Tage der Sigmund Freud Banknote*, 2002. Collage, ink

and pencil on paper. Courtesy the artist and Baumgartner Gallery, New York

42 Andrew Bush, *Short Snorters Series, Dollar Bill (US)*, 1994. C-print, 193.5 x 419.5 (30 x 65). Courtesy Julie Saul Gallery, New York

43 Andrew Bush, *Short Snorters Series, Kilroy (France)*, 1994. C-print, 193.5 x 419.5 (30 x 65). Courtesy Julie Saul Gallery, New York

44 Tom Friedman, *Untitled*, 1999. Thirty-six dollar bills, 35.6 x 89.5 (14 x 35 1/4). Courtesy of the artist and Feature Inc., New York. Photo Oren Slor

46 Boris Becker, *Damenschuhe 'Kokain' Kunststoffgemisch 'Costa Rica'*, 1999. C-print, 130 x 150 (51 1/8 x 59). © Boris Becker

47 Boris Becker, *Löschpapier Kokain Kolumbien*, 1999. C-print, 130 x 150 (51 1/8 x 59). © Boris Becker

48 Hans Haacke, *Broken R.M....*, 1986. Gilded snow shovel, enamel plaque. © DACS 2004, Photo Fred Scruton

50 Piero Manzoni, *Merda d'artista nº 066*, 1961. Metal can, 4.8 x 6.5 (1 7/8 x 2 1/2). © DACS 2004

52 (top) J.S.G. Boggs, *94 Stories – No 16*, 1994. Mixed media on CJ10 Print/CJ10 Paper, 6.6 x 15.6 (2 5/8 x 6 1/8). Image courtesy Szilage Gallery, St Petersburg, FL, USA. © jsg boggs 2001–2004 ALL RIGHTS RESERVED

52 (middle) J.S.G. Boggs, *50 BM Boggs Mark #JSG0107*, 2001. HP970 cse Print on German Paper, 6.6 x 13.2 (2 5/8 x 5 1/4). Image courtesy Szilage Gallery, St Petersburg, FL, USA. © jsg boggs 2001–2004 ALL RIGHTS RESERVED

52 (bottom) J.S.G. Boggs, *Money of Colour*, 1994. CJ10 on CJ10 paper, 6.6 x 15.6 (2 5/8 x 6 1/8). Image courtesy Szilage Gallery, St Petersburg, FL, USA. © jsg boggs 2001–2004 ALL RIGHTS RESERVED

53 Cildo Meireles, *Zero Cruzeiro*, 1978 (front and back). Print, 7 x 15 (2 3/4 x 7 5/8). Courtesy of UECLAA (University of Essex Collection of Latin American Art)

54 Boris Becker, *Markenpiraterie Jeans*, 1999. C-print, 180 x 240 (70 7/8 x 94 1/2). © Boris Becker

55 Boris Becker, *Olbild 1651 Kokainfarbe*, 1999. C-print, 244 x 190 (96 x 74 3/4). © Boris Becker

56 Neil Cummings and Marysia Lewandowska, *Capital*, 2001. Installation. © Neil Cummings and Marysia Lewandowska. Courtesy of chanceprojects

57 Neil Cummings and Marysia Lewandowska, *Capital (Bank of England Monetary Analysis)*, 2001. Installation. © Neil Cummings and Marysia Lewandowska. Courtesy of chanceprojects

58 (left) Neil Cummings and Marysia Lewandowska, *Capital (Matisse's Snail Ready to Go)*, 2001. Installation. © Neil Cummings and Marysia Lewandowska. Courtesy of chanceprojects

58 (right) Neil Cummings and Marysia Lewandowska, *Capital (Tate Archive Bankers' Boxes)*, 2001. Installation. © Neil Cummings and Marysia Lewandowska. Courtesy of chanceprojects

59 Neil Cummings and Marysia Lewandowska, *Capital (Conservation)*, 2001. Installation. © Neil Cummings and Marysia Lewandowska. Courtesy of chanceprojects

60 Minerva Cuevas, (top) *MVC Website*, 2002; (middle) *Barcodes*, 2002; (bottom) *MVC Student ID card*, 2002. Courtesy Minerva Cuevas

61 Minerva Cuevas, (top) *MVC Logo*, 2002; (bottom) *IDs Desk*, 2002. Courtesy Minerva Cuevas

62–65 Takashi Murakami, *Kase Taishuu Project*, 1999. 4 C-prints, 74.9 x 56.2 (29 1/2 x 22 1/8) each. © Takashi Murakami. All rights reserved. Courtesy Marianne Boesky Gallery

66–67 Maurizio Cattelan, *Untitled (MoMA Project #65)*, 1998. Papier mâché, paint, costume mask. Courtesy the artist and Marian Goodman Gallery, New York

68 Sean Landers, *Attn. Miss Gonzales*, 1991. Ink on paper, 8 leaves, 27.9 x 21.6 (11 x 8 1/2) each.

© Sean Landers. Photo Peter Muscato. Courtesy Andrea Rosen Gallery

70 Sean Landers, *Sean Landers*, 2001. Oil on linen, 188 x 584.2 (74 x 230). © Sean Landers. Photo Marc Domage/Tutti. Courtesy Andrea Rosen Gallery, New York and Galerie Jennifer Flay, Paris

72 Maurizio Cattelan and Jens Hoffmann (co-curators), *The 6th Caribbean Biennial*, 1999. Performance. Courtesy of the artist and Marian Goodman Gallery, New York

74 Andy Warhol, *Thirty are Better than One*, 1963. Synthetic polymer paint and silkscreen ink on canvas, 279.4 x 240 (110 x 94 1/2). © The Andy Warhol Foundation for the Visual Arts, Inc./ARS, NY and DACS, London 2004

76 Santiago Sierra, *Ian the Irish*, 2002. Ikon Gallery, Birmingham

78 Santiago Sierra, *Línea de 160 cm Tatuada Sobre Cuatro Personas*, 2000. Courtesy Galerie Peter Kilchmann, Zurich

79 Santiago Sierra, *Forma de 600 x 57 x 52 cm Construida para ser Mantenida en Perpendicular a una Pared*, 2001. Courtesy Galerie Peter Kilchmann, Zurich

81 Peter Fischli and David Weiss, *Untitled*, 2001. Objects out of polyurethane, graven and painted, real size. Courtesy the artists and Galerie Eva Presenhuber, Zurich

82 Roxy Paine, *Scumak 2*, 2002. Aluminium, computer, conveyor, electronics, extruder, stainless steel, polyethylene, Teflon, 228.6 x 701 x 185.4 (90 x 276 x 73). © Roxy Paine. Courtesy James Cohan Gallery, New York

83 Roxy Paine, *PMU (Painting Manufacture Unit)*, 1999–2000. Aluminium, stainless steel, computer, electronics, relays, custom software, acrylic, servo motors, valves, pump, precision track, glass, rubber, 279.4 x 398.8 x 447 (110 x 157 x 176). © Roxy Paine. Courtesy James Cohan Gallery, New York

84–85 Philippe Parreno, *Workbench*, 1995. Mixed media (wooden tables, teddy bears with electronic chips, t-shirts). Courtesy Schipper & Krome, Berlin

86 Rob Pruitt, *101 Art Ideas You Can Do Yourself: No. 22 Fill a desk drawer with gravel and make a secret zen garden*, 1999. Mixed media. Courtesy Gavin Brown's Enterprise, New York

87 (left) Rob Pruitt, *101 Art Ideas You Can Do Yourself: No. 21 Pour a glass of water to look at*, 1999. Mixed media. Courtesy Gavin Brown's Enterprise, New York

87 (right) Rob Pruitt, *101 Art Ideas You Can Do Yourself: No. 19 Toilet paper the inside of your house*, 1999. Mixed media. Courtesy Gavin Brown's Enterprise, New York

89 Bernard Frize, *Gabarit*, 1998. Acrylic and resin on canvas, 116 x 89 (45 5/8 x 35). Courtesy Galerie Micheline Szwajcer, Antwerp

90–91 Hans Haacke, *Der Pralinenmeister*, 1981. Collage on silkscreen. © DACS 2004. Photo Lothar Schnepf. Collection Gilbert and Lila Silverman

92 Tom Friedman, *1000 Hours of Staring*, 1992–97. Stare on paper, 82.6 x 82.6 (32 1/2 x 32 1/2). Courtesy of the artist and Feature Inc., New York. Photo Oren Slor

94 Andreas Gursky, *99 Cent*, 1999. C-print mounted to plexiglass in artist's frame, 207 x 336.9 (81 1/2 x 132 5/8). Courtesy Monica Sprueth Gallery/Philomene Magers, © DACS 2004

95 Andy Warhol, *Brillo Boxes*, 1969. Silkscreen ink on plywood, 45 boxes: each 50.8 x 50.8 x 43.2 (20 x 20 x 17). Version of 1964 original. Norton Simon Museum, Pasadena, CA. Gift of the artist, 1969. © The Andy Warhol Foundation for the Visual Arts, Inc./ARS, NY and DACS, London 2004

96–99 Rob Pruitt, *Flea Market*, 2000. Performance. Courtesy Gavin Brown's Enterprise, New York

100–1 Andrea Bowers, *Aunt Dee's T-Shirt Shop*, 2000. Video stills. Courtesy of the artist and Mary Goldman Gallery

102 Franco Mondini-Ruiz, *Infinito Botanica: San Antonio, Texas*, 1995–98. Installation view. Courtesy the artist

103 Franco Mondini-Ruiz, *Infinito Botanica: NYC Whitney Biennial*, 2000. Performance/installation view. Courtesy the artist

104 Franco Mondini-Ruiz, *Infinito Botanica: ArtPace, San Antonio, Texas*, 1996. Installation view. Courtesy the artist

105 Franco Mondini-Ruiz, *Infinito Botanica: Museum of Contemporary Art, San Diego, California*, 2000. Installation view. Courtesy the artist

106 (top) Michael Ray Charles, *(Forever Free) Buy Black!*, 1997. Acrylic latex, stain and copper penny on paper, 78.1 x 61.5 (30 3/4 x 24 1/4). Courtesy Tony Shafrazi Gallery, New York

106 (bottom) Michael Ray Charles, *(Forever Free) Tommy Hilnigguh*, 1999. Acrylic latex, stain and copper penny on canvas, 91.4 x 153 (36 x 60 1/4). Courtesy Tony Shafrazi Gallery, New York

107 Michael Ray Charles, *(Forever Free) Art n American*, 2000. Acrylic latex, stain and copper penny on canvas, 213.3 x 152.4 (84 x 60). Courtesy Tony Shafrazi Gallery, New York

108–9 Christian Jankowski, *Point of Sale*, 2002. Video stills. Courtesy Christian Jankowski, Maccaroni, Inc., New York, and Klosterfelde, Berlin

110–11 Claude Closky, *Untitled (Supermarket)*, 1996–99. Wallpaper, silkscreen print. Photos © Joséphine de Bère. Courtesy Gallery Jennifer Flay, Paris

112 Martin McGinn, *Iceland*, 2001. Oil on canvas, 213.4 x 365.8 (84 x 144). Saatchi Collection

113 Martin McGinn, *Boxes*, 2001. Watercolour on paper, 57 x 76 (22 1/2 x 30). Courtesy the artist and Houldsworth, London

114 Claes Oldenburg, *The Store, 107 East 2nd Street, New York*, 1961. Installation. Courtesy Claes Oldenburg. Photo Robert McElroy. Robert R. McElroy /VAGA, New York/DACS, London 2004

116–17 Elizabeth Sisco, Louis Hock and David Avalos, *Arte Reembolso/Art Rebate*, 1993. Black-and-white photograph, bilingual flyer (English side), receipt. Photo: Elizabeth Sisco. Courtesy the artists

118 Dave Muller, *Thanks (Three Day Weekend)*, 1994. Acrylic on paper. Courtesy Dave Muller and Blum and Poe, Los Angeles

119 Dave Muller, *People are Animals (Three Day Weekend)*, 2000. Acrylic on paper. Courtesy Dave Muller and Blum and Poe, Los Angeles

121 Mark Lombardi, *Gerry Bull, Space Research Corporation and Armscor of Pretoria, South Africa*, c. 1972–80 (5th version), 1999. Coloured pencil graphite on paper, 147.3 x 193 (58 x 76). Photo John Berens. Courtesy of The Judith Rothschild Foundation

122–23 Mark Lombardi, *George W. Bush, Harken Energy and Jackson Stephens* c. 1979–90 (5th version), 1999. Graphite on paper, 50.8 x 111.8 (20 x 44). Photo John Berens. Private collection

125 Laura Kurgan, *Global Clock No. 2*, 2002. Digital display driven by real-time feeds from financial and stock-exchange markets. Courtesy Laura Kurgan.

126–27 Danica Phelps, *Artist, Collector, Curator, Spy*, 2002. Laser prints on paper on wood, dimensions variable. Courtesy Danica Phelps and LFL Gallery, New York

128–29 Paul Etienne Lincoln, *New York – New York*, 1986–present. Artist performance with bonds. Courtesy Alexander and Bonin, New York

130 (left) Paul Etienne Lincoln, *New York – Hot*, 1986–present. Brass and mixed media, approx. height 355.3 (140). Courtesy Alexander and Bonin, New York

130 (right) Paul Etienne Lincoln, *New York – Cold*, 1986-present. Aluminium and mixed media, approx. height 355.5 (140). Courtesy Alexander and Bonin, New York

131 Paul Etienne Lincoln, *New York – New York (model)*, 1986–present. Brass, aluminium, wood, board, Bakelite, two drawers each with printed Mylar diagrams, Plexiglas, 114.5 x 183 x 61

(45 x 72 x 24). Courtesy Alexander and Bonin, New York

132 (left) Barton Lidice Benes, *Smorgasbord (United States)*, 2002. US currency on paper, 26.7 x 21 (10 1/2 x 8 1/4). Courtesy Lennon, Weinberg Inc., New York

132 (right) Barton Lidice Benes, *Smorgasbord (Italy)*, 2002. Italian currency on paper, 26.7 x 21 (10 1/2 x 8 1/4). Courtesy Lennon, Weinberg Inc., New York

133 (left) Barton Lidice Benes, *Smorgasbord (Vietnam)*, 2002. Vietnamese currency on paper, 26.7 x 21 (10 1/2 x 8 1/4). Courtesy Lennon, Weinberg Inc., New York

133 (centre) Barton Lidice Benes, *Smorgasbord (Mexico)*, 2002. Mexican currency on paper, 26.7 x 21 (10 1/2 x 8 1/4). Courtesy Lennon, Weinberg Inc., New York

133 (right) Barton Lidice Benes, *Smorgasbord (Russia)*, 2002. Russian currency on paper, 26.7 x 21 (10 1/2 x 8 1/4). Courtesy Lennon, Weinberg Inc., New York

134–35 Neil Cummings and Marysia Lewandowska, *Free Trade*, 2002–3. Installation, mixed media. © Neil Cummings and Marysia Lewandowska. Courtesy of chanceprojects

136 Joseph Beuys, *Kunst=Kapital*, 1979. Courtesy Editions Klaus Staeck, Heidelberg. © DACS 2004

138–39 Daniel Lefcourt, *Merger*, 1999–2001. Digital C-prints. Courtesy Daniel Lefcourt

140 (left) Paul Graham, *Waiting Area, Hackney DHSS, East London, 1985*. Fuji crystal archive print, 88.5 x 106 (34 7/8 x 41 3/4). © The artist. Courtesy Anthony Reynolds Gallery, London

140 (right) Paul Graham, *Queue, Paddington DHSS, West London, 1985*. Fuji crystal archive print, 88.5 x 106 (34 7/8 x 41 3/4). © The artist. Courtesy Anthony Reynolds Gallery, London

141 Joel Sternfeld, *A Lawyer with Laundry, New York, New York, October 1988*. Photograph. Courtesy the artist and Luhring Augustine, New York

143 Robert Morris, *Money*, 1969. 15 letters and 2 cheques mounted on board and framed, 54.6 x 170.2 (21 1/2 x 67). Courtesy Leo Castelli Gallery, New York. © ARS, NY and DACS, London, 2004

144 Danica Phelps, *Brooklyn*, 2000. Mixed media, dimensions variable. Courtesy LFL Gallery, New York

145 Danica Phelps, *Brooklyn: Portraits, 2000*. Graphite, Central Park portraits and watercolour, dimensions variable. Courtesy LFL Gallery, New York

146–47 Tom Otterness, *Life Underground (14th Street/8th Ave.)*, 2001–2. Multiple figures, bronze, dimensions variable. Photo Patrick Cashin. Courtesy of the artist and Marlborough Gallery

148 Peter Saul, *Poverty*, 1968. Acrylic and oil on canvas, 163 x 122 (64 1/8 x 48). Centre Pompidou-MNAM-CCI, Paris. Photo © CNAC/MNAM Dist. RMN

149 Tom Otterness, *Free Money*, 2001. Bronze, height 273 (107 1/2). Courtesy of the artist and Marlborough Gallery

150 Takashi Murakami, *DOB Mousepad*, in production since 1999. © 1999 Takashi Murakami/Kaikai Kiki Co., Ltd., all rights reserved. Courtesy Kaikai Kiki Co., Ltd.

151 Takashi Murakami, *DOB in the Strange Forest*, 1999. Oil paint, acrylic, synthetic resin, fibreglass and iron, 152.4 x 304.8 x 304.8 (60 x 120 x †20). © 1999 Takashi Murakami. Courtesy Tomio Koyama Gallery

152–53 Fabian Marcaccio, *We...You were doing so well (with the contract). Why this now? Paintant*, 2002. Pigment inks and acrylic, 20.3 x 185.4 (8 x 73) each. Photo courtesy of Gorney Bravin and Lee, New York

154 Fabian Marcaccio, *Economic Concentration Camp*, 2002. Pigmented based inks, oil, acrylic, silicone on canvas, 76.2 x 101.6 (30 x 40). Photo courtesy of Gorney Bravin and Lee, New York

155 Fabian Marcaccio, *Semantic Fabric Paintant*, 2002. Pigmented based inks, oil, acrylic, silicone and polyoptics on canvas, 182.9 x 243.8 (72 x 96). Photo courtesy of Gorney Bravin and Lee, New York

156–57 Sarah Morris, *Capital*, 2000. 16mm/DVD (duration 18 mins, 18 secs). Courtesy Jay Jopling, London

158–59 Philippe Parreno, *Anywhere Out of the World*, 2000. 3D animation movie transferred onto DVD, sound Dolby Digital Surround, blue carpet, poster, 3.5 mins. Courtesy Friedrich Petzel Gallery, New York.

160 The Art Guys, *Suits*, 1998–99. Performance. Courtesy Art Guise Archive Limited.

162–63 Felix Gonzalez-Torres, *Untitled (USA Today)*, 1990. 300 lbs of candies, individually wrapped in red, silver and blue cellophane, dimensions variable. © The Estate of Felix Gonzalez-Torres. Photo Peter Muscato. Courtesy of Andrea Rosen Gallery, New York, in representation of The Estate of Felix Gonzalez-Torres

164 Rirkrit Tiravanija, *Untitled (Free)*, 1992. Installation view, 303 Gallery. Courtesy Gavin Brown's Enterprise, New York

165 Rirkrit Tiravanija, *Untitled (Rehearsal Studio No. 6 Silent Version)*, 1996. Courtesy Gavin Brown's Enterprise, New York

166–67 Rob Pruitt, *Cocaine Buffet*, 1998. Two Plexiglas mirrors, each part 30.5 x 243.8 (12 x 96). Courtesy Gavin Brown's Enterprise, New York

168 Lee Lozano, *Real Money [parts 1–3]*, 1969. Graphite on paper, 27.9 x 21.6 (11 x 8 1/2). Courtesy Jaap van Liere

170 Rainer Ganahl, *Searching Karl Marx on Amazon.com*, 2000. Installation view, wallpainting, height *c.* 500 (197). Courtesy Rainer Ganahl–www.ganahl.info

171 Rainer Ganahl, *Capital*, 2000. Installation. Courtesy Rainer Ganahl–www.ganahl.info

172 (top left) Rainer Ganahl, *Reading Karl Marx, Frankfurt, Germany*, 2000. Photograph. Courtesy Rainer Ganahl–www.ganahl.info

172 (top right) Rainer Ganahl, *Reading Karl Marx, Brooklyn, USA*, 2000. Photograph. Courtesy Rainer Ganahl–www.ganahl.info

172 (bottom left) Rainer Ganahl, *Reading Karl Marx, London, UK*, 2001. Photograph. Courtesy Rainer Ganahl–www.ganahl.info

172 (bottom right) Rainer Ganahl, *Reading Karl Marx, Kingston, UK*, 2001. Photograph. Courtesy Rainer Ganahl–www.ganahl.info

174–77 Jeremy Deller, *The Battle of Orgreave*, 2001. Performance. Courtesy Jeremy Deller and Arcangel, London

178 Tom Otterness, *Rebellion to Tyrants*, 2002. Bronze, height 59 (23 1/4). Courtesy of the artist and Marlborough Gallery

179 Allan Sekula, *Waiting for Tear Gas*, 1999–2000. Slide projection (81 images) and text. Courtesy of the artist and Christopher Grimes Gallery, Santa Monica, CA

180 Joseph Beuys, *Nur Noch 1017 Tage*, 1984. Blackboard and chalk. H.W. Grave. © DACS 2004

INDEX OF ARTISTS

Page numbers in *italics* refer to illustrations

6729 23